BEAT

BEAT

Published by Last Gasp
777 Florida Street
San Francisco, CA 94110
www.lastgasp.com

Designed by Linda Johnson/Swell Design, Inc.
Santa Fe, NM.

Printed and bound in China by Prolong Press Ltd.

First Printing January, 2007.
07 08 09 8 7 6 5 4 3 2 1

ISBN-13: 978-086719-671-9

ISBN-10: 0-86719-671-8

BEAT

CHRISTOPHER FELVER

PHOTOGRAPHS/COMMENTARY

CONTENTS

I FIRST MET DEAN not long after my wife and I split up. I had just gotten over a
serious illness that I won't bother to talk about, except that it had something
to do with the miserably weary splitup and my feeling that everything was
dead. With the coming of Dean Moriarty began the part of my life
you could call my life on the road. Before that I'd often dreamed of going west,
seeing the country, always vaguely planning and never taking off.
Dean is the perfect guy for the road because he actually was born on the road,
when his parents were passing through Salt Lake City in 1926, in a jaloppy, on their
way to Los Angeles. First reports of him came to me through Chad King, who'd
shown me a few letters from him written in a New Mexico reform school. I was tre-
mendously interested in the letters because they so naïvely and sweetly asked for
Chad to teach him all about Nietzsche and all the wonderful intellectual things that
Chad knew. At one point Carlo and I talked about the letters and wondered if we
would ever meet the strange Dean Moriarty. This is all far back, when Dean was not
the way he is today, when he was a young jailkid shrouded in mystery. Then news
came that Dean was out of reform school and was coming to New York for the first
time; also there was talk that he had just married a girl called Marylou.

One day I was hanging around the campus and Chad and Tim Gray
told me Dean was staying in a coldwater pad in East Harlem,
the Spanish Harlem. Dean had arrived the night before, the first time in New York,
with his beautiful little sharp chick Marylou; they got off the Greyhound bus at
50th Street and cut around the corner looking for a place to eat and went right in
Hector's, and since then Hector's cafeteria has always been a big symbol of New
York for Dean. They spent money on beautiful big glazed cakes and creampuffs.
All this time Dean was telling Marylou things like this:

"Now, darling, here we are in New York and although I haven't
quite told you everything that I was thinking about when we crossed Missouri and

BEATS + COHORTS

The Beats dropped into the still pond of mid-1950s poetry, and sent shock-waves in all directions, engulfing other poets and artists on the same wave-length all over the country and, eventually, all over the world.

Today, the "Beat message" is still spreading its Word of dissident non-violent crazy wisdom and beatitude, in a world that needs it more than ever.

Ferlinghetti

The World of Chris Felver

THE PHOTOGRAPHER. Identified because you might know some other Chris Felvers, who ain't the real one. The real one is a dangerous photographer. And like most of them guys (& dolls) he is a flick-addict. Will snap snap snap snap you into the next book. I usually tell them, (after the tenth "Hold your head up Amiri, push yr glasses up"), like the public service ads, "Just say No!" But they never do. And the only way you're gonna ever see that likeness of yr selves is to buy the book. Or be kidnapped by the photographers' Quaeda and held hostage till you write an introduction!

"Help!"

Anyway, what you have to know is that Felver is a skilled photo-terrorist. The so called Paparazzi have been rendered virtually inobnoxious by the serpentine clickings of the Felver photomatrix.

He has been programmed, like Keanu Reeves to be Neo, the One. (Am I Laurence Fishburne? Not at this salary.) And his mission is to register the inner sanctum of the clandestine, the rarely visited domiciles of the sensationally glimpsed.

For Felver, The-Ghost-Who-Shoots, he has been savaged psychologically, as some kind of emotional poll tax, to be a Drummer for the media rabbit called The Beats. What Al Aronowitz pulled out of his hat, when he was working for the New York Post as, what? "The Beat Generation!" And both (Felver & Aronowitz) have suffered deep psychological damage as a result.

Yet the photographs are fascinating. To see these shreds of a time, place and condition, as human forms, faces, to have them summon you with their actuality to where they were caught and fixed like that, forever.

The Ginsbergs, Kerouacs, Corsos, Burroughs, Ferlinghettis, di Primas, Whalens, Joans, Dorns, Duncans, Kaufmans, Joneses, Barakas, Hunckes, Snyders, Creeleys, Olsons, Michelines, Kochs, O'Haras, Ashberys, Lamantias, Rivers, are returned to us, and the Ornettes and Cecils and Pharaohs, (these musicians identified with "the new thing," "Avant Garde") should give clarity to just why "Beat" was called such, though the itchy pun of being "worn out," as well, could be tortured into relevance if we remember a few "cats" who turned ultimately corny on everybody. But for the most part, with the named faces are also returned the multitude of spirits who completed the human context of a certain time and the places and conditions of its detailed telling.

But there is in these images, not just those faces and places, a sense of the whole revelation (of that "epoch") that was unfurling like a scroll to be peeped and thought about and maybe even understood. Though these are, in the main, targeted aspects of the "forever after" that vouchsafes its imagined trail of fantasy after any telling

of a particular group during a particular period and doing. So that we can see the "somewhat later" and the "way after," which at times is touching or informing, sometimes near tragic.

When the dog does bark it means we have slipped into simple nostalgia which is not wholly removed from neuralgia, painfully useless. And there is nothing which cannot be made to be that, except we want to understand ourselves or other selves and looking at them helps us do that.

What were they doing, what was I doing, who is that they are with, what place is that, why do they look like that, do you remember so & so and their reaction to whatchamacallit. Though some of the flicks are very very specific as to the whats and whys. We can re-dig North Beach, the Lower East Side, the Camp and decamping, the momentary, the still unfolding, the lost and the desired.

So come the scadillion poetry readings, the diverse methods of filling the vacant lots of US needings, the hangouts and the hanging outers, at times it all seems like Camptown, but what is best is the sense of a rush of opening sensibility to feel, to know, to become, which given the surrounding context of then, an Eisenhower world changing to a JFK so distant Camelotian social epiphany (always much shallower and pockmarked by disregard for the actual) that too quickly became, under the burdens of state assassination, imperial slaughter and attempted annexation, transformed into the hideous jowled accent of an LBJ world.

So that what lived out of that zooming sphere scattered seeking survival, new belief or bigger stages to be outrageous. The dead, Felver lines up as if they were still alive. The still living bulk the book with newer questions and the recitations of history many have forgotten or never knew. The fact is that we need that energy, defiance, determination today, if we are to survive an era where the huge rock of our best desire has not only rolled back down upon us, after we had rolled it up the mountain of north American promise yet another 'gin, in true Sisyphus style. But now, it has rolled into the Bushes!

Perhaps there is something in these images that Felver has marshaled despite Homeland insecurity, that will help us to push the rock back up the mountain yet "One mo' time!"

– AMIRI BARAKA . 2005

JACK
KEROUAC
M.C.

7TH AVE AT W 4TH ST

**CIRCLE
IN THE
SQUARE**

PHILIP LAMANTIA
HOWARD HART
DAVID AMRAM
French Horn

1957

jazz poetry trio

Every
this ∧ FRIDAY at

Midnight

:ommencing MARCH 31, every MONDAY at 8:40 TICKETS: OR 5-9437

I Hear America *Swingin'*

DAVID AMRAM

In 1956 when Jack Kerouac and I first began sharing words and music at Saturday night Bring Your Own Bottle parties at painter's lofts in downtown New York City, often in the wee hours, we were surrounded by other writers, poets, musicians, composers, painters, sculptors, actors, and dancers, people with everyday jobs and endless imaginations. We never dreamed that nearly a half a century later, we would all appear together again, reunited in a book of brilliant photographs by Chris Felver.

Beat is a tonic for the soul as America goes through yet another series of growth spurts. Always accentuating the positive, like Felver himself, this collection of photographs creates a sense of joy along with the bittersweet.

Felver has collected many priceless moments for us to enjoy and share with our friends and the younger generation who are now discovering these artists and the work they leave us.

The relationship of Felver with all of the movers and shakers documented in this book, as well as his keen eye and sense of time and place, make him the perfect host and reporter to tell a story through his work, just as the musicians, painters and artists we see in the pages of *Beat* tell their stories through sounds and images rather than words. Felver has the natural gift of allowing his subjects the freedom to be themselves and you to feel at home with them. By the end of *Beat* you feel as if you are part of the book yourself.

Nat Hentoff's and Nat Shapiro's classic book *Hear Me Talkin' to Ya'*, first published in 1955, presented to us the masters of jazz telling their own stories in their own words. Hentoff caught the magical moments and documented what would have been lost forever. Like Hentoff's book, Felver's *Beat* captures these moments, as Robert Frank did in *Pull My Daisy*. When Frank completed editing his Beat film classic in 1959, just before Kerouac did the spontaneous narration with my improvised music and later my composed score, Frank said to me: "David, with *Pull My Daisy*, we captured a moment in time."

Throughout the pages of *Beat*, we can feel this extended family speaking to us in these precious one-time moments on film. Rather than having his subjects pose in front of a truck load of equipment, making us all appear as if we were imprisoned in a bottle of formaldehyde and embalming fluid, Felver presents us as we were and are, just as renowned film makers like Fellini and Truffault did in their work, which was so influential for all of us.

This sense of spontaneity (no matter how long and how much hard work it took to make it appear this way) was also the hallmark of the prose of Jack Kerouac, Joyce Johnson, Carolyn Cassady, Terry Southern, and in the poetry of Gregory Corso, Gary Snyder, Anne Waldman, and Lawrence Ferlinghetti. Also part of the spontaneity were the paintings of Robert Rauschenberg, Larry Rivers, and Willem de Kooning, and the wonderful improvisations and compositions of Dizzy Gillespie, Herbie Hancock, Elvin Jones, and Cecil Taylor. This also included the timeless folk renditions of Odetta, Ramblin' Jack Elliott, Pete Seeger, Lou Harrison's compositions, as well as my own symphonies. In the world of drama, members of the Actors' Studio, especially Elia Kazan and John Cassavettes, made films contributing to this new artistic attitude.

We all valued the relationship of spontaneity and formality as parts of the whole. We were taught to pay attention. We learned that to be a real artist, you had to always look and listen, and respect every single person you ever met in life and to learn from them. These ideas served as unspoken rubrics we, members of the so-called Beat Generation, shared in common. We were influenced by the philosophy of the painters as well as the glorious music-makers of our era, all of whom were searching for a new way of expressing universal truths. We all wanted our art and what we did in everyday life to speak to others. The visual artists helped us to celebrate the rich heritage of classical European, Asian, and African art, along with the unsung treasures of the New World.

Many of us first received more recognition abroad, often decades before receiving it at home. We were holding a mirror up to America, rejoicing in sharing its many treasures in a fresh and honest way. Each of us tried to do it without imitating what had already been done so well by others.

In spite of our often crazy styles of day to day living and late night carousing, we were workaholics, nonstop underground scholars, and always found the time to encourage one another, even when we were told to give it up and go back home.

We were in-clusive, not ex-clusive.

We were each other's floating Twelve Step Program of Survival in the Arts. We were upbeat, no matter how hard the road seemed to others.

Another thing we shared during this rich era of the 1950s, which later became known as Beat, was endless energy, and the ability to laugh at ourselves as well as the rest of the world as we relentlessly pursued our dreams. While we were as cantankerous and individualistic as any group of young men and women could possibly be, we still valued lasting relationships, and remain, among those of us still blessed to be here, each other's lifelong friends and fans. This is because in our youth we shared high ideals and a sense of humor, along with all that we hoped to achieve. We all felt that Kerouac's explanation of Beat was the one we shared in common. Simply that life is a journey meant to discover and practice the Beatific.

This unspoken approach toward understanding why we were here and what we should do with our lives was the spirit that many of us shared. This was at the opposite end, the yin, not the yang, of the collective albatross around our necks, that image of the moronic, sociopathic, untalented, whining, and infantile Beatnik.

This cliché of the Nouveau Lower Slobbovian as subhuman was never insulting enough to make us forget who we were, and what we wanted to share with the world.

Our era and our legacy was not created by a computer, a career counselor, a battery of lawyers, or a public relations firm. It was lived person-to-person and day-by-day. We were trained to be survivors, and to be much better than we were ever expected to be, and to encourage others to be the same.

We were the beneficiaries of our elders who had survived the Great Depression, World War II, racism, and a society that ignored much of the beauty that surrounded us in our daily lives. Our mentors, some now celebrated, some forgotten, taught us to count our blessings, and to see America and the world in a fresh and honest way, and not to be afraid to speak up and speak out.

Like all artists whose work survives the ever-changing worlds of fashion and commerce, we dared to celebrate the everyday and the commonplace, and to share the beauty part in everything we did. We didn't separate art and life. We learned to respect others and their achievements, not put them on a pedestal, or try to tear them down.

Felver's pictures are in that spirit; there is no sense of posing, air brushing, or phony lighting making any of us look like models hired for a plastic surgeon's convention.

Finally, we can thank Chris Felver for showing that all this did not end after *On the Road* was published in 1957. *Beat* shows us a much larger and more accurate picture of the community of artists who were, and still are, part of a much larger picture. Many of the younger artists who appear in *Beat* are now creating their own enduring work.

In *Beat*, we see that the geographical meccas for creativity are anywhere and everywhere: wherever creative people congregate.

– DAVID AMRAM. 2003

Carolyn Cassady
20 Wellingtoniaf
Warfield Park, Bracknel Burks
RG42 3RL, UK TA CC

July 2, 2003

Dear Carolyn,

You are so hip — thank god for meeting you again in Paris. You can't imagine how excited I am to have your insight & real historical perspective on the two people that I could never meet — Jack and Neal. Without you, the story doesn't seem whole!

 I thought the most direct way to approach this introduction is to ask you several questions that have been meandering around my brain lo these many years. First, though, I wanted to give you background as to how I got in this situation.

 After getting discharged from the Army, I moved to Stockbridge, Massachusetts and started hanging out at the Bookstore in Lenox. Every week I'd hitch a ride to New York City to see a friend who happened to work at the 8th Street Bookstore. He passed me Neal's book *The First Third* and immediately I felt a real connection and compassion for Neal. Since I was stationed at Fitzsimmons in Denver and worked at Your Fathers Moustache in Larimar Square, so many of his geographical references were also mine.

 In July 1971 a *Time Magazine* article appeared, "Poetry Today: Low Profile, Flatted Voice" by A.T. Baker. The portraits together with the poems sparked my imagination and I wanted to meet the poets. From then on I was hooked and read all the poetry I could get my hands on. In 1975, while attending the London College of Printing, a fellow student asked if I knew anything about Kerouac. "I think I've been living like him" was my reply. That led to my writing *The Last Time I Saw Neal* which was produced the next year at LCP. About a year later I met Lawrence Ferlinghetti, and my life took on a new dimension.

 So as I finish my inquiry into the Beat Generation, it's only perfect meeting you, the primary source, to shed some light & answer the loose questions that remain:

1. What did Neal actually feel for Jack?
2. What were the dimensions of Neal's relationship with Allen, and how did he feel about Allen's portrayal of him?
3. How did you feel about their relationship?
4. What was your influence on Neal's work?
5. Why do you think Neal didn't finish *The First Third*?
6. What's your take on the circumstances of Neal's death?
7. What was Neal's vision in his lost writing?
8. What was Neal's relationship to and influence on his children?
9. How did he feel about being hero of *On the Road*?
10. Did he consider himself part of the Beat Generation or an alienated other?
11. If Neal were alive today, do you think he would relish the iconic status he shares with Allen, Jack, and Corso?
12. How would you like Neal to be remembered?
13. When all is said and done, what is Neal's legacy?
14. Tell us about the legacy of Kerouac and Ginsberg. What remains? Where does it appear in popular culture?
15. How has literature and the arts returned to, or relied upon, a Kerouac aesthetic?
16. Who are the heirs to this aesthetic? And what are they doing with it?
17. Who can possibly replace Kerouac in the 21st century?
18. How has Kerouac been most misunderstood?
19. Now that the myth has been supplanted by appreciation, do you feel the group is vindicated and how do you feel about it?

Why don't you take a peek at these, and give me your take. Ideally, I'd like to publish this Q&A just as it is. Feel free to answer any or all of these. The easiest way to get them back to me is probably e-mail.

I'm reaching for the wine.... — Chris

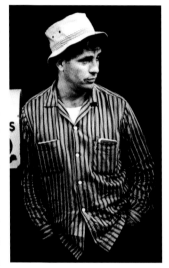

1] There must have been an immediate empathy between Neal and Jack – a recognition from the start. They weren't into analyzing each other, as academics are wont to do, and I am when coerced. It was partly the case of opposites attract, in that physically they were so un-alike, but each envied and admired what in the other he lacked himself. Jack wished he had Neal's energy and prowess with women and his self-control, because he, himself, was a klutz and so terribly sensitive, paranoid, self-conscious and shy. On the other hand, Neal envied and admired Jack's ability to write and put his joy of life into words. Neal had written him, "Perhaps words are not my way," but he desperately wanted them to be one way. Neal envied somewhat Jack's family life, a more ordered one than his own chaotic and painful one. All men I knew at that time had an ultimate goal of a solid family and home – even Allen Ginsberg, who wrote us an amazing letter about how his wedding would be and all the children he would sire!

Both Jack and Neal were sensitive, perceptive, non-violent and more compassionate than anyone I've ever known. These assets were uncommon in macho men, so to find another "real man" with a soft center was very unusual and created a strong bond. They didn't judge or criticize each other; they just loved the other as he was. Neal was torn watching Jack destroy himself with alcohol, just as Jack regretted Neal's dependency on drugs, but neither would ever accuse the other. They valued each other on a higher and deeper level, and their love remained as strong until the day each died. Many academics have picked on quarrels and differences in viewpoints as permanent rifts; such was not the case at all. Like families who have tiffs, the anger disappears in the underlying love.

Physically, they were opposites again, although most depictions of them which are based on my photo with the strong light insist they looked just alike. Where Hollywood got the idea Neal was blond, I cannot explain. Neal had a wiry build with taut long muscles. He was agile and swift in movement and alert and sharp. Jack was stocky and clumsy. He had bulging muscles, his legs muscle-bound from football, and he was sad he couldn't achieve the lotus position when he embraced Buddhism. Unless after a drink or two, his eyes were downcast or squinting when he was shy. He made a lot of faces and used fake voices to mask his self-consciousness. His handsomeness was more like the Clark Gable sort, fleshier than Neal's and ruddier. Some photos taken in complete repose don't appear so, but he only looked like that when not animated. They must be the ones that made Johnny Depp think he was this sober serious Poet. Normally, he was anything but. When drunk he was garrulous and crude. Neal had a narrower face and a rather Grecian look because of his broken nose. Strong bone structure and very fair skin. His smile was dazzling, and the lucky lad was immune to dental decay. He always carried a toothbrush. Sometimes he looked very handsome and other times not at all. The light made a big difference.

2] Neal was very fond of Allen, admiring his mind and, of course, appreciating his praise. I feel, however, Neal's early letters to Allen full of love could be an exercise in kindness – something of a con really, because Neal kept telling Allen he didn't desire him sexually and could not be gay. Neal didn't have as much in common with Allen as he did with Jack – sports, action, less poetry, more novels. In later years when Allen became anarchistic, judgmental and often negatively oriented, they grew farther apart.

Allen also developed an enormous ego from his lifelong belief in his worthlessness. (When he stayed in my residence hotel room in Denver, he looked for work, but came back daily to moan about his rejections. One job was on an assembly line, and his finger wouldn't fit whatever machinery that was required. "I'll never amount to *anything*," he sobbed.)

In later years I tried to tell him that unless he could believe all the accolades, he would never get enough. And so it seemed. When first meeting him after a long interval, he wouldn't say "hello, how are you?" but start right off listing his recent honors. Poor guy – he never did hear me. A very good documentary was made about him, and at the end the last photo is of Allen, who says, "I'm just a shit."

I suppose Neal was flattered to some extent by Allen's praise of him and his writing, taking into account, however, that Allen was in love with him sexually. Neal admired Allen's erudite mind and sense of fun, and Neal felt a strong compassion for Allen's childhood with his mentally-ill mother and his struggles with his homosexuality and psychiatry. Fortunately, Neal didn't live to learn of Allen's later promotion of homosexuality with children and his exhibitionism; he would have been disgusted. Also, Allen's egotistical bent in his later years made him often become rude or high-handed to fans.

Neal, on the other hand, felt equally unworthy, but the only evidence of any ego was his bragging about being the best in any sport or job; mostly, I suspect, to prove to himself he was good for something – yet always the Catholic "guilty miserable sinner."

3] I didn't feel anything in particular about their relationship. I had many cherished homosexual friends. I found them creative, wise, full of humor – and no threat. Quentin Crisp is one of my idols. I knew Allen loved Neal as much as I, and I was sorry for him. Just a matter of gender separated them. I didn't resent his physical love for Neal until he betrayed my trust in my own home after he had assured me he no longer desired Neal sexually. Neal welcomed sex in almost any form, but he didn't seek male

partners. I'm sure he never committed an aggressive action, in spite of Allen's fantasy journals after Neal's death. I knew how much Neal desired women all too graphically.

I lost Allen's friendship ten years before his death when he recalled my rejection. It was a sad loss. In Denver he had lived in my residence hotel room for a couple of weeks, and often helped me with my school-work with remarkable results for me. In San Jose when Neal was at work and I busy with housework or the children, he wrote poetry or read and recorded them. But when we were both free, he would come with me to hunt lots on which I hoped to build our new home. He was the perfect guest; he insisted on doing most of the cooking and washing up, although I'd persuade him to talk to Neal instead if he were home. He cared about me and my concerns, and if Neal wasn't home, Allen and I would go to movies or lie naked on the floor with the French doors open and Allen spouting poems at the moon. I really enjoyed having him there as such a considerate companion.

For many years after he moved out, he was still kind to me, and one time he even invited me to dinner in San Francisco to meet his father and step-mother. When in New York, I would have a ritual brunch with him at his flat. In the late sixties after Neal's death, when Allen came to the West Coast to perform, he always invited me as well as my son, John, his namesake, and was thereafter kind to John, having him play guitar behind Allen's readings.

Now, after learning further lessons from Neal about attitudes, I might have been able to accept and ignore Allen's sexual advances to Neal, but alas, at that time I was still responding from my early conditioning. When I drove him to Berkeley, apologizing all the way, Allen said he understood and forgave me and kissed me good-bye.

I was not, however, the WASP shrew he later made me out to be to Bill Burroughs, which is graphically described in a biography of Bill – with dialogue by me in quotes which never took place. For the last ten years of his life, alas, he looked back and renewed his resentment. One of the poems he wrote just before his death begins with "Why do I still resent Carolyn?" How I wish he'd asked himself that question ten years earlier.

But when he came to London in his last years, he would still invite me to his performances – another pair of clapping hands, but that was all.

4] I don't believe I had any influence on Neal's writing other than approval and the occasional aid in grammar, punctuation, and spelling. His own vast knowledge of literature, especially Proust, Dostoyevsky, Céline, and Spengler, combined with his photographic memory and the encouragement from Jack and Allen were the sustaining influences.

It's curious that Neal asked Jack to teach him how to write, when then Jack changed his whole style of writing because of Neal's letters as well as the opinions on how to write that Neal wrote to Jack in a letter.

5] As is.

6] When Neal died I had only a few concrete facts as to the actual events. His girl friend, Janice Brown, or JB as she was known, was at the time given to hearing voices, etc. so her testimony is open to doubts. More facts have been unearthed since, but we will never know the exact cause of his death. I know all there is to know and have published these facts, but wild myths persist and seem preferred.

Neal arrived at JB's home in San Miguel de Allende, Mexico, and she said they had a row. He swallowed some Nembutal and set off to go collect his luggage from the previous rail station. Why? Who knows. On the way, it is said, he passed the church where a wedding had just ended. We know nothing for sure what happened here, or even if it's true. Whoever made that assertion also said he consumed alcohol. Some stories say he "chug-a-lugged gallons of pulque," which cannot be true. Neal's stomach was so sensitive that anything stronger than beer made him deathly ill. He didn't like wine because of his memories

of his wino father. But if someone had asked him to toast the bride, even knowing the possible result of what the combination of Nembutal and alcohol could do, he would have toasted the bride. (Ken Kesey corroborated this theory of mine.)

He walked on, but it was only a few yards beyond San Miguel that he collapsed on the railroad tracks. (Kesey's wonderful story of "The Day Superman Died" will probably always be taken as fact – a myth that won't be superseded by truth.) Neal did not die of "exposure." The exact cause of death was not entered in the autopsy report, said the doctor, (unearthed by concerned friends) because "drugs were involved, and he was a foreigner." So all it says is that "all systems were congested." Renal failure can cause this result, which seems possible, but we'll never know for sure. I have copies of all the relevant papers – death certificate, etc.

7] I'm not quite sure what you meant by "vision" and "lost writing." If you mean in all that he might have written what his vision of it was – hmmmm. Neal's large body of written letters to Jack and Allen in which he chronicles the events of his life, both past and present, as well as his opinions on various subjects were the inspiration for Jack's change of style, as noted. Neal was also intrigued by Jack's consequent books relating as spontaneously episodes in his own life and his views on all life. I rather think that's what Neal envisioned for himself, although he made an effort to be more traditional, too.

8] Neal was a wonderfully loving father, but he didn't believe in discipline, which was hard on me. If Neal was caring for the children while I was at some production I'd designed for, on my return the kids would always greet me with revelations of what Daddy had let them do that I had discouraged. This created a double standard for them, but they learned to tell the difference. He never gave them advice on their future choices, only lectured them on right and wrong – ironically. "Don't do like I do; do like I say." He loved passing on words of wisdom, both spiritual and mundane. He never scolded nor criticized; always approved and took joy in them when with them, entering into their games or activities and making great struggles to get to their important performances, either Jami's ballet productions or John's Scout or sport activities.

They all adore their father and declare they'd rather have had him than anyone they know of. In later life, as they learned of his behavior away from home, that [knowledge] has done nothing to diminish their love. They've all turned out to be model adults, and they now enjoy the circus which has become his heritage.

9] As was.

10] Again, Neal felt his iconic status was for the wrong reasons, and that irritated him. He didn't answer fan mail, little of it though there was. He disliked Jack's portrayal of him in *On the Road* and said he wished no one would read the book, although he would never have told Jack that.

11] As I said, he was not egotistical. He never talked about the advent of his becoming "famous" or "infamous" (as Allen did constantly). Besides, he would (as I wished) rather be approved for his mind, his insights, his knowledge, his memory, his wisdom, his compassion. This idolization was actually painful for him, showing him how far from his ideals he was regarded and increasing his sense of guilt. Later, when he was living with Kesey and the Pranksters, he just gave up ever trying to be the respectable citizen he had held as his purpose in life. Now a felon and therefore a non-entity, he said he just went along with what people expected of him – a clown or a trained bear performing anything that came to his drug-oriented mind.

Allen, Jack, Corso were lionized for their writing mostly; their behavior was tolerated. For poor Neal it was the reverse. He was not lauded for his extensive writing but for his behavior. The latest book of his

correspondence is a book of revelations even to me, and he reveals even more horrific hedonism and deception than I heretofore knew. He truly did live a double life – or more, and perhaps schizophrenia is the scientific although vague term. Dr. Jekyll and Mr. Hyde comes closer, or perhaps *The Picture of Dorian Gray*.

12] As is.

13] If Neal has a legacy, I'm afraid for the general public it is of a fearless con-man and felon with exceptional energy who behaved in socially outrageous ways, drove dangerously and talked all the time. Is that what people want to believe? I knew one lady journalist who did. She didn't want to hear anything good I said about him; she wanted him bad. I think he was a fantasy of hers. In her published interview with me she twisted all my words, wrote that we had three-way balls and other items she made up herself. I was afraid to leave my flat for two weeks and had to reassure my neighbors and shopkeepers none of it was true. Yet Neal taught me priceless lessons in human relationships and right attitudes of which most of society is still ignorant. My life was changed immeasurably for good.

14] As I wrote – I'm not qualified to answer this.

15/16] Far too much has been based on a mistaken idea of what Kerouac represented – i.e. Freedom. Those who thought they were following his lead didn't know there is no freedom without fences, so their idea became license and then chaos. Throughout history in societies that have become smug and hypocritical, as was ours after the war, an upheaval occurs, but eventually the wheat is sifted from the chaff, and order returns. Only those creations that are in accord with Universal harmony will survive. The Universe demands order. Little by little this is happening now.

17] I don't believe anyone can be "replaced." If you mean in popularity, they come and go. Each soul is an individual; there are no two alike – as in all of nature. Many men in past ages have been prominent and added or subtracted from the evolution of the planet, and there will surely be others in future. But there will never be another Kerouac. New idols are created year after year. Some are made of clay; others, like Shakespeare, will live forever and continue to reveal more wisdom and truth about our lives on planet Earth.

18] (see 15/16) Young people felt Kerouac had given them a passport to selfish self-indulgence; they could now do anything that took their fancy. They abandoned homes and schools and threw the baby out with the bath water. They didn't stop to think that Kerouac had no responsibilities and had to be free to roam in order to pursue his one aim – writing. He never meant to promote drug abuse, free love, or irresponsibility. When he was cast as "The King of the Beats" and "The Father of the Hippies," he was shattered. He thought he was promoting love and appreciation of Life in all its forms, a joyous celebration and awe derived from that love, with its ups and downs. He was basically very conventional, a gentleman of the old order who didn't swear in mixed company nor talk about sex except with male cronies. He told me he was going to drink himself to death. I thought he was joking, but that is exactly what he did.

19] I'm not sure I understand the question. Which "myth"? What "group"? By "vindicated" do you mean just because those false values are now accepted? I think I've covered what I think about it, and what Kerouac thought about it. Ginsberg and Picasso thoroughly learned their craft (all art forms have basic rules). They then could do anything they liked, good or awful, but they did it not because they knew no better but from an educated choice. They had paid their dues – few today have done so.

– CAROLYN CASSADY signing off.xx

My Dear Dear Carolyn; Not since we last quaffed, or is it quiffed, gardenias together has 2 hrs. 43 min. & 12 seconds passed so quickly as did that amount on our Wed. afternoon of consoling inspiration. & while the consolation may not have been mutually equivicable, for its quite impossible I could have given you more than a portion of the peace that mere sight of your bravely benign face (reminds me, todays Pope, the 42nd, is St. Boniface) imparted to me; its possible, even probable, that we were emotionally inspired in better balance both because we, by blessing each the other, albeit un-conciously perhaps, bent our belief toward a similar degree of uplift & because the day, aug. 6th, was, & surely not by chance, the feast of that supereminent proto-type for inspiring noble effort, the transfiguration of our Lord on Mt. Thabor before Peter, James & John. So, besides wishing the doz. or so subsequent ones (every 2 months, remember) match its beautitious nearness despite that facilities elsewhere permit NO kissing, must claim in all sincerity that your visit was as benificial as it was timely, especially since the manifest result has been — beyond just the everpresent feeling of same which is not trustworthy, in itself, as is objectively known thru St. Thomas & subjectively so by marijuana — an acute conciousness of entering somewhat further into a higher plane of angelic reality (you should read St. Tom on this now!) that one of an almost infused contemplation as it were, why, I could actually say it hinged on the "Beatific" would this term not somehow smack of plagerism from Kerouac & other more mystical authors. Anyway, believing they should smoothly seep, rather than vicariously enhance anyone's latent voyeurism, I resist temptation to dwell on the love expressions in our all-to-short-no-matter-its-length conversation & instead demand such prosaic information as: Did you find the Hi school diploma & my birth certificate in our House papers strongbox? where is the letter you said was ready to mail? Did you get a ticket, or mental warning to slow, on 50 M.P.H. section of freeway below Oakland as my intuition, contrary to knowledge

& your driving habits, says you did? & House tire with leaky valve?

Via registered letter with 6³ postage finally heard from father, whose changed address, presumably to be nearer, & thus more frequently use, the public bath house wherein I once swam — from Johnnys to Cathys age. Poor old pop, he's the sweetest darn thing, ignoring all the wine it would buy & fact hes scuffled for over a year to get $125 for teeth that'll make it "a lot butter than Eating soupe, ha, ha," he sent me a $5 money order, so, from next sat., when I draw them, there'll be plenty of envelopes. Another funny thing, far stranger to me than was the dear souls money sacrifice, & which I need even less tho its only an unimportant complication of records at worst; for the first time in all the years we've corresponded he wrote his, & my, name with an "a" & this just when I, also for the first time, spell mine with an "i"! Gee, sure hope the F. B. I. — he addressed me as in "Fed. Pen." — doesn't find out hes using an alias, J. Edgar's too busy as it is. Most incomprehensible tho, apart from usual lack of syntax & punctuation which, by my letters, but verifies hes my father, is the part of his letter I now quote: "Neal is theer anything I can do to help you if so let me know I well come & see you & how aboot visiting certain hours to see you pleas let me know Neal" Unhappily, the misspellings I've underlined still don't change the meaning which sounds as if he were practically on his way, doesn't it? Why, the silly big hearted bundle of well meant foolishness, aside from being dead broke, hes too decrepit to even ride the rails 'bo style let alone hitchike, so lets pray, &, of course, I'll write him to do same tho he stays put until 1960 anyhow. After some hesitation have decided theres no more appropriate time to start communicating with our children than on their upcoming birthdays, therefore, first week in Sept., will devote entire letter to all three, right? You might write suggesting sample sentences you desire me to get across to them. Incidently, did you know Cathys, Sept. 7, is the very day celebrated in church liturgy as Feast of our Lady's nativity; her birthday & Virgin Marys is same!! Until next sunday then, I remain your ever remorseful husband who, judging by finding on rereading no vital content herein, apparently, has little to say except — I love you. N.

ALLEN GINSBERG'S ADDRESS BOOK was an integral part and metaphor for the AG roadshow. Allen was an eclectic collector and promoter of people, and had virtually everyone's number who is pictured in this book. Back in the fifties, AG and his friends were habitués of the Cedar Bar in its day. Besides being a true citizen of the world, he was an early and longtime participant in St. Mark's-in-the-Bowery's Poetry Project and cofounder of Naropa's Jack Kerouac School of Disembodied Poetics. The Whitney *Beat* exhibition was one landmark in his lifelong career of connecting poetic souls. He was an ambassador of camaraderie, a great networker with a keen awareness of the accomplishments of his friends, always seeking out those whose life-practice was poesy and art. And his hip pocket address book was the directory.

These are the artists whom I've come across on my personal beatitude, my personal journey. In one way or another, Ginsberg turned me on to all of these people. They are focused on bardic friendship and trust. Everyone in *Beat* is part of the same culture, the extended family, as David Amram quotes Jack Kerouac's explanation of Beat, one we share in common, "Life is a journey meant to discover and practice the beatific."

One time when AG came to San Francisco he lost his address book and it really stressed him out. So I got to thinking later how the process with which Ginsberg had reconstructed his address book was like the process of making this book, a friend calling a friend, until the puzzle of a life was reconstructed. On his death bed, he called all of his friends. That kind of path, that trail of friendship and trust, is how this book was made.

"This is Allen," is how the conversation would start. And the poetic friendship magic would begin. I put this book together after AG died, after learning that Allen's last call to Lawrence Ferlinghetti inspired an expression of this magic, a poem for Ginsberg's passing. AG had fast friends in all corners of the earth on whom he called regularly. *Beat* tries to reflect Allen's diverse group of cohorts.

I like to think that Ginzy gave everyone in this book a ring before he slipped into the great beyond. No one could forget the excitement of receiving a call from AG.

"Hello, this is Allen."

— CHRISTOPHER FELVER . 2006

PREFACE

In 2001, Ron Whitehead and I made a pilgrimage to Thomas Merton's grave to meet Father Patrick Hart. He had with him two poems that Jack Kerouac had contributed to Merton's journal, *Monks Pond*, summer 1968. Reading this poetry drew me back to St. Sebastian's school in Akron, Ohio, where the passion and gentleness of Merton's *Seven Story Mountain* first crept into my consciousness. Merton's celebration of life's holiness and the connectedness of all creation struck a note with Kerouac. The beatitudes of the Sermon on the Mount led directly to Kerouac's conception of life as a caring crusade. Merton held the lantern that illuminated for me the Beat sensibility. For the Beats, Buddha spoke the lingo of the American street. The path of the Tao led to the open road.

TWO POEMS DEDICATED TO THOMAS MERTON

by Jack Kerouac

I

It's not that
everybody's trying
 to get into the act,
as Jimmy Durante
says----it's that
 EVERYBODY IS
 IN THE ACT
 (from the point
 of view of
 Universality)

Rhymes
With
Durante

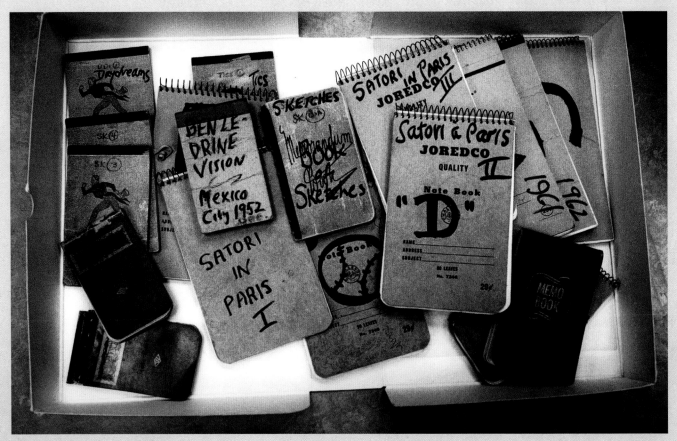

Jack Kerouac's notebooks, 1999

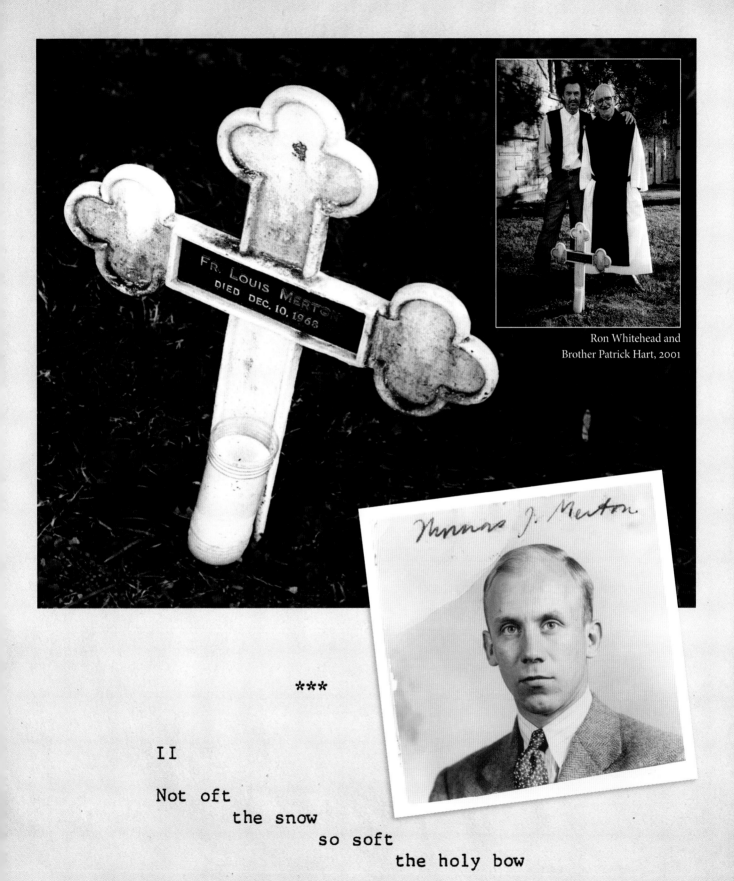

Ron Whitehead and
Brother Patrick Hart, 2001

II

Not oft
 the snow
 so soft
 the holy bow

This first long poem of allen's was read at the Six gallery in San Francisco in October 1955. I was 22 years old and gave my first reading also that night. I read a poem titled FOR THE DEATH OF 100 WHALES and other poems of nature and consciousness. Our co-readers that night were Whalen, Snyder & Lamantia. Kenneth Rexroth was M.C. I met Jack Kerouac that night.

The group of us -- minus Lamantia -- read again in Berkeley, March 1956, on a rainy evening. It was a fine evening for poetry and I remember my pleasure in allen's comic "America." I read mostly from a new huge notebook of experimental poems of consciousness.

Michael McClure

the original mimeo ditto sheets were typed by the poet
Robert Creeley & printed off by Martha Rexroth
at S. F. State College as she says below.

Allen Ginsberg

H O W L

for

Carl Solomon

by

Allen Ginsberg

"Unscrew the locks from the doors!
Unscrew the doors themselves from their jambs!"

I cranked the ditto master at SF state
first time around — and I went to the reading.

Martha Rexroth

```
                    Dedicatory Page

                         To

        Jack Kerouac newBuddha of American prose who spit forth intelli-
gence into eleven books written in half the number of years (1951-1956)
---ON THE ROAD, VISIONS OF NEAL, DR. SAX, SPRINGTIME MARY, THE SUBTER-
RANEANS, SAN FRANCISCO BLUES, SOME OF THE DHARMA, BOOK OF DREAMS, WAKE
UP, MEXICO CITY BLUES, & VISIONS OF GERARD---creating a spontaneous bop
prosody and original classic literature.  Several phrases and the title
of Howl are taken from Him.

        William Seward Burroughs, author of NAKED LUNCH, an endless novel
which will drive everybody mad.

        Neal Cassady, author of THE FIRST THIRD, an autobiography 1949,
which enlightened Buddha.  All these books are published in Heaven.

        Lucien Carr, recently promoted to Night Bureau Manager of New York
United Press.
```

When Allen first read Kaddish in SF,
I read too. I was 22.

Ferlinghetti

Philip Lamantia

Gary Snyder

Philip Whalen

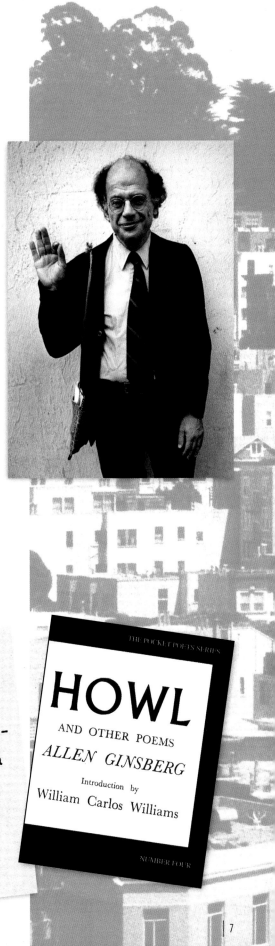

```
          H O W L

        for Carl Solomon

              I

I saw the best minds of my generation destroyed by
        madness, starving  hysterical  naked,
dragging themselves through the negro streets at dawn
        looking for an angry fix,
angelheaded hipsters burning for the ancient heavenly
        connection to the starry dynamo in the machin-
        ery of night,
who poverty and tatters and hollow-eyed and high
        sat up smoking in the supernatural darkness
        of cold-water flats floating across the tops
        of cities contemplating jazz,
who bared their brains to Heaven under the El and saw
        Mohammedan angels staggering on tenement roofs
        illuminated,
who passed through universities with radiant cool eyes
        hallucinating Arkansas and Blake-light tragedy
        among the scholars of war,
who were expelled from the academies for crazy &
        publishing obscene odes on the windows of
        the skull,
who cowered in unshaven rooms in underwear, burning
        their money in wastebaskets and listening to
        the Terror through the wall,
who got busted in their pubic beards returning through
        Laredo with a belt of marijuana for New York,
who ate fire in paint hotels or drank turpentine in
        Paradise Alley, death, or purgatoried their
        torsos night after night
with dreams, with drugs, with waking nightmares,
        alcohol and cock and endless b
incomparable blind
```

Peyo

```
         6 POETS AT 6 GALLERY

Philip Lamantia reading mss. of late John
Hoffman-- Mike McClure, Allen Ginsberg,
Gary Snyder & Phil Whalen--all sharp new
straightforward writing-- remarkable coll-
ection of angels on one stage reading
their poetry. No charge, small collection
for wine and postcards. Charming event.

         Kenneth Rexroth, M.C.

   8 PM Friday Night October 7,1955

    6 Gallery 3119 Fillmore St.
                San Fran
```

who c

The Six Gallery poetry event at San Francisco's Gallery Ubu in October of 1955 became the defining moment for the Poetry Renaissance. On a fog-shrouded night Allen Ginsberg unleashed the wild energy of "Howl" as Jack Kerouac, Kenneth Rexroth, and other poets urged him on. It took thirty-seven minutes to beat out the Beat rhythms of a latter-day *Leaves of Grass*, decrying the loss of love and the triumph of Moloch. Soon afterward, Lawrence Ferlinghetti published Ginsberg's *Howl and Other Poems*. Ironically, the infamous *Howl* obscenity trial put Ferlinghetti's City Lights Books on the map and catapulted the Beats into national consciousness.

Jack Kerouac's *On The Road* was published in 1957 to critical acclaim. The poets surrounding Ginsberg and Kerouac were seen as free spirits who clung to their own ideas of artistic freedom. Some of the artists lived on the east coast, others on the west coast, while some were constant travelers. *The Evergreen Review* devoted an entire issue to the San Francisco scene and helped expand awareness of the Beats. Ferlinghetti at City Lights Books published the Pocket Poets Series, giving a public surface to much of the work of these Beat bohemians. In the ensuing years nearly all the original members lived in or drifted through San Francisco. They remained active in this North Beach community, like an extended family, giving readings and acting out the Beat life in the neighborhood.

My introduction to North Beach came while walking up Grant Street on May Day, 1979. There was a poetry benefit being held at the Spaghetti Factory that evening, and during the intermission the audience was outside the theatre and spewing onto the street. The group seemed to pirouette around each other, telling stories and entertaining one another like vignettes from a warm family reception. Neeli Cherkovski spotted me and signaled me to join him. He gave me a rundown on the scene, introduced me to a few people, and invited me in for the second half of the reading. Jack Hirschman, Howard Hart, Philip Lamantia, Lawrence Ferlinghetti, Gregory Corso and a gang of other readers gave enthusiastic performances that left me feeling as though I could actually be part of their poetic community. As the festivities wound down, everyone took to the streets, and Neeli invited me over to his Harwood Alley apartment for coffee the next day.

I arrived with camera in hand and was invited into Neeli's tiny kitchen amid a stream of poetic banter with Kirby Doyle, Raymond Foye, Jack Mueller and George Scirvani. Poet Bob Kaufman was on his way over and it appeared that Neeli's pad had become the salon

for San Francisco hipsters. Kaufman arrived, extended his hand, and proclaimed "mi casa es su casa." Within twenty-four hours, I had stepped into the world I had dreamed about since first reading Ferlinghetti's *The Coney Island of the Mind* in college. These were to be my new friends and I felt right at home in their company.

The bedrock of the North Beach community was artistic collaboration, free expression and openness. Performance spaces featuring poetry spread all over the neighborhood. City Lights Books scheduled readings, as did Intersection for the Arts, the Savoy Tivoli, the Spaghetti Factory, and there were spontaneous readings in all of the cafes frequented by the poets. It was the true bohemian cafe society spirit with an audience always ready to hear new work. As Harold Norse remarked, "there are more poets in San Francisco than people." The poets would hang out at the Cafe Trieste, drinking cappuccinos endlessly while entertaining each other with literary tales as the afternoons rolled on. I was silent for months, just photographing and listening, convinced they were gum-chewing geniuses. My portraits found a home at Poetry Flash and started being published by Joyce Jenkins, the editor.

When Ginsberg hit town, it was always an event. He would stop at City Lights to rendezvous with Ferlinghetti, then on to Shig Murao's Grant Street apartment where he always stayed. For Allen it was like old home week, with friends magically appearing out of the woodwork. The first time I heard Allen read was at the Kabuki Theatre on Broadway with Gregory Corso, who was living in North Beach. During the opening set Allen and Gregory played off one another as Gregory got wilder and drunker with each poem. The second set Allen had a band back him, as Bob Kaufman danced the twist to Allen's reading of *America*. I could hear Ezra Pound whispering to me, "Listen to the sound it makes."

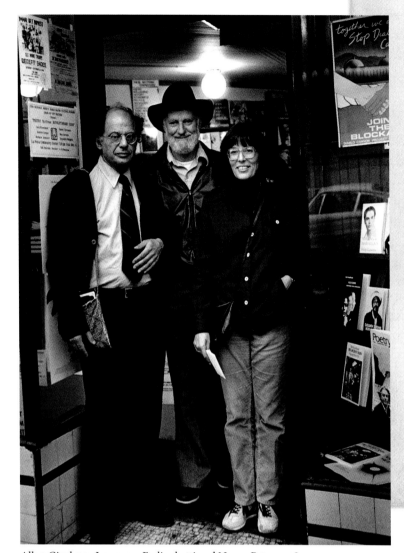

Poets,
descend to the street
of the world
once more
And open your minds + eyes
with the old visual delight
Clear your throat,
and
speak up!
Poetry is dead,
long live poetry...

Lawrence Ferlinghetti

Allen Ginsberg, Lawrence Ferlinghetti and Nancy Peters, 1981

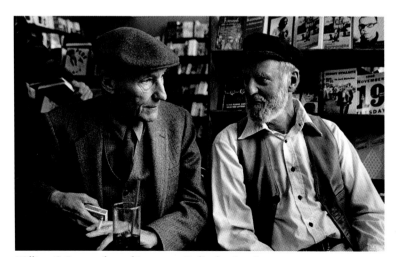

William S. Burroughs and Lawrence Ferlinghetti, 1981

William S. Burroughs and Harold Norse, 1981

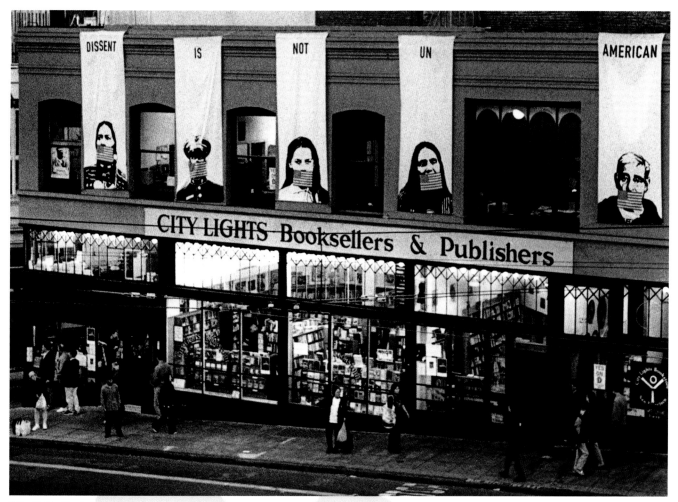

City Lights Book Shop, 2001

Philip Whalen and Gregory Corso, 1981

Bob Kaufman and Harold Norse, 1981

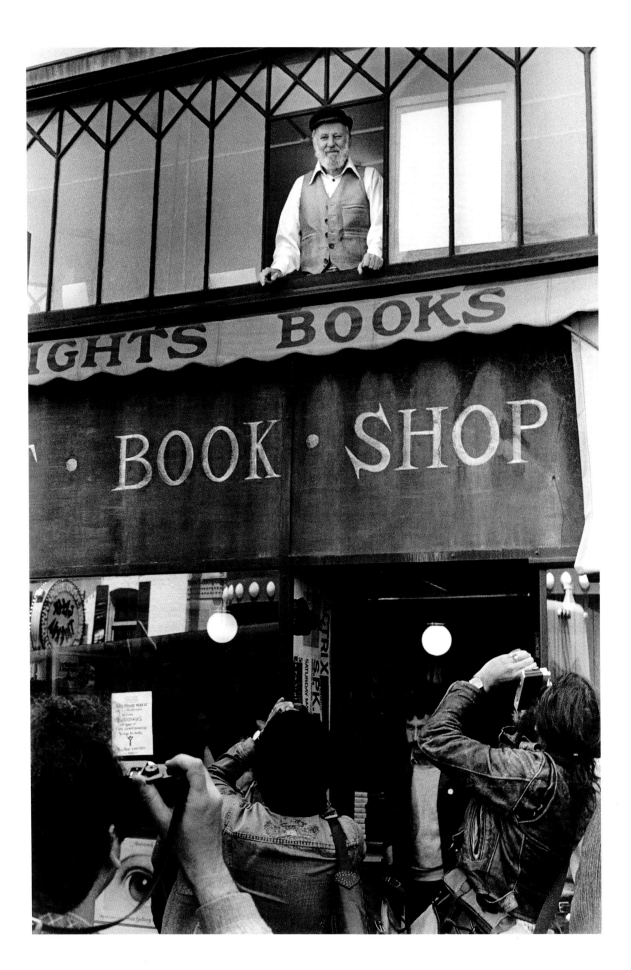

Anti-Heroes

The hero has a thousand faces,
and so does the anti-hero;
only his face is the true face
of the creative artist in everyone.

Ferlinghetti

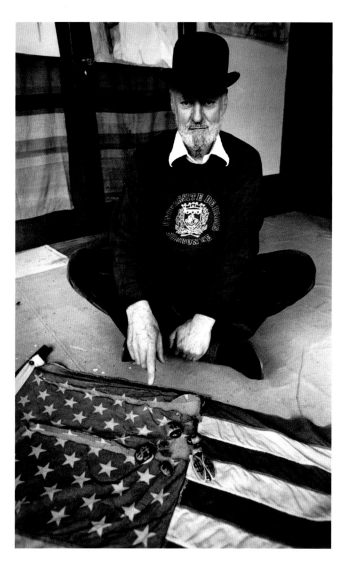

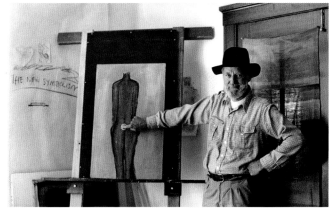

Lawrence Ferlinghetti, 1981

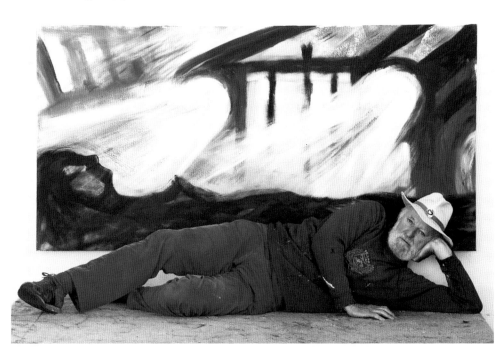

Lawrence Ferlinghetti

at City Lights

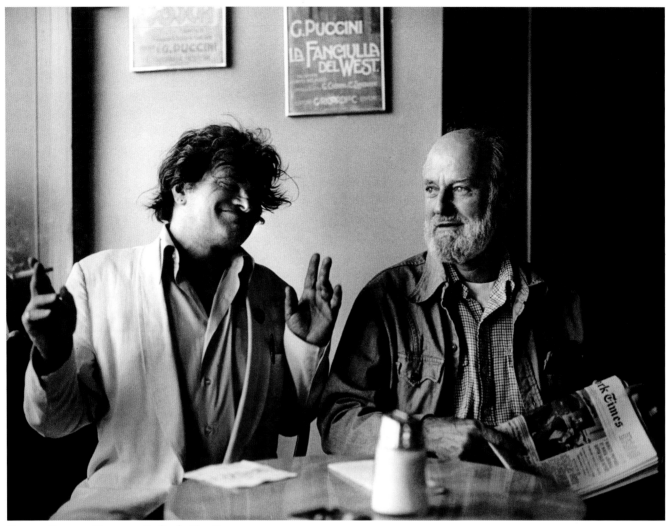

Gregory Corso and Lawrence Ferlinghetti, 1982

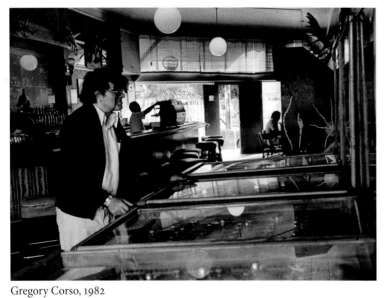

Gregory Corso, 1982

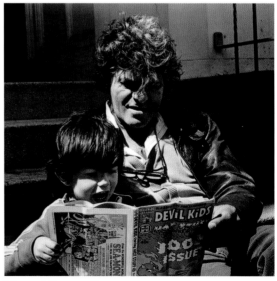

Max and Gregory Corso, 1982

To BE is to Do (DESCARTES)
To $Do is to BE (SARTRE)
DO BE DO BE DO (SINATRA

Compiled by

Gregory Corso

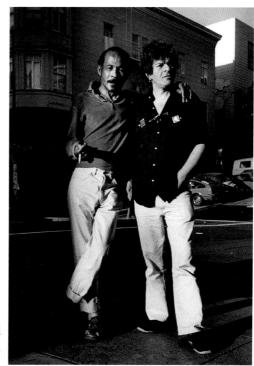

Bob Kaufman and
Gregory Corso, 1981

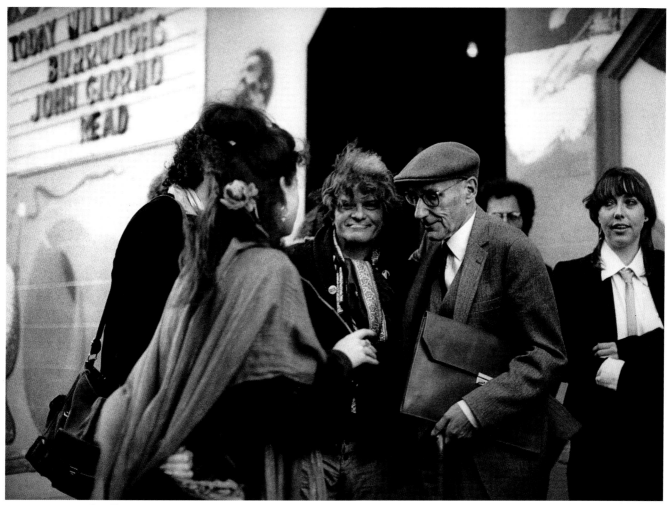

Gregory Corso and William S. Burroughs, 1981

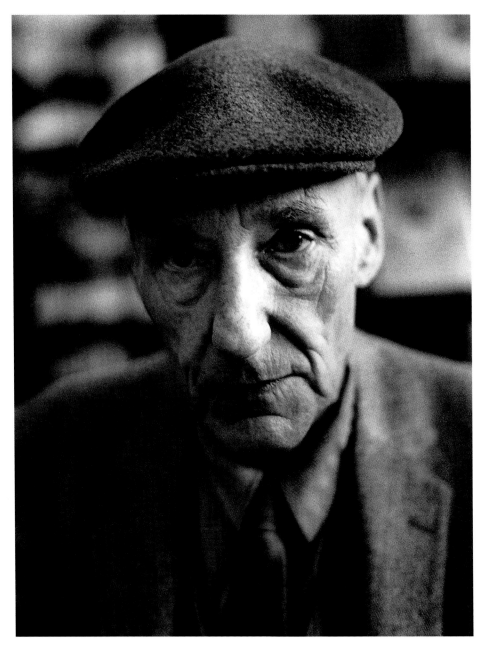

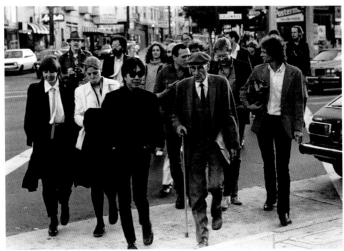

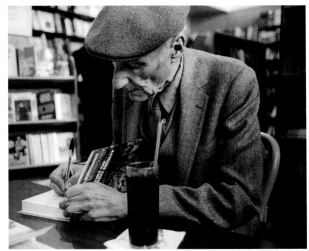

on a memorable
occasion at the
Keystone Korner
William S. Burroughs
May 14, 1981

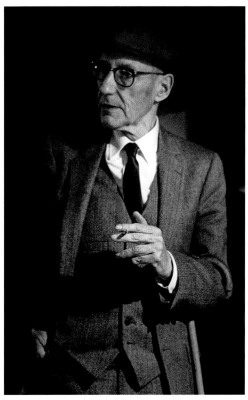

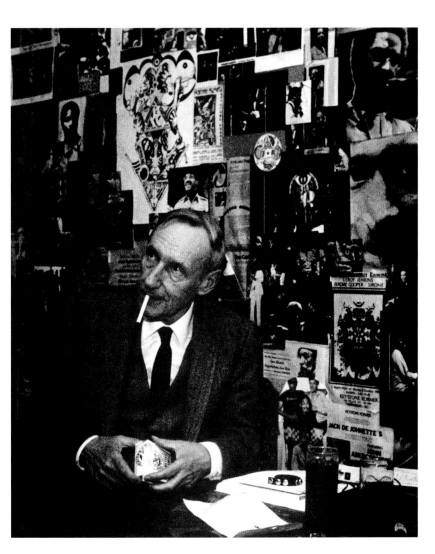

EARTH VERSE

Wide enough to keep you looking

Open enough to keep you moving

Dry enough to keep you honest

Prickly enough to make you tough

Green enough to go on living

Old enough to give you dreams

Gary Snyder

the hand and face of the
poet -- birdtracks, wrinkles,
leaves blown in dust, it's
good to see hand and face
brought together here by
Chris Felver. Neither
can lie, calligraphy is
character, and we measure
each other "at the crossroads
of the new world" by the
look in the eye. Chris
draws both out with his gentle,
insistent skill--no escape.

Gary Snyder
29 November '83

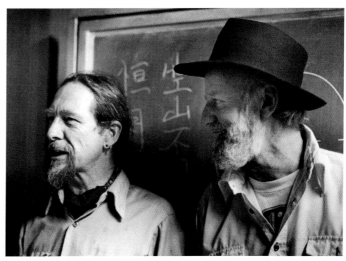

Gary Snyder and Lawrence Ferlinghetti, 1980

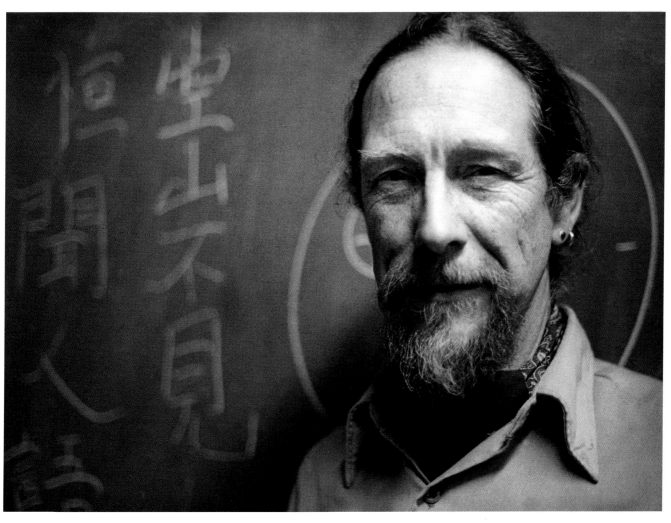

The Truth

If you should see
a man
Walking down
a crowded street
talking aLoud
to himself
Don't Run
In the opposite direction
But run toward him
for he is a poet!
You have nothing to fear
from the poet
but
 the
 Truth

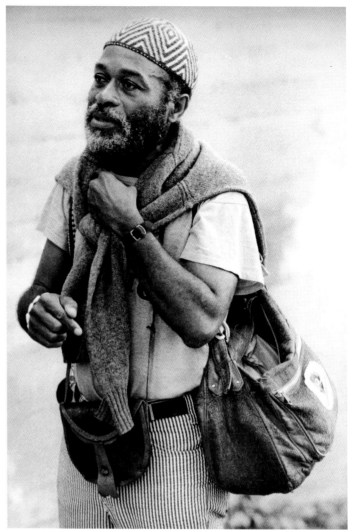

Ted Joans, 1981

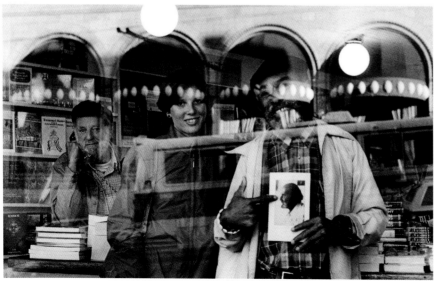

Lawrence Ferlinghetti and Ted Joans, 1981

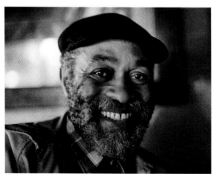

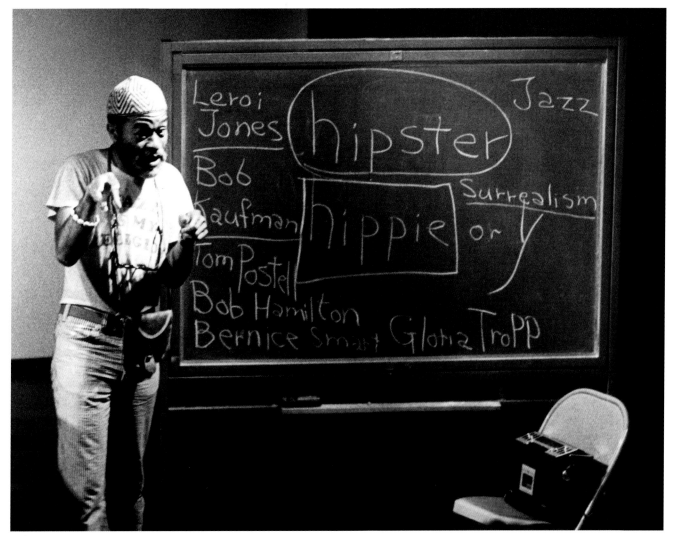

Ted Joans, 1980

Two Cats confront a double head
Korhogo Senfu Spirit 'in 'B' natural
last night at noon

Bob Kaufman, 1981

ABºMUNIST MANIFESTº

ABOMUNISTS JOIN NOTHING BUT THEIR HANDS OR LEGS, OR OTHER SAME.

ABOMUNISTS SPIT ANTI-POETRY FOR POETIC REASONS AND FRINK.

ABOMUNISTS DO NOT LOOK AT PICTURES PAINTED BY PRESIDENTS AND UNEMPLOYED PRIME MINISTERS.

IN TIMES OF NATIONAL PERIL, ABOMUNISTS, AS REALITY AMERICANS, STAND READY TO DRINK THEMSELVES TO DEATH FOR THEIR COUNTRY.

ABOMUNISTS DO NOT FEEL PAIN, NO MATTER HOW MUCH IT HURTS.

ABOMUNISTS DO NOT USE THE WORD SQUARE EXCEPT WHEN TALKING TO SQUARES.

ABOMUNISTS READ NEWSPAPERS ONLY TO ASCERTAIN THEIR ABOMINUBILITY.

ABOMUNISTS NEVER CARRY MORE THAN FIFTY DOLLARS IN DEBTS ON THEM.

ABOMUNISTS BELIEVE THAT THE SOLUTION TO PROBLEMS OF RELIGIOUS BIGOTRY IS, TO HAVE A CATHOLIC CANDIDATE FOR PRESIDENT AND A PROTESTANT CANDIDATE FOR POPE.

ABOMUNISTS DO NOT WRITE FOR MONEY; THEY WRITE THE MONEY ITSELF.

ABOMUNISTS BELIEVE ONLY WHAT THEY DREAM ONLY AFTER IT COMES TRUE.

ABOMUNIST CHILDREN MUST BE REARED ABOMINUBLY.

ABOMUNIST POETS, CONFIDENT THAT THE NEW LITERARY FORM "FOOT-PRINTISM" HAS FREED THE ARTIST OF OUTMODED RESTRICTIONS, SUCH AS: THE ABILITY TO READ AND WRITE, OR THE DESIRE TO COMMUNICATE, MUST BE PREPARED TO READ THEIR WORK AT DENTAL COLLEGES, EMBALMING SCHOOLS, HOMES FOR UNWED MOTHERS, HOMES FOR WED MOTHERS, INSANE ASYLUMS, SANE ASYLUMS, U. S. O. CANTEENS, KINDERGARTENS, AND COUNTY JAILS. ABOMUNISTS NEVER COMPROMISE THEIR REJECTIONARY PHILOSOPHY.

ABOMUNISTS REJECT EVERYTHING EXCEPT SNOWMEN.

* Notes Dis- and Re- Garding Abomunism *

Abomunism was founded by Barrabas, inspired by his dying words: "I wanted to be in the middle, But I went too far out."

Abomunism's main function is to unite the soul with oatmeal cookies.

Abomunists love love, hate hate, drink drinks, smoke smokes, live lives, die deaths.

Abomunist writers write writing, or nothing at all.

Abomunist poetry, in order to be compleatly (Eng. sp.) understood, should be eaten . . . except on fast days, slow days, and mornings of executions.

WE WHO ARE ABOUT TO DIE SALUTE YOU
Bob Kaufman

FROM NOW ON PRESIDENT'S HAVE TO BE MOVIE STARS.
Bob Kaufman

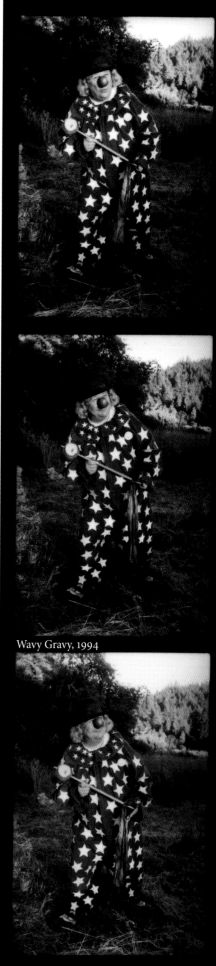

Wavy Gravy, 1994

Ken Kesey, 1982

street Haiku
wind, tree, window, street
howling words, the eye
of the mind in the
hand of a poet

Neeli Cherkovski

Allen Ginsberg and Neeli Cherkovski, 1981

Kirby Doyle, George Scrivani, Neeli Cherkovski, Raymond Foye and Jack Mueller, 1980

Raymond Foye, 1980

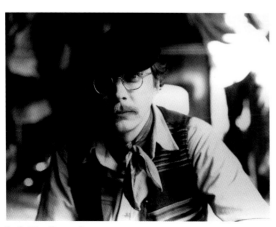

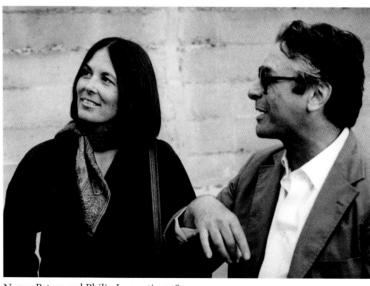

Jack Mueller, 1980

Nancy Peters and Philip Lamantia, 1981

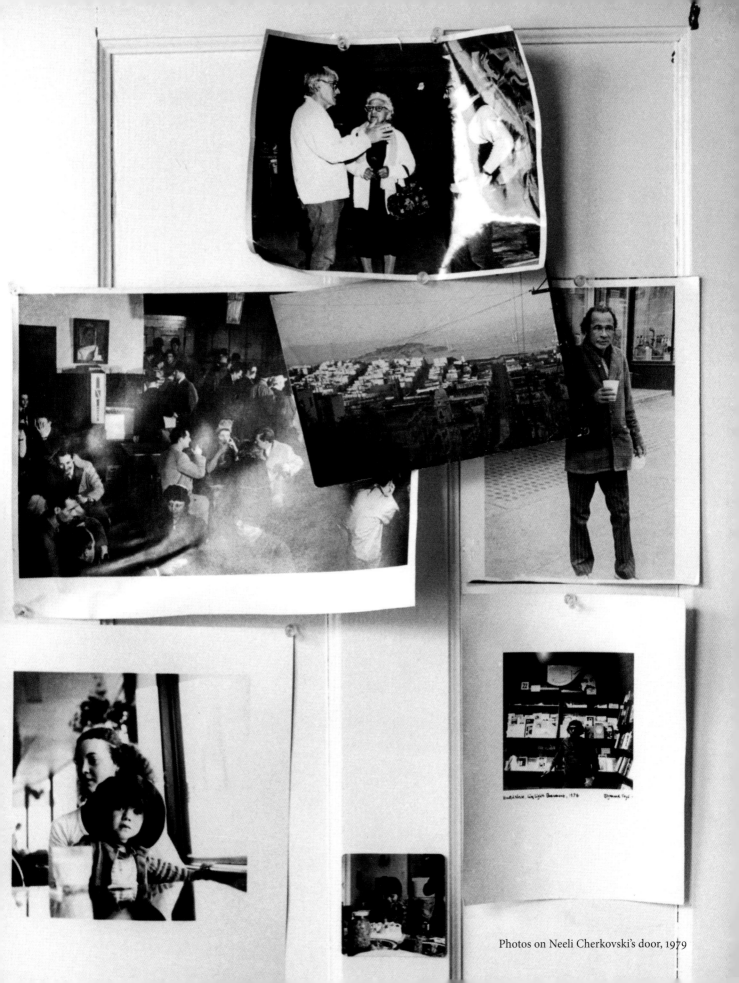

Photos on Neeli Cherkovski's door, 1979

Radiant Opal

The languorous nimble
Through the thicket
The humming glen
Sights
The raven of the rainbow

Philip Lamantia

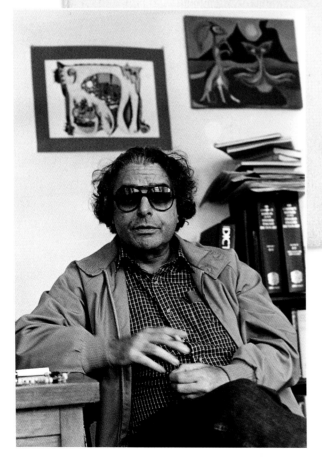

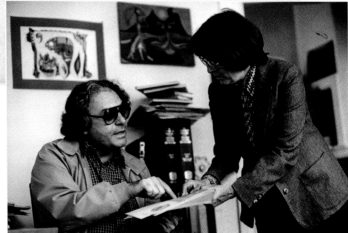

Philip Lamantia and Nancy Peters, 1985

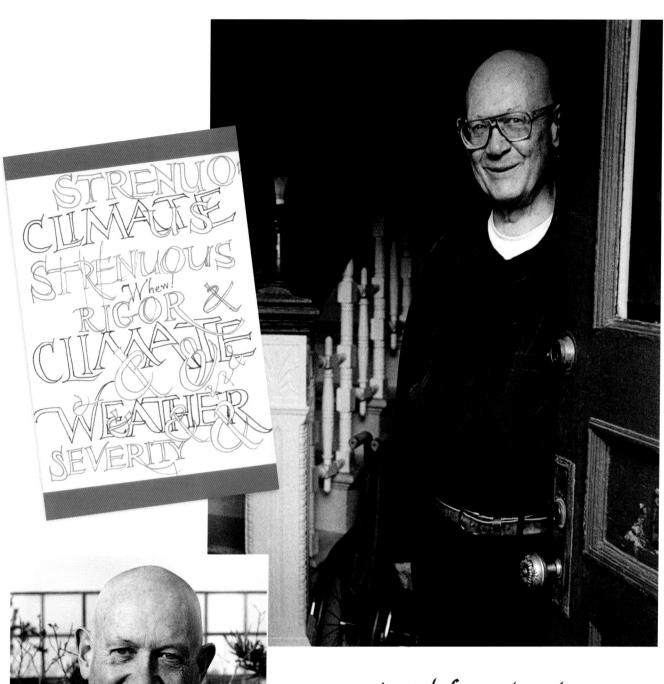

This printed face doesn't see
a curious world looking in —
Big map of nothing.

PHILIP WHALEN
SAN FRANCISCO
4 : IX : 81

Philip Whalen, 1981

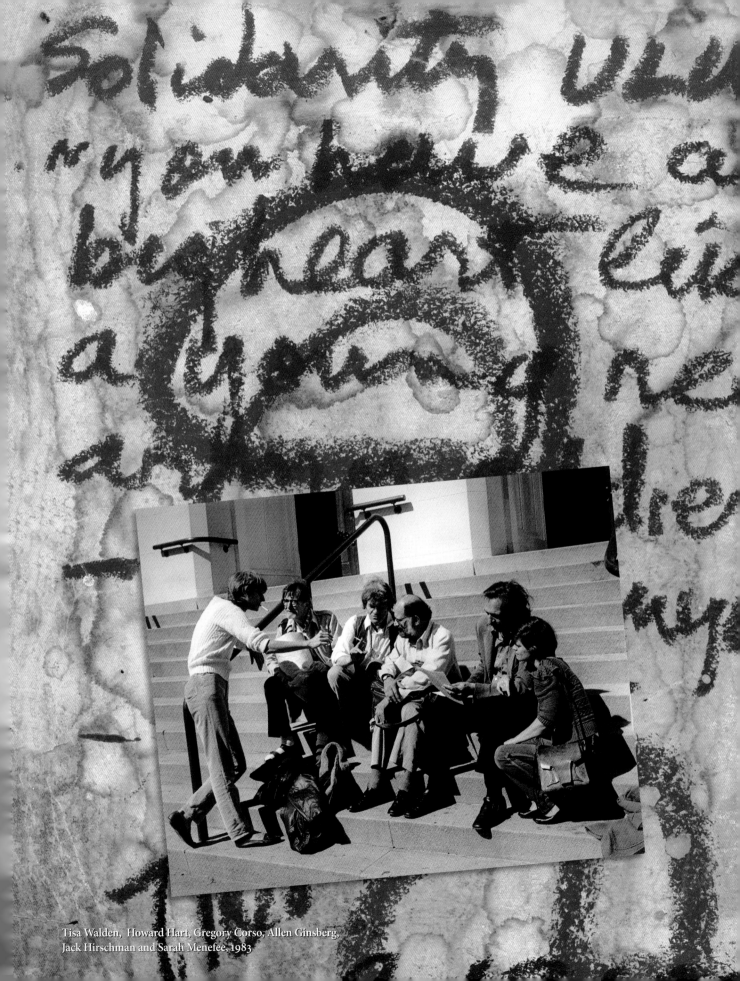

Tisa Walden, Howard Hart, Gregory Corso, Allen Ginsberg,
Jack Hirschman and Sarah Menefee, 1983

The
way
you

Solednitz Vier

Wo Klein

lightly take
me into
your darkness

leibie geiter
present

Jack Hirschman, 1981

31

Joanne Kyger, 1982

To Live in this World Again

you must hide yourself
change your flamboyance
to a dull true

Does this mean I'll never
have any fun?

no one will notice you
The gods won't drag you off
the earth for their own

Entertainment. You are Camouflaged
with simplicity

Joanne Kyger
2000

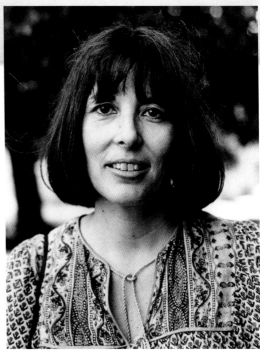

Bobbie Louise Hawkins, 1983

Nancy Peters, 1982

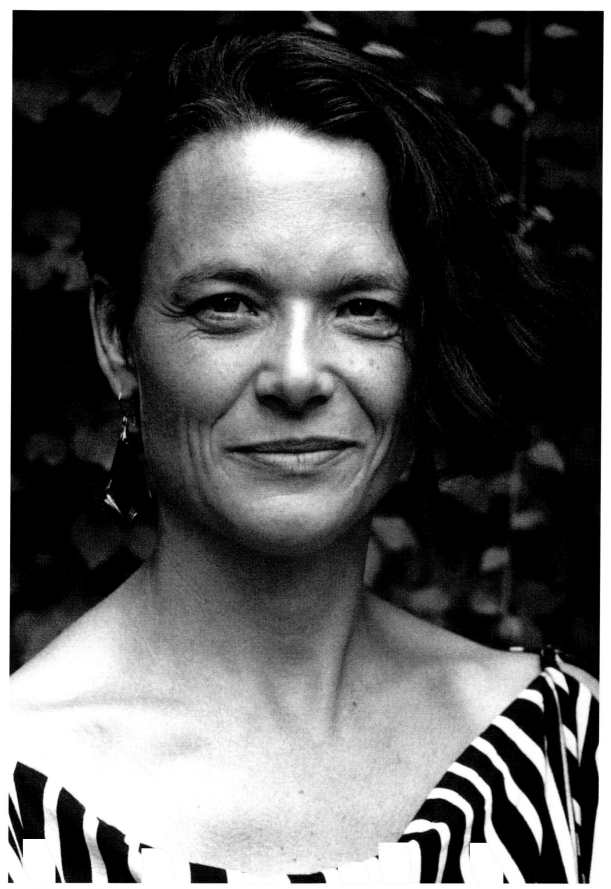

Anne Waldman, 1981

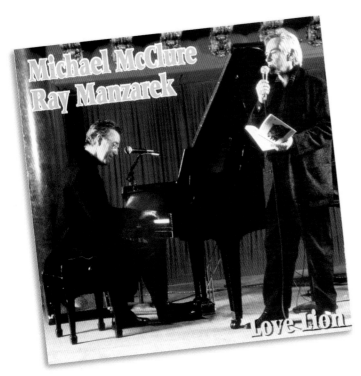

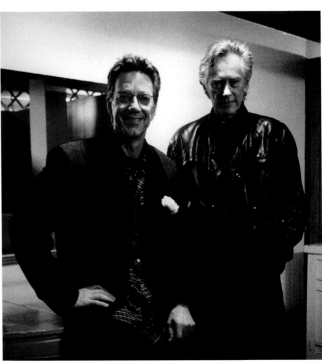

Ray Manzarek and Michael McClure, 1988

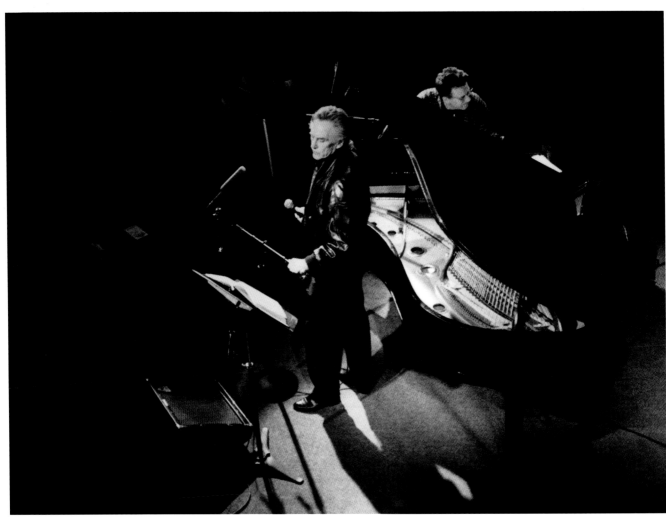

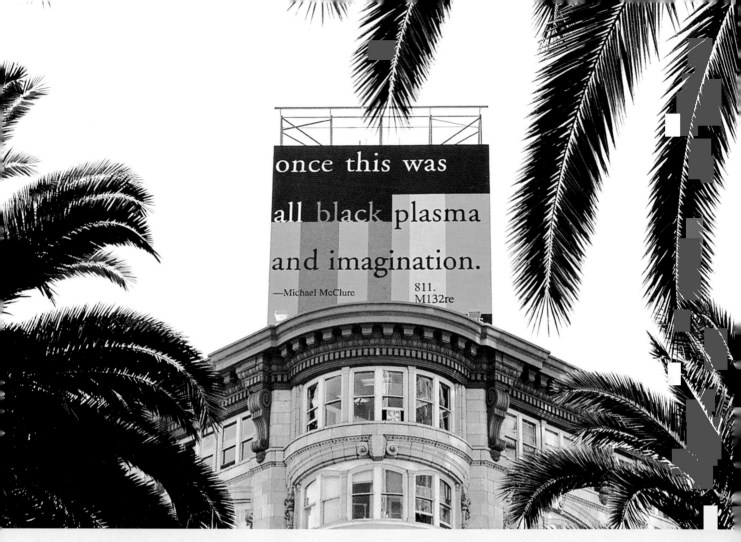

ONCE THIS WAS ALL BLACK PLASMA
AND IMAGINATION
before fantasies of flood
and conflagration.
See, no nations but mammals
and animal perception.
Politics of cruelty
and smoke
are also
nothingness.

Michael McClure

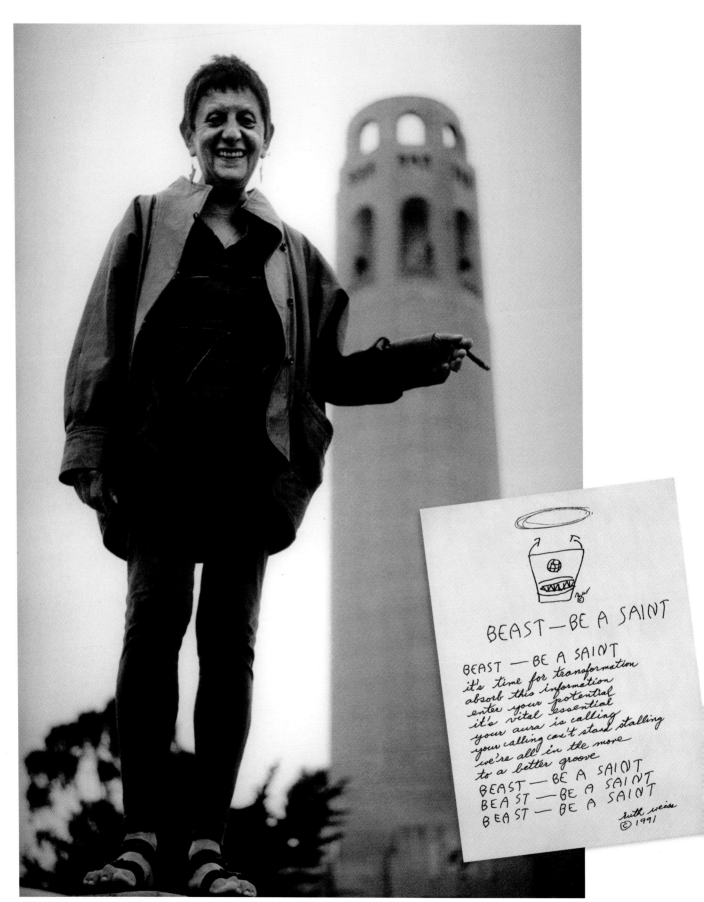

ruth weiss, 1991

O wind and water! Like a gale at dawn
Man hits the wave of woman She arches her throat
For the stab of his lips. Over the wallowing blood
His sudden face divides her life; his terrible gift
Wreathes her with flame!

William Everson

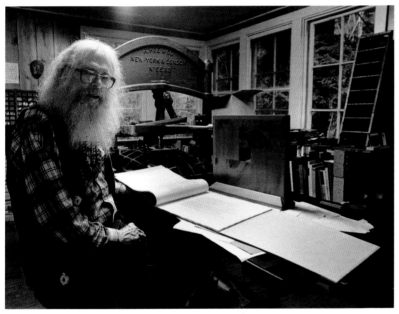

William Everson with Robinson Jeffers' *Granite and Cypress*, 1982

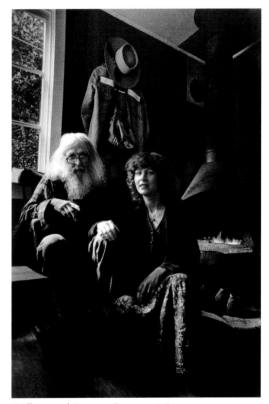

William and Susanna Everson, 1982

William Everson at Kingfisher Flat, 1982

All of it revolved around my having
been spun out of a ball of light
like a blue incandescent hatchet

I adore this woman
Her sensitive hands bite the closing
 darkness with disdain
Cream invites the berry
 strawberry rasberry
From the dark thing
Buried in the earth
Tastes of persimmon disappear
 within her armpits
Birds are silent inside her thighs

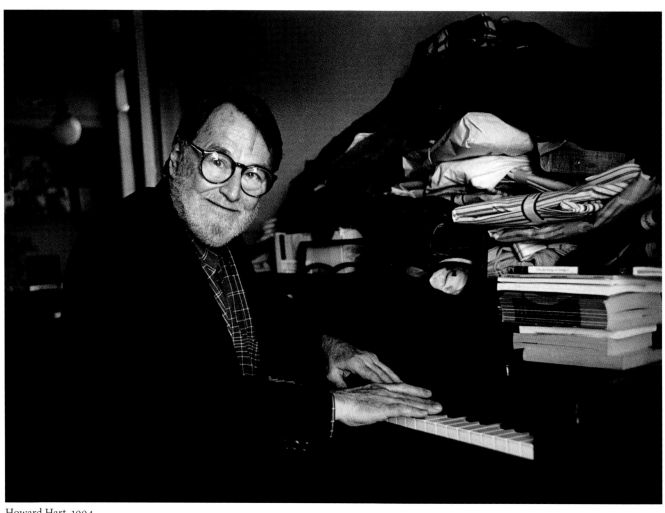

Howard Hart, 1994

Love is the goal, hate is the rule.

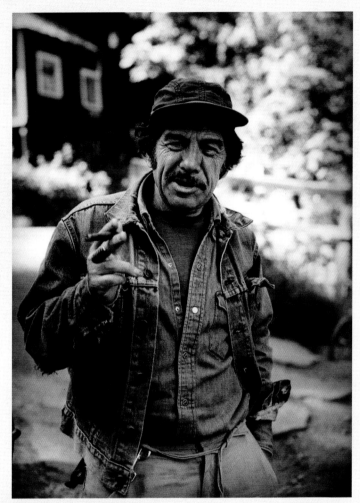

Harold Norse, 1980

This photograph was taken in May.
I gave the hat away in November,
so you'll never see me wearing it again.
Richard Brautigan

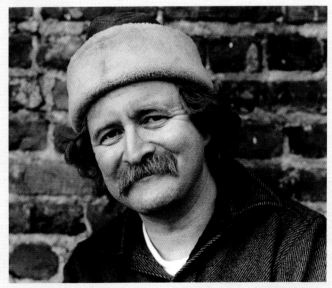

Richard Brautigan, 1981

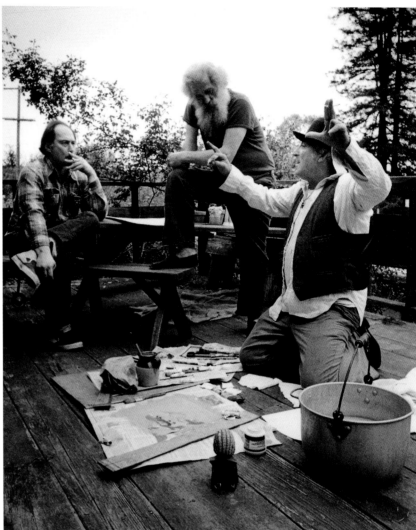

Dan Propper, Eddie Balchowsky and Jack Micheline, 1980

THIS ABOVE ALL
TO THINE OWN
SELF BE TRUE....

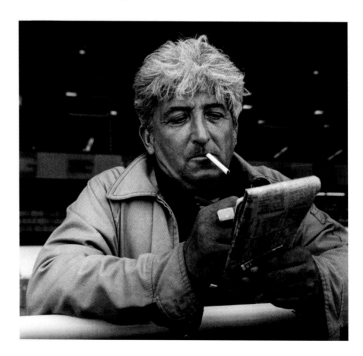

The role of the artist is to raise the light.

Jack Micheline

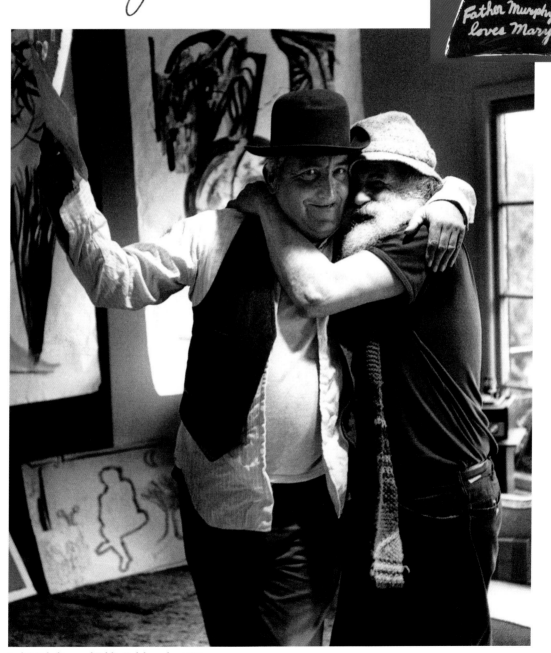

Jack Micheline and Eddie Balchowsky, 1980

Father Murphy loves Mary

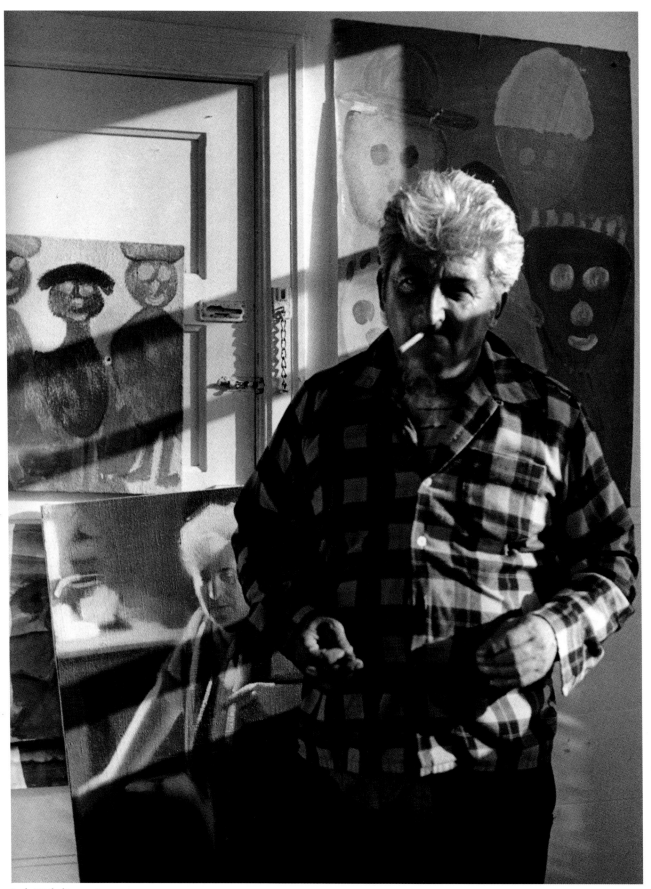

Jack Micheline, 1981

Poem

Genius is a ragged lion
 holding sunlight in his hands
Friend of outlaw, rare grotesque
 Alone he flies with eyes of eagles
Lunatic,
 Ape,
 Angel,
 Demon,
 Fiend,
Torn and spit upon by cowards
 he walks with angels and despair
Genius, poet, ragged lion
 holding sunlight in his hands.

Jack Micheline

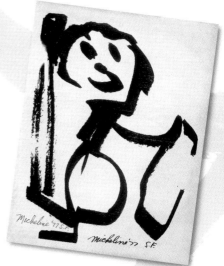

Micheline '77 S.F.
Micheline '77 S.F.

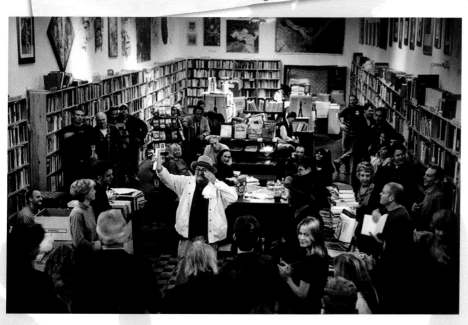

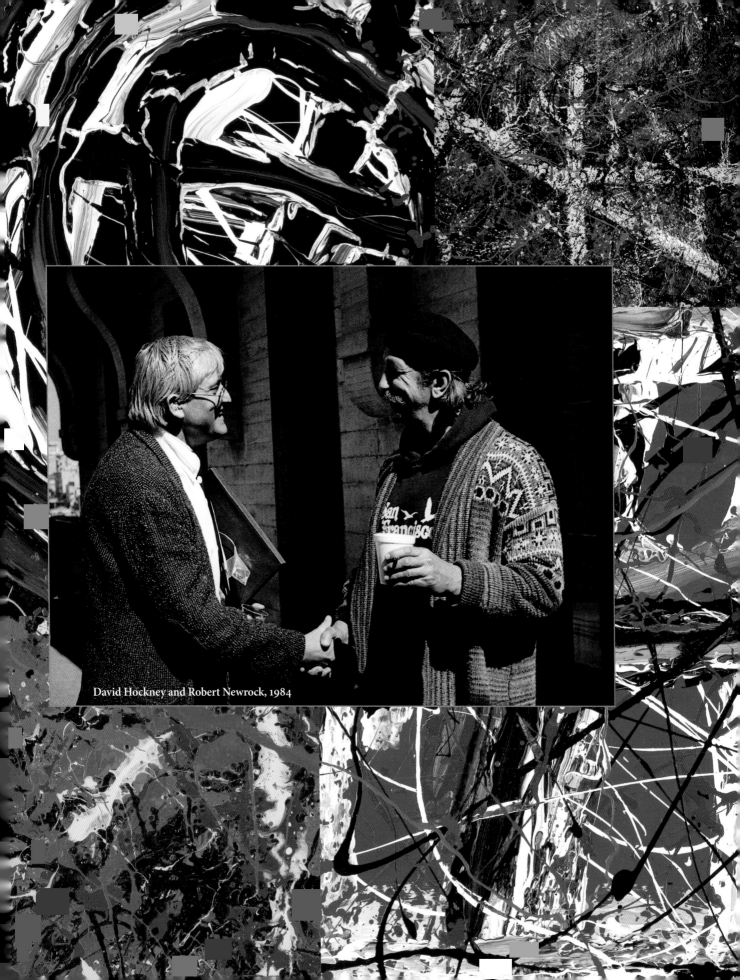

David Hockney and Robert Newrock, 1984

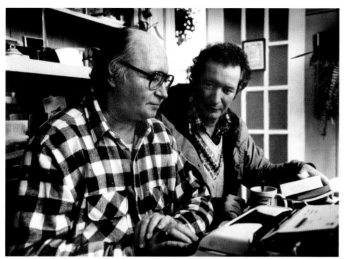
John Logan and Eugene Ruggles, 1982

Herbert and Ari Gold, 1980

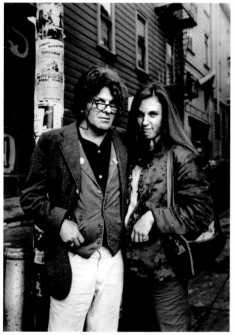
Gregory Corso and Kaye McDonough, 1982

Even the moon must go down —
Patience is halfway to detachment.
In the chablis afternoon
we drink to flatness on another
level,
to the gone balls of Francois Villon
Smiling goes with another hairdo
& children have no fantasy on Guerrero
What I consider a realistic fix
Roberto calls a gorilla stormtrooper
A carnivorous saxophone comes in
the door,
is this real grass growing in the sky?

August 10/11, 1981
San Francisco
Ira Cohen

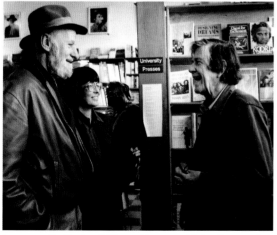
Lawrence Ferlinghetti, Nancy Peters and John Cage, 1984

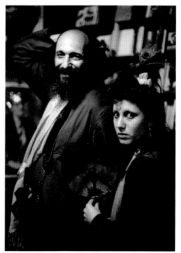
Ira Cohen and
Caroline Gosselin, 1981

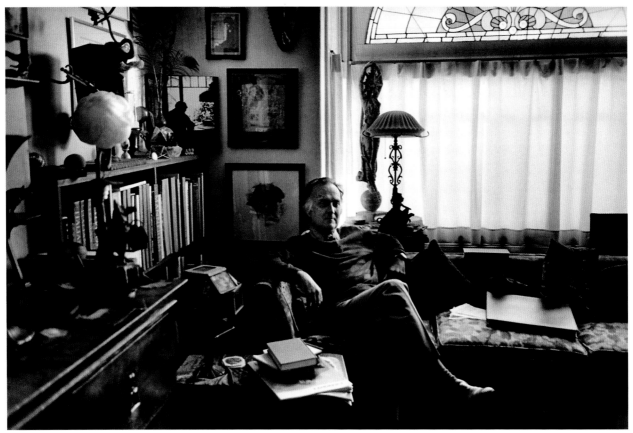

Robert Duncan, 1982

In sound and sense it is the music of inner relationships that moves me ℞

Jess Collins, 1988

This is &
and I am &
and you are &
and so is that
and he is &
and she is &
and it is &
and that is that

James Broughton

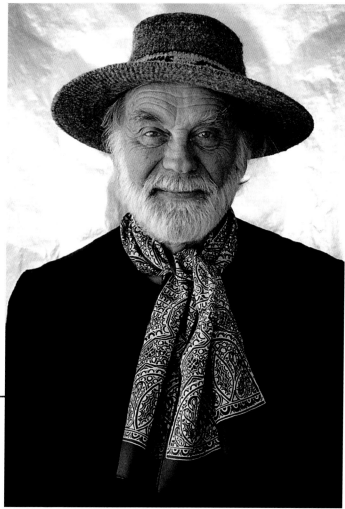

James Broughton, 1983

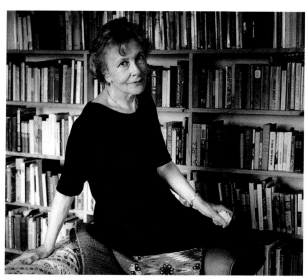

Denise Levertov, 1995

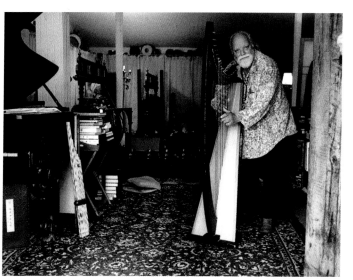

Lou Harrison, 1994

LIFESTYLE

Guerrill...
New film shows
See review, Pag...

Beat era's writers are lively survivors

S.F. writers of the '50s reminisce on TV film

By Diana Ketcham
The Tribune

What inspired the young Ken Kesey to migrate to the Bay Area, where he founded the Merry Pranksters and perpetrated one of the liveliest cultural legends of the '60s? He got the idea from reading Jack Kerouac's "On the Road," the 1957 novel that defined the free-wheeling Beat spirit for at least two generations of youthful rebels.

Or so Kesey tells us in "West Coast: Beat and Beyond," a KQED TV documentary about the legacy of San Francisco's Beat writers, aired last night and to be repeated Saturday at 10 p.m.

Kerouac died in 1969, at the age of 47, but a nucleus of Beat generation survivors is alive and remarkably well in San Francisco today. This is the message of local filmmaker Chris Felver and writer Gerald Nicosia, who interviewed 13 writers associated with the Beat scene for their hour-long documentary.

Narrated by Kerouac's friend Allen Ginsberg, the film is a roster of the participants in the Bay Area's most notorious literary escapade. Given their reputation for pursuing ecstasy and enlightenment via drugs, sex and physical risk, this group of survivors appears surprisingly rosy and cheerful these days.

It is difficult to identify the frolicsome Ginsberg and Jack Micheline of the film with the fabled decadence of the Beats, or with any serious political critique

WEDNESDAY BOOKS

of the Eisenhower years. Despite its title, the film is not a look back at the '50s, so much as a reminder of how many of that era's legendary characters are still very much with us.

Poet and publisher Lawrence Ferlinghetti is shown presiding at his City Lights bookstore, the locus of Beat publishing in the '50s. Ferlinghetti reads from his poem "Look Homeward, Jack," dedicated to Kerouac, while Beat historian Nicosia talks about Kerouac's affinity with novelist Thomas Wolfe, author of "Look Homeward, Angel." Jazz drummer Howard Hart, one of Kerouac's New York roommates, nurses a beer in a North Beach bar. There are cameo readings by poets Micheline, Philip Lamatia, Gregory Corso, Harold Norse, Bobbie Louise Hawkins and Joanne Kyger.

An irrepressible Ginsberg narrates the film, with the air of a Jewish patriarch entertaining his grand-children with tales of a scandalous youth. Ginsberg reads from "Howl," the poem he dedicated to Kerouac, plays the guitar with Kesey, and provides a much needed overview of the origins of anti-establishment writing in the Berkeley Renaissance of the '40s, and the growth of that movement into the San Francisco Beat scene a decade later.

Ginsberg sketches the lineage of West Coast protest writing. He begins with the anti-war magazines of the 40s, the Ark, Cirle, and Illiterati, the The Ark, a journal originally published at the World War II consci-entious objectors' camp at Walport, Ore., by a group including poet William Everson and printer Adrian Wilson.

The memory of Kerouac is the organizing spirit of

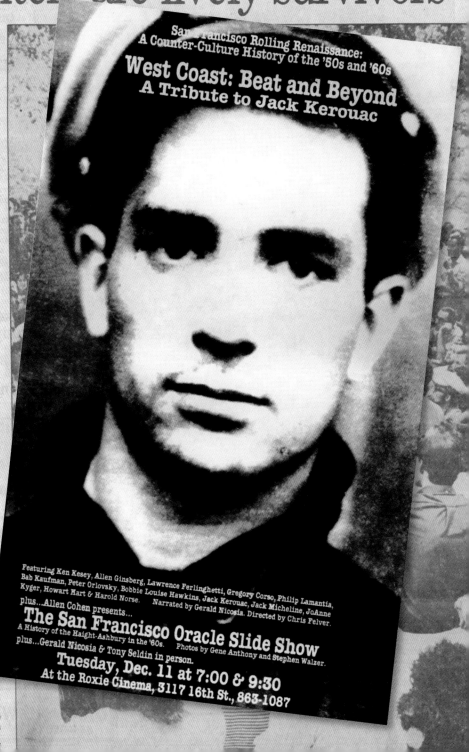

Beat

KQED SPECIALS

PUBLICITY DEPARTMENT KQED INC 500 EIGHTH ST SAN FRANCISCO CA 94103 415-553-2215

5/15/84

FOR IMMEDIATE RELEASE:

CONTACT: Julia McHugh
(415) 553-2244

KQED PRESENTS "WEST COAST: BEAT AND BEYOND,"
A DOCUMENTARY TRIBUTE TO JACK KEROUAC AND
THE SAN FRANCISCO LITERARY RENAISSANCE,
FEATURING ALLEN GINSBERG, PHILIP LAMANTIA,
LAWRENCE FERLINGHETTI, KEN KESEY AND OTHERS.
(AIRDATE: Tuesday, June, 26, 10pm
Saturday, June 30, 10pm, Ch. 32)

In the late 1950's, San Francisco became the center of a literary and spiritual movement called "the Beat Generation." The virtual godfather of the movement was Jack Kerouac, whose epic novel, "On the Road," rocked the literary establishment and inspired a new generation of writers to experiment with form, content and 'beat.' Kerouac died in 1968, but sparked a literary renaissance that continues today. A one-hour documentary special, "West Coast: Beat and Beyond" features thirteen writers who knew Kerouac, including his daughter, Jan. Narrated by Kerouac's biographer, Gerald Nicosia, the special is only a testament to one-writer's influence, but a showcase for the [...] s of the remaining Beat Movement artists. "West Coast: Beat and Beyond" [...] on Tuesday, June 26th at 10:00 p.m. (Reshown: Saturday, June 30, 10pm, Ch. 32)

"Beat and Beyond" was filmed on location in San Francisco's North Beach [...] and at a recent conference celebrating the 25th anniversary of the publi- [...] on of "On the Road." Many rare photos, along with recent photo portraits [...] producer Chris Felver, are interspersed with performances and interviews. [...] ald Nicosia introduces each artist with their background and relationship [...] h Kerouac and the Beat Movement.

Appearing in "Beat and Beyond" are: Allen Ginsberg, whose legendary [...] em Howl was dedicated to Kerouac, his longtime friend. Ginsberg provides [...] overview of the development of radical thought and art in the Bay Area, [...] nd reads from several of his works. Lawrence Ferlinghetti, owner of the [...] amed "City Lights" bookstore, publisher and poet, reads from "Look Homeward, [...] Jack," dedicated to Kerouac. Jan Kerouac, the writer's only child, renders an account from her mother's memoir, "Life with Jack." Howard Hart, one-time Kerouac roommate and jazz drummer, recounts his early days in New York with Kerouac and Ginsberg.

(more)

For Chris
BARM, JACK

The only ones
who said something
out of their skins
were Peter Orlovsky
and Bobbie Lou Hawkins.

Philip Lamantia
looked like Duke Mantee, a
petrified poetry was
had by all.

Jack Micheline's
a sewing machine.

Allen Ginsberg's
an old gas bag.

Gregory Corso
is a horse, so
Harold Norse
by hearsay
stole the floorshow.

Lawrence Ferlinghetti
better shd. play lotto.

Howard Hart
craned.

Joanne Kyger
got her Geiger
counter
to the rye.

Bob Kaufman's
Bob Kauf
bombed.

Jack Kerouac's
coffin creaked.
A bone
for this
Roland

Young
Topper
Teevee
world.

And the
beat goes
wan.

[...] was not the Beat writers' st [...] They were away from home a lot, and [...] was the unfortunate example of Wil [...] oughs, who shot his wife. So it seemed li [...] note for the documentary to include Bo [...] se Hawkins, the former wife of poet Ro [...] ley, and Joanne Kyger, who went to J [...] poet Gary Snyder in the '60s.

[...] t is a pointless gesture toward rectifying [...] d to include these women in a film abou [...] s. Both Kyger and Hawkins have come [...] own as poets and entertainers. It seer [...] to classify them, not very accurately eve [...] ndages of the Beat scene.

[...] "Beat and Beyond" may not be history, b [...] entertaining film anthology of poetry [...] rs who still feel the influence of the tenac [...] Beat legend.

ac, author of beat novel, 'On the Road'

| 49

In 1976, at the base of the Flatiron Mountains near Boulder Colorado, Allen Ginsberg, with codirector Anne Waldman, joined Tibetan Buddhist Chogyam Trungpa in creating the Jack Kerouac School of Disembodied Poetics at the Naropa Institute. In this bucolic setting and mountain retreat of culture and idealism, the Naropa Institute became an alternative retreat from mass culture, a lantern casting its glow on human transformation and poetic vision. The instructors were a collection of Ginsberg's eclectic cadre of characters, including Gregory Corso, Robert Creeley, Diane di Prima, Gary Snyder, William Burroughs, and even Timothy Leary.

I was in Ohio in the summer of 1981 when the phone rang, and on the other end was Gregory Corso. He asked if I was coming through Boulder on my way back to California. My father had died a few years earlier, and Gregory remembered a story I'd told about the piles of pills left in his room. He never forgot a detail. "Bring the pills and come to my class." After two days of driving I arrived in Boulder with the stuff. Gregory's poetics class was about to begin, but we had time to stop at the liquor store for a pint of Hennessey to go with the Demerol. This class was the whole "ballgame" in one lesson. Gregory laid out all the goodies on his main men, Shelley and Keats, and the lecture became more and more a matter of free association. No one ever forgot time spent with Gregorio. Afterwards, we went over to the University Apartments where Allen and Peter Orlovsky were living. As the day went on, it seemed amazing to me how Gregory never missed a beat, and the mutual admiration society between old comrades was always tender and nonjudgmental. I stayed at Larry Fagin's apartment and went swimming with Anne Waldman almost every day. Each night readings and events were programmed, so there was always a lively interaction between students and faculty.

The following summer the Naropa Institute celebrated the twenty-fifth anniversary of the publication of *On The Road*. Everyone associated with Kerouac was invited. The weeklong festivities brought together filmmakers, musicians, historians, poets and writers for symposiums, art exhibitions, poetry readings, and all night poker games. It was a complete takeover by city slickers in this sleepy university town. I met Robert Frank for the first time when he was filming the event. I kept a close eye on how he worked—shooting with a hand-held Arriflex while a friend helped with the sound. No muss no fuss; just how I thought it would be. This celebration resulted in an explosion of ideas and a renewed

II

NAROPA

awareness of the impact these artists and writers had on society. It was exciting to be with so many from the mythologized world of Jack Kerouac who "dug" each other and reveled in their friendship.

In the spring of 1983, Ferlinghetti asked if I wanted to join him on a fact-finding trip to Nicaragua to witness the unjustified intervention of the US there. We were hosted by Ernesto Cardenal, Minister of Culture, and for a week toured the countryside, often in an armed convoy, meeting compañeros, junta leaders, and Sandanista writers. Each night though, the Sandanista armed guards locked us in our house. Lawrence's sense of humor kept the serious nature of our journey on an even keel. Many Sandanistas, including editors, officials of the junta, and members of the writer's union, gave us interviews. At the Ruben Dario Poetry Festival, Lawrence presented Ernesto with a seed from Pasternak's grave, given to him by Andrei Voznesensky. That fall City Lights published *Seven Days In Nicaragua Libre*, Ferlinghetti's journalistic memoir of our trip, with my photos.

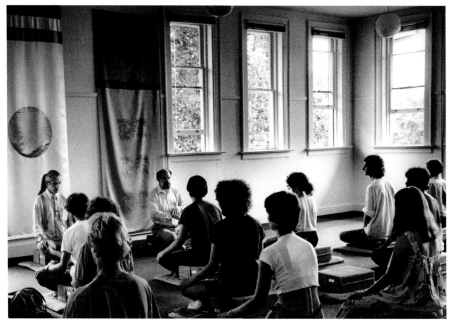

Peter Orlovsky and Allen Ginsberg, 1981

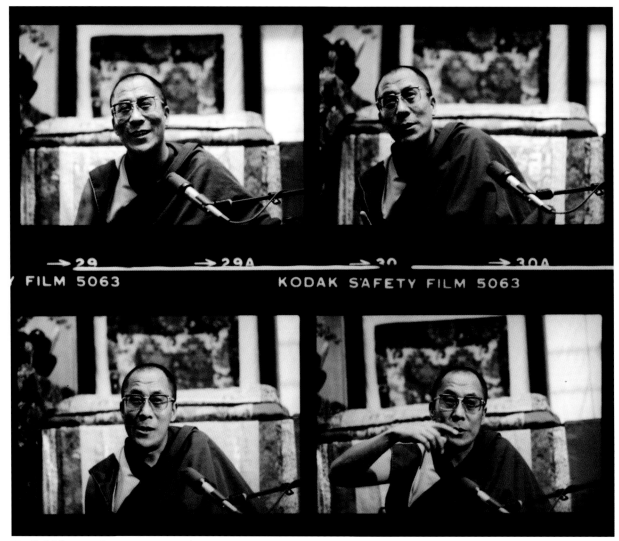

The Dalai Lama, 1980

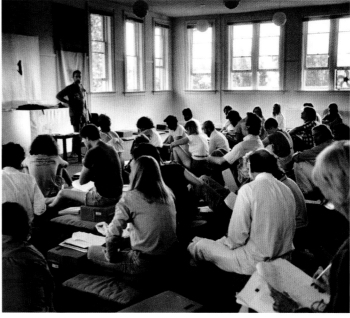

THE AUTHOR WILL READ FROM HIS WORKS

Gary Snyder

MR. SNYDER'S FIRST ENGAGEMENT IN BOULDER IN EIGHT YEARS

NAROPA *Summer* INSTITUTE

FRIDAY, AUGUST 12
Boulder High School
17th & Arapahoe $6/$4 students **8 P.M.**

Gary Snyder, 1981

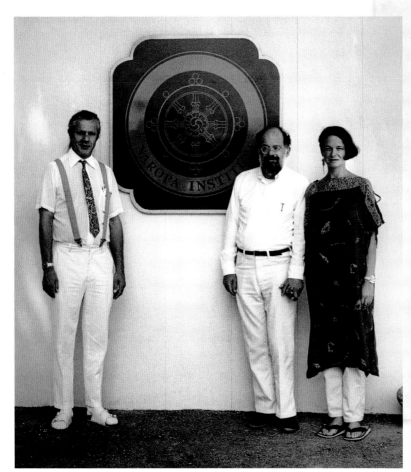

Peter Orlovsky, Allen Ginsberg and Anne Waldman, 1981

NAROPA INSTITUTE
1111 Pearl Street • Boulder, Colorado 80302 • (303) 444–0202 • Cable: NALANDA

"So this is the forest of Arden!"
—w.s.

Allen Ginsberg
July 29, 1981

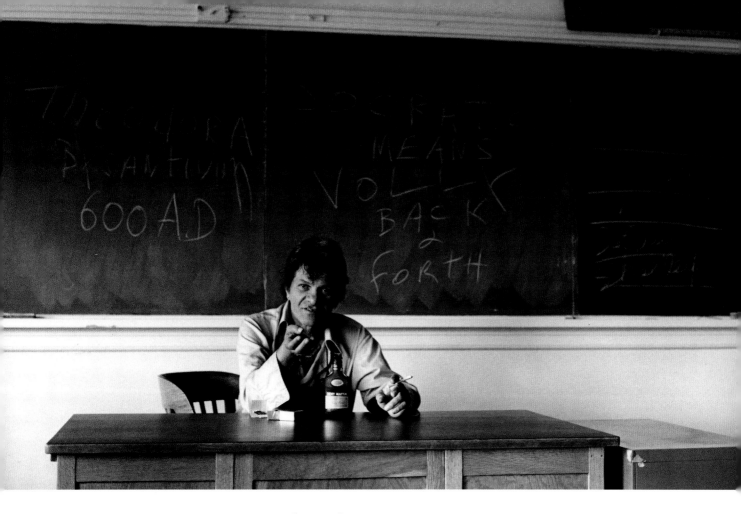

Art is as old in America as it is in Europe, if not older —

The dead dinosaur, our unfortunate relation, is not bewailed. We do however bewail the living whale (green-peace etc) — Thus we are living artists in art in America. Consider this — I speak of LIFE IN ART... help preserve it... or else it'll become oil; the polluting spirit of dinosaur. S Corso

Allen Ginsberg and Gregory Corso, 1981

Allen Ginsberg (signature)

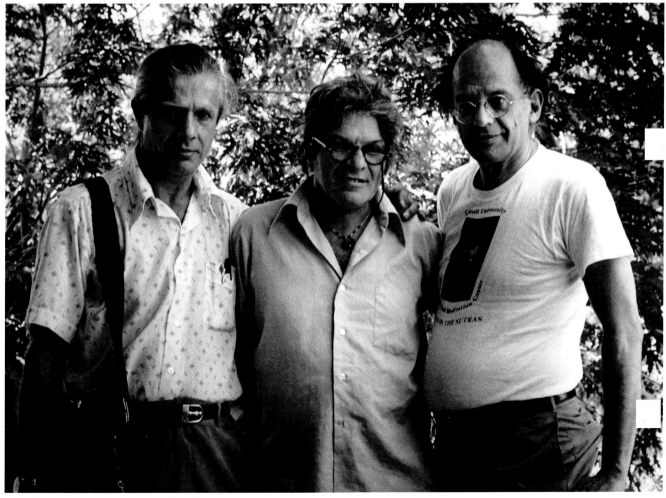

Peter Orlovsky, Gregory Corso and Allen Ginsberg, 1981

For Chris Felver

What Luck to be The Human Bag of Plums
That Falls at Naropa Inot's School Door
Ready to Sweeten The Thousand student
Smile.

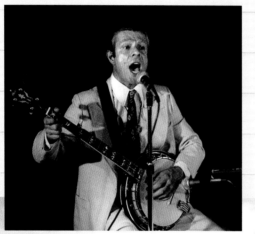

Peter Orlovsky
July 30, 1981
Boulder, Col.

"Tho I grew tall, &
huge of frame, I
had a perfect heart."
— Ted Berrigan
July 26,
1982

Distance Traveled

for Ted Berrigan

Hoist sail, little bark of my wit!
Mighty Captain gazing 'round —
How can I speed without you?
The light of the moon rising in Aries
makes me set a face to the hillside
Nor was our parting over
at the foot of the mountain.

Anne Waldman

PULL MY DAISY

Title song from the 1959 Film,
narrated by Jack Kerouac with
musical score by David Amram.

Music: David Amram
Lyrics: Jack Kerouac,
Neil Cassidy
and Allen Ginsberg

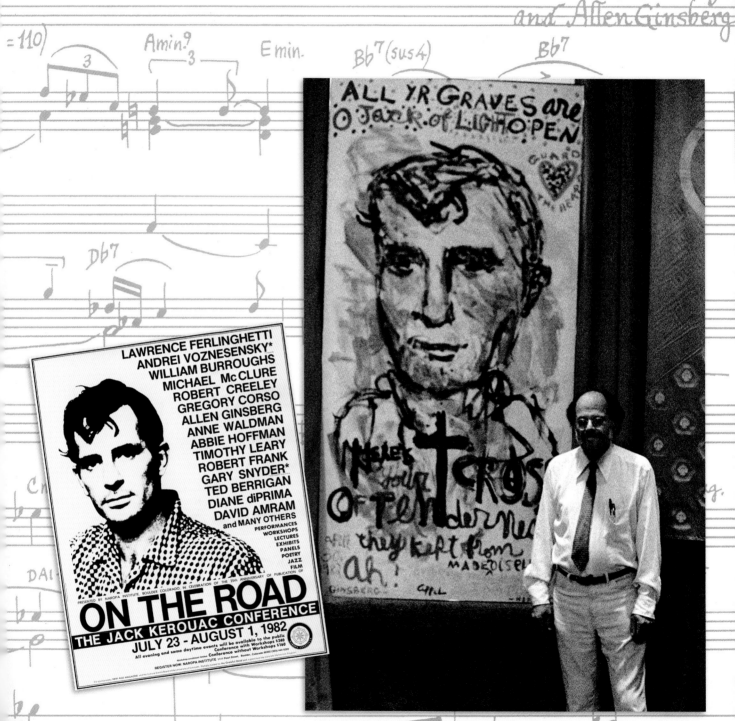

Larry Rivers
and
Delphine Seyrig
in "Pull My Daisy"
1960

Frank
directing
Leslie &
Corso →

Alice
↓
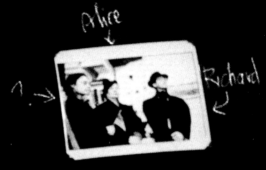
∧ → Richard
↙

Jack
Kerouac
↴
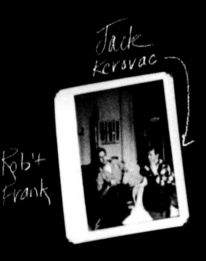
Rob't
Frank

Kerouac David
↓ Amram
↓
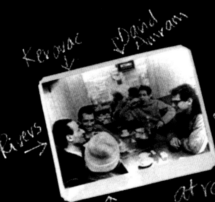
Rivers → Allen
↙
↑
Gregory
at restaurant Allen ↑
near filming

Peter Larry
↓ ↓

Gregory
↙

Kerouac
↓

Al
← Leslie

in Chinese
Restaurant

Robert
Frank
←
Al
Leslie ↑

John Cohen's *Pull My Daisy* stills, 1982

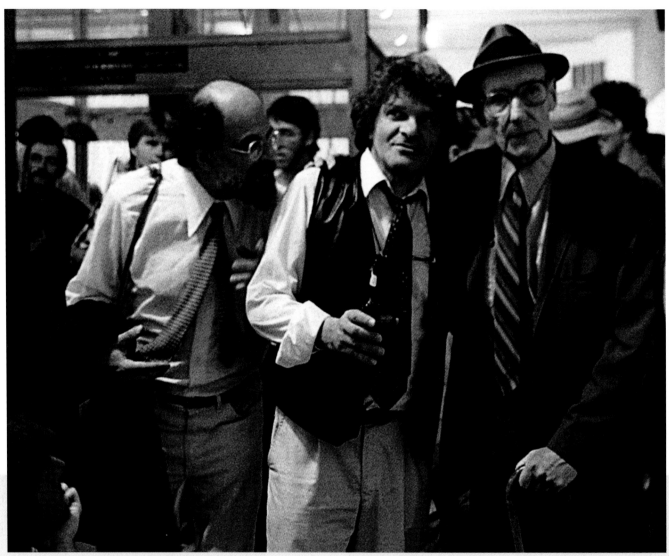

Allen Ginsberg, Gregory Corso and William S. Burroughs, 1982

THREE ROSES STAND
IN THE FIELD
watching a vision.

CHEERS!

Michael McClure

WILLIAM BURROUGHS COMMUNICATIONS

P.O. BOX 147
LAWRENCE, KANSAS 66044
TELEPHONE 913-841-3905

Since dreams are a biologic
necessity we are literally
such stuff as dreams are
made of 'and real poetry is dream.

William S. Burroughs

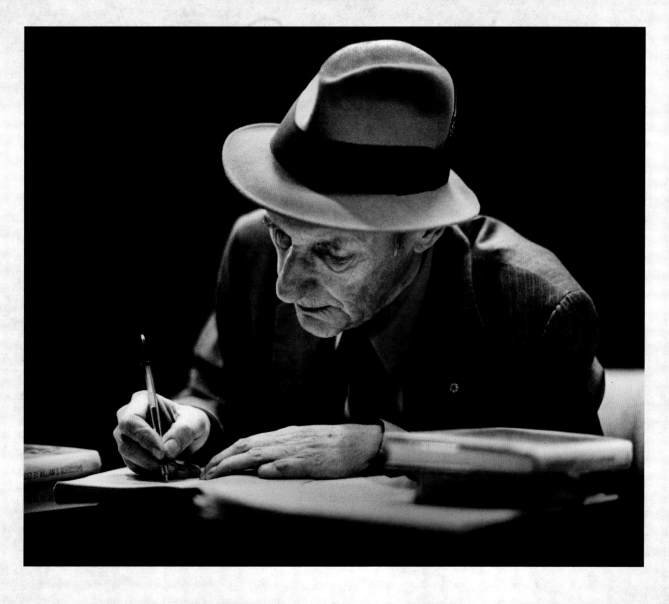

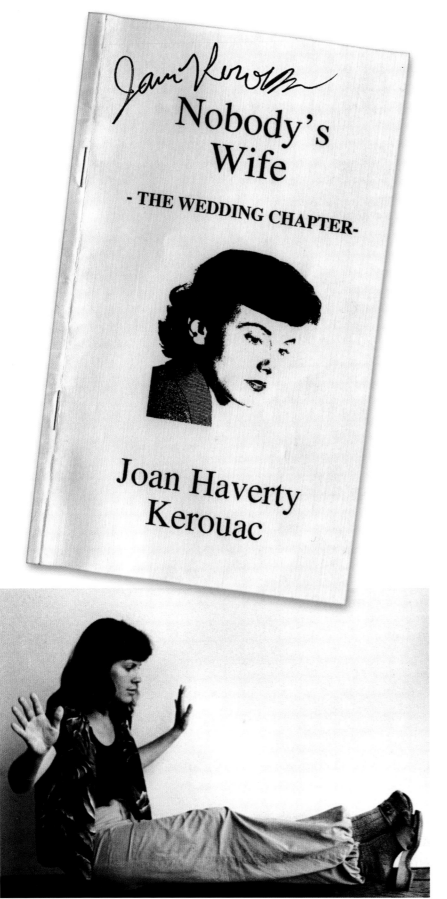

Nobody's
Wife

- THE WEDDING CHAPTER -

Joan Haverty
Kerouac

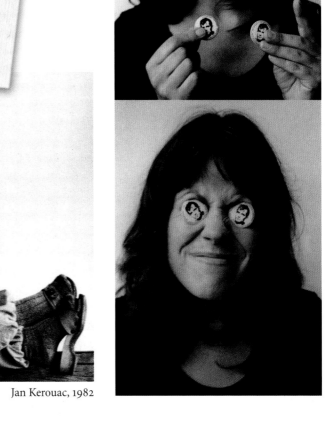

Jan Kerouac, 1982

Return to that Familiar

Return to that familiar
damp smell at dawn

Sparrows eat the plumblossoms

old Dead Head
of sunflower still
stands propped
up in head high Kale
the Quail love to eat
so much

February 9, 2000
Joanne Kyger

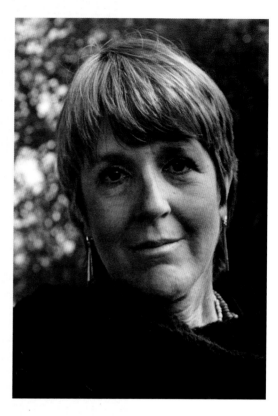

It's so quiet
you can hear
the wasps sipping water.
in the courtyard fountain

January 25, 2002
Patzcuaro
Joanne Kyger

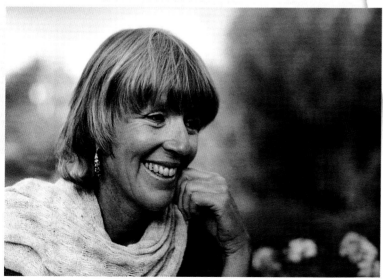

Joanne Kyger, 1986

Diane di Prima and Robert Creeley, 1981

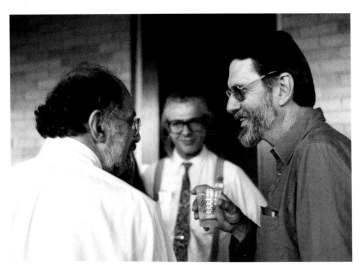

Allen Ginsberg, Peter Orlovsky and Robert Creeley, 1982

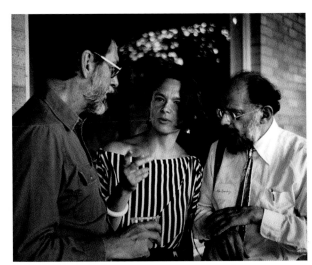

Robert Creeley, Anne Waldman and Allen Ginsberg, 1982

FROM "CLEMENTE'S IMAGES": 22

Enjoying out
each complicating part,

each little twist of mind inside,
each clenched fist,

each locked, particularizing thought,
forgotten, emptying out.

R. C.

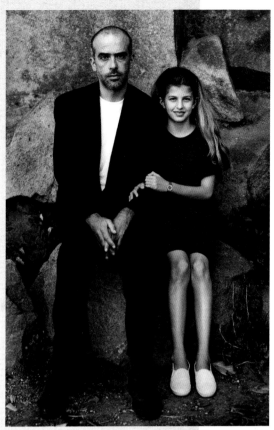

Francesco Clemente and Nina Clemente, 1988

Creeley by Francesco Clemente

SAD ADVICE

If it isn't fun, don't do it.
You'll have enough to do that isn't.

Such is life, like they say,
no one gets away without paying

and since you don't get to keep it
anyhow, who needs it.

Robert Creeley

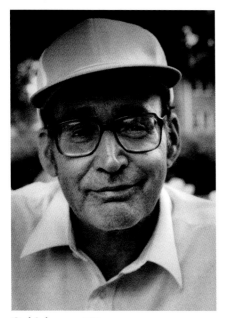

Carl Solomon, 1982

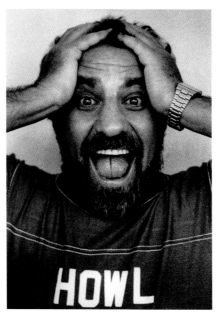

Abbie Hoffman, 1982

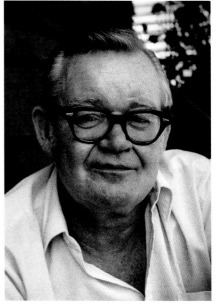

John Clellon Holmes, 1982

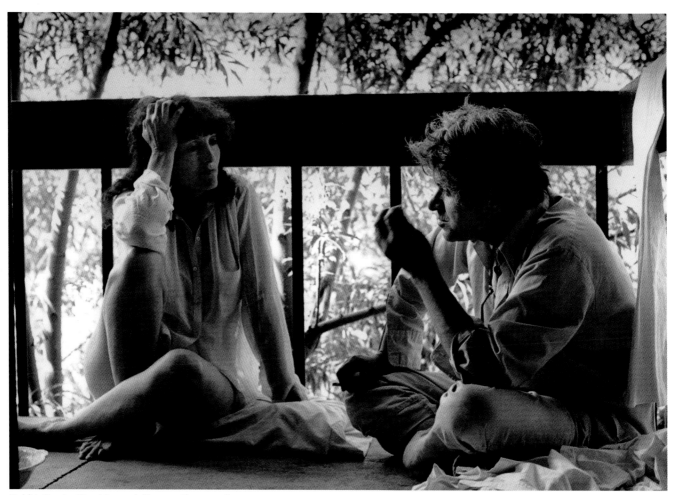

Bobbie Louise Hawkins and Gregory Corso, 1982

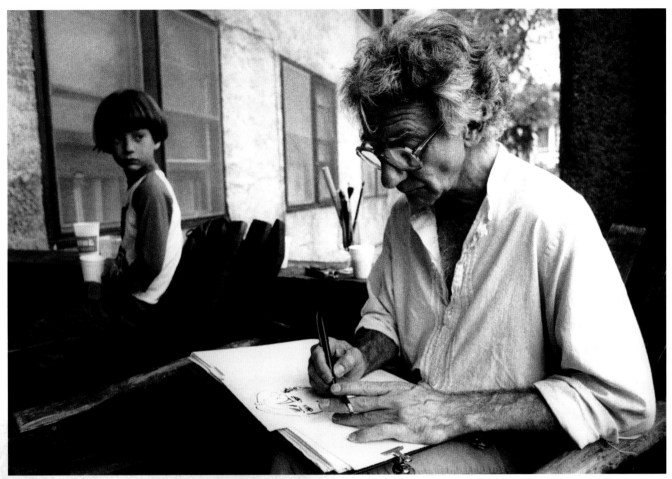

Robert LaVigne, 1982

Trouble and hope
Tumble the days
like dice

Bobbie Louise Hawkins

Paul Krassner, 1982

In the west
In the east —

This dark is the shadow
of light upon Light

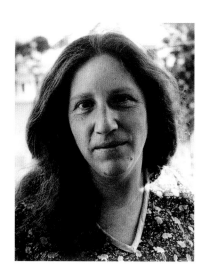

Diane di Prima

Winter Solstice,
1981

IN THE ROOM OF NEVER GRIEVE

register
& escape
 the traps
a last judgement
cheetah under her skin
one window on the sunny side

still life with stylus
w/ rancour
still life with daggers
size of a postcard

no harm will come to the dolls
of which I am the Queen

ghosts gather
scald
seethe.

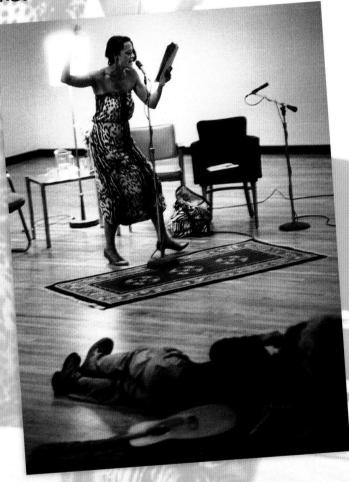

Anne Waldman, 1982

Feb 14 1983

Intelligence
Is the Ultimate
Aphrodisiac

Timothy Leary

Aphrodisiac is the
Ultimate Intelligence

Timothy Leary, 1981

Baba Ram Dass, 1984

Ed Dorn, Jenny Dorn, and Stan Brakhage, 1981

SEVEN DAYS IN NICARAGUA LIBRE

Lawrence Ferlinghetti

SEVEN DAYS IN NICARAGUA LIBRE. By Lawrence Ferlinghetti. Photos by Chris Felver.

An eye-opening argument for the humanistic, non-Stalinist side of the Sandinista revolution, vividly illustrated by many on-the-spot photos, this is the inside story of the author's recent trip to Nicaragua during which he met and talked at great length with the most important government leaders including Daniel Ortega, Father Miguel D'Escoto, Jaime Wheelock, Tomas Borge, Rosario Murillo, and Father Ernesto Cardenal.

Touring the country with Minister of Culture Cardenal, Ferlinghetti wrote this behind-the-scenes account of life in a poor country which is striving to create a truly free and truly democratic society in the face of a U.S. policy ~~seemingly~~ seemingly designed to force Nicaragua into the Soviet

-160-0 112 pp. Camp. With 50 photographs by C.F.
$6.95

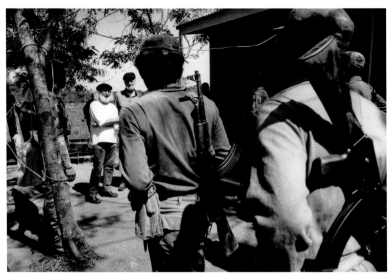

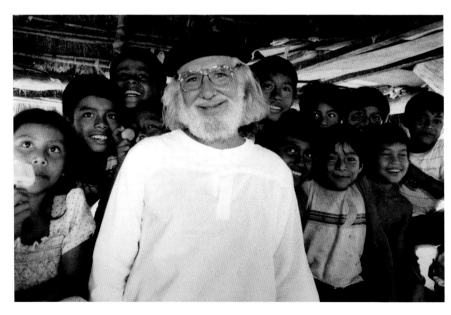

Ernesto Cardenal, 1983

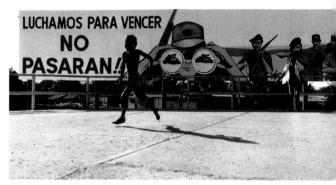

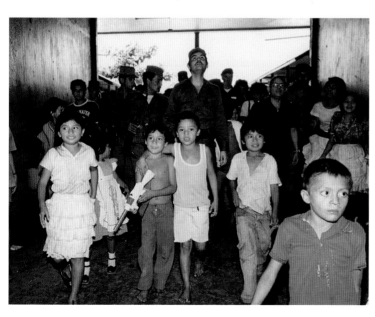

By 1984 I moved to New York City. The first week, I took my portfolio of prints to publisher Alfred van der Marck, as poet Jerome Rothenberg had suggested. That very day I submitted my portrait work, Alfred promised he would publish *The Poet Exposed*. I was taken aback by how quickly things happen in NYC. I suggested we make a more balanced book with an equal number of poets from the New York School and the West Coast. So I set up shop at 38 McDougal Street and hooked up with Larry Fagin again, who gave me a list of poets he considered essential.

Surrealist poet Ted Joans was passing through town from Paris and needed a place to stay. He made it his raison d'être to know just about everyone. When we met in San Francisco he told me, "keep movin', kid." I liked his philosophy. It was as though he'd been reading my mail. Ted made his daily rounds to see old friends from the 1950s, some of whom had joined him at "rent a beatnik" parties. One evening he suggested that we meet up with "the maestro," Cecil Taylor. He was viewing the *African* exhibit at the Brooklyn Museum when we caught up with him. He invited us to his Fort Green brownstone for champagne and a bite to eat. Cecil had an upcoming solo concert at Carnegie Hall, so a little practice was in order. From the first chord cluster he played, I knew why Ted called Cecil the maestro. His coloration of notes began setting the tone for my New York experience. One could literally seize the sacred from the air and hear in his music the illuminated articulation of modern life.

The following week found me on the train to East Hampton to hook up with David Amram, who was playing at Guild Hall. Kenneth Koch was reading his poetry in the gallery before the music began, and his humorous takes on particular scenes struck a chord. His poems seemed very cosmopolitan and different in delivery than what my friends in North Beach were writing. Kenneth was one of the founding members of the New York School, along with Frank O'Hara and John Ashbery. We had a drink after his reading, and when it came out that I played a little tennis, he invited me to stay in touch with him. We watched Amram's performance together as he displayed his virtuosity, playing a multitude of instruments, including the amulets strung about his neck. David is a classically trained ethnomusicologist who composed the music for Robert Frank's film *Pull My Daisy*, while collaborating with Ginsberg, Cassady, and Kerouac on the film's theme. David is a renaissance man and was a true friend of Kerouac's, always sincerely dedicated to keeping the bohemian spirit alive.

Much later that evening at an exhibition of Herman Cherry's paintings, I met Dane Dixon, who invited me to The Springs in East Hampton to hang out with the local artists and crash at his Art Shop. I knew this was Jackson Pollock territory and that drinking was part of the routine. The next day, following a night of debauchery, Dane took me over to meet Willem DeKooning. In the presence of the mischievous prodigy, I immediately felt euphoric in his glass-enclosed studio filled with canvases in various stages of completion. He seemed totally "with it," and upbeat in Dane's company, asking me to come back when my pictures were developed—a magical moment for me.

Driving back to the train, it suddenly hit me—I had been in NYC only two weeks, and already I felt right at home, making what I thought were serious pictures. Ginsberg had just returned from touring and called to welcome me to New York, seeming genuinely interested in my movements about town. He invited me over to his pad on 12th Street and we exchanged photographs, my picture of Noguchi for his picture of Gregory in the Paris Beat Hotel. From then on Allen would leave my name at the door wherever he was performing. In this cultural capital there was so much energy. I realized that unlike San Francisco, here it was possible to connect with almost anyone.

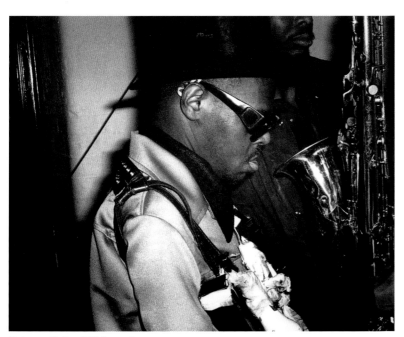

Rahsaan Roland Kirk, 1976

Ted Joans and Cecil Taylor, 1984

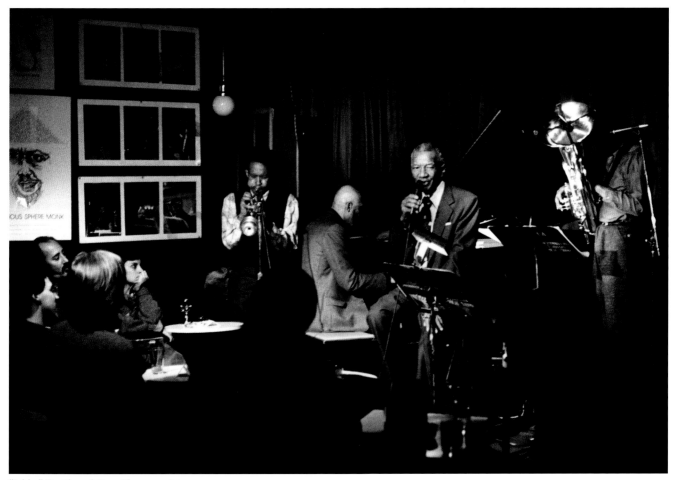

"Jabbo" Smith and Don Cherry, 1986

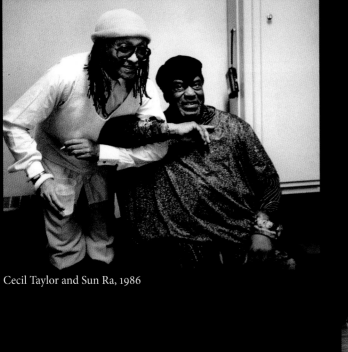
Cecil Taylor and Sun Ra, 1986

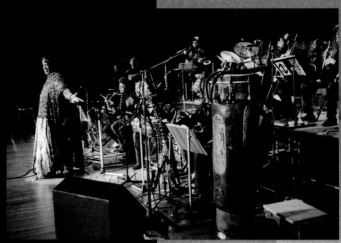

Oct. 30, 1985

In regard of the Beats on a fall day in 1985 — for Christopher Felver.

Emanating good will and a bright gleam in the eye, Chris asked for a photograph and a few lines to use opposite. — These, will have to do.

The sharp wind through the dry leaves, the grey skies speak of the years end and once again the rekoning of time.

Forget the anger, the hate and inundating stupidity. Greet hope and welcome the past and future.

Herbert Huncke

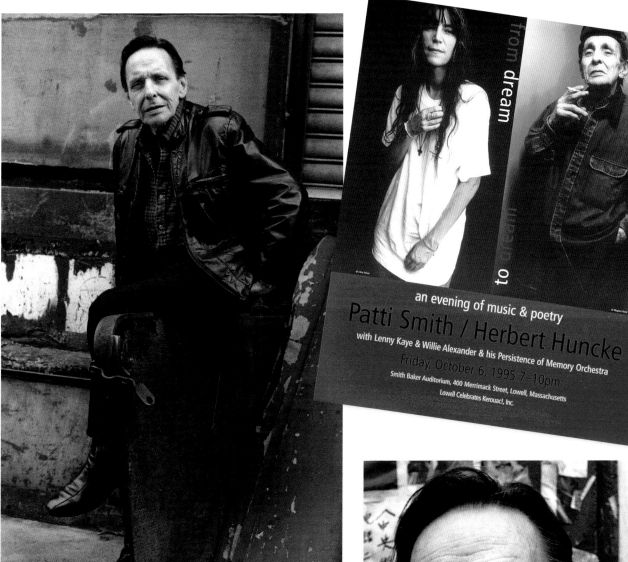

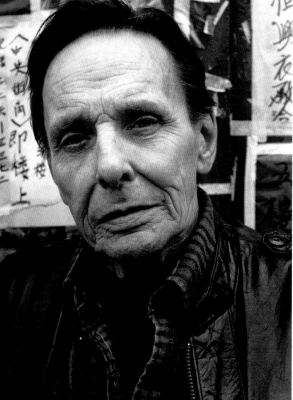

Raymond Foye and Herbert Huncke, 1995

HONOR SONG FOR SITTING BULL

David Amram

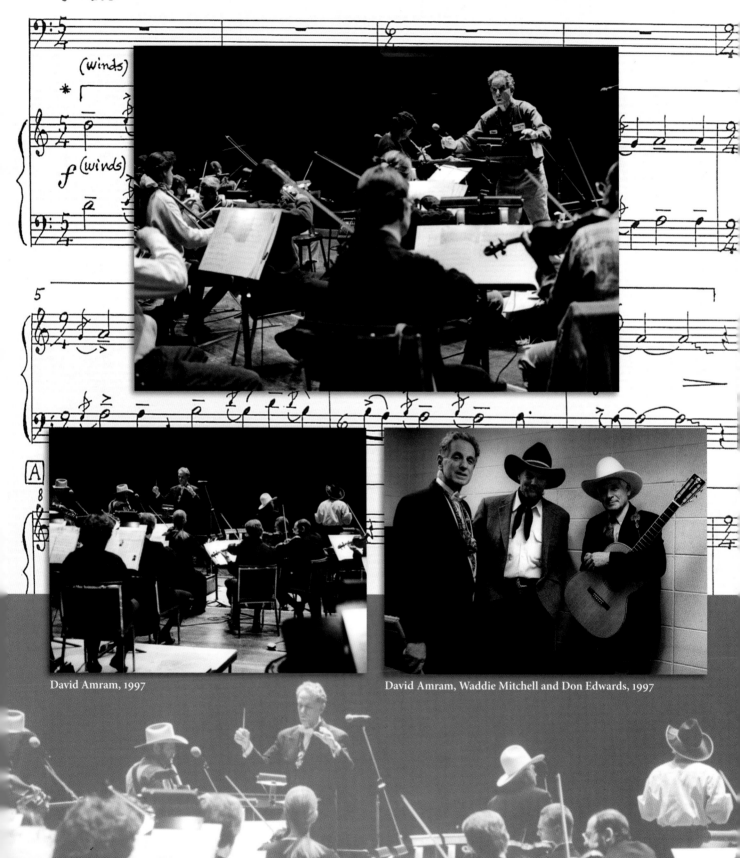

David Amram, 1997

David Amram, Waddie Mitchell and Don Edwards, 1997

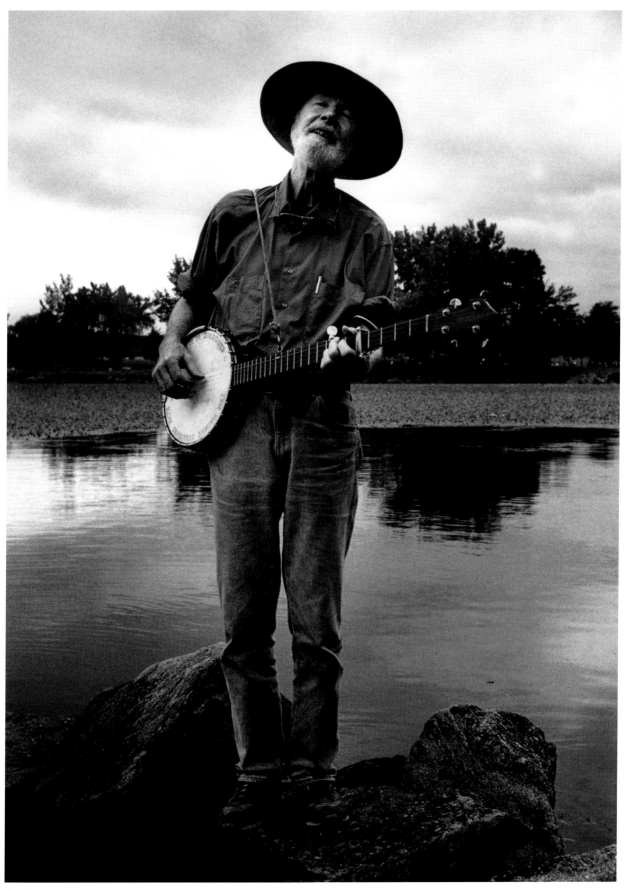

Pete Seeger, 1995

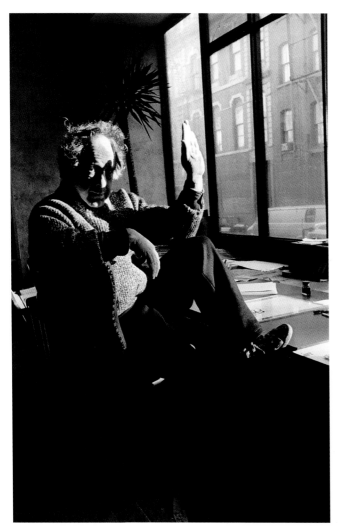

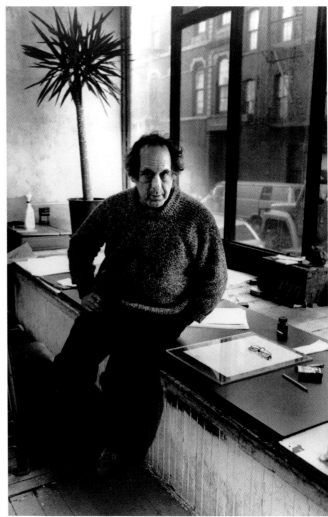

Robert Frank, 1985

BY ROBERT FRANK

BOOKS:

The Americans (1958)
The Lines of My Hand (1972, 1989)

FILMS:

Pull My Daisy (1959)
The Sin of Jesus (1961)
OK End Here (1963)
Me and My Brother (1964)
Conversation in Vermont (1969)
Life-Raft-Earth (1969)
About Me: A Musical (1971)
Cocksucker Blues (1972)
Keep Busy (1975)
Life Dances On... (1979)
Energy and How to Get It (1981)
This Song for Jack (1983)
Candy Mountain (1986)
Hunter (1990)

ONE HOUR

Robert Frank

Robert Frank
NYC Oct. 4. 92

HANUMAN BOOKS
Madras & New York
1992

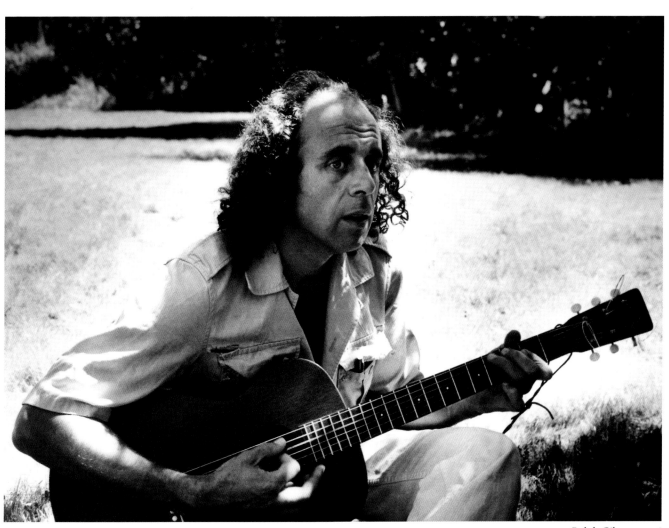

Ralph Gibson, 1976

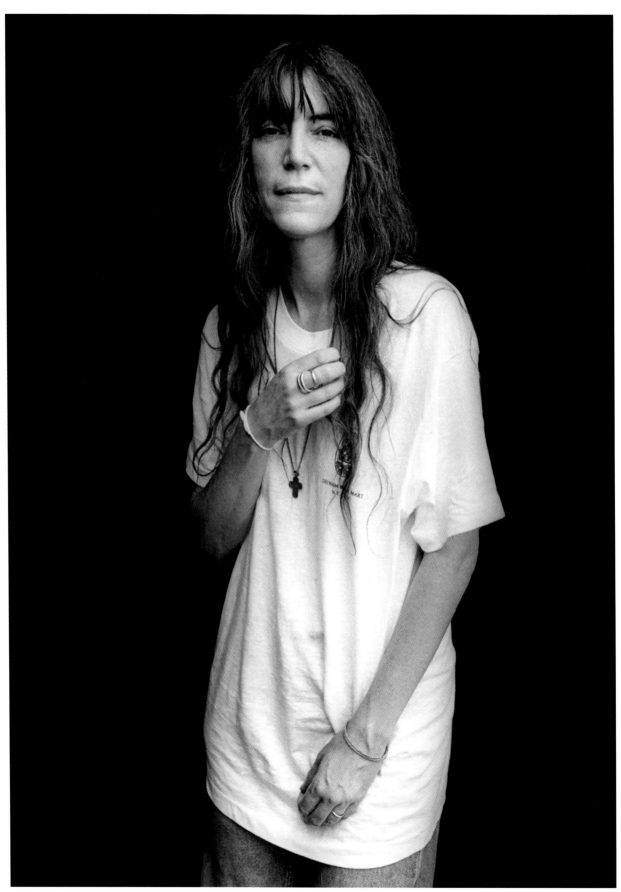

Patti Smith, 1995

Frances Steloff, Lawrence Durrell
and Ted Joans, 1986

THE
POET
EXPOSED

Portraits by Christopher Felver

Prologue by Gary Snyder
Foreword by Robert Creeley
Afterword by William E. Parker

The Gotham Book Mart

cordially invite you to preview an
exhibition of photographs from

□

THE POET EXPOSED

by Christopher Felver

□

GOTHAM BOOK MART GALLERY
41 WEST 47TH STREET, NYC

TELEPHONE: 212-719-4448

□

Reception: March 2, 5 to 7
The exhibition is on view M
10 AM to 6 PM March 2 –

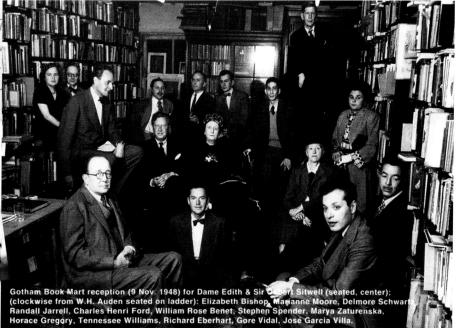

Gotham Book Mart reception (9 Nov. 1948) for Dame Edith & Sir Osbert Sitwell (seated, center);
(clockwise from W.H. Auden seated on ladder): Elizabeth Bishop, Marianne Moore, Delmore Schwartz,
Randall Jarrell, Charles Henri Ford, William Rose Benet, Stephen Spender, Marya Zaturenska,
Horace Gregory, Tennessee Williams, Richard Eberhart, Gore Vidal, José Garcia Villa.

I don't know if I can bear all this
West Coast energy in old New York....
SK

What's This Cat's Story?

KRIM

What's This Cat's Story?

the best of
SEYMOUR KRIM

Plus an excerpt from his
unpublished prose poem
CHAOS

with a foreword by JAMES WOLCOTT

PARAGON
HOUSE

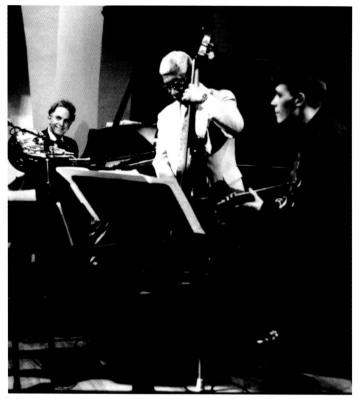

The David Amram Trio, 1998

Stanley Twardowicz and Lillian Dodson, 1984

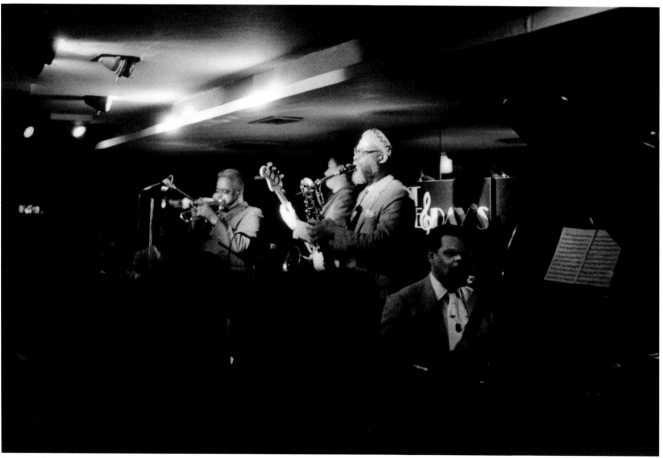

Dizzy Gillespie, 1984

Larry Rivers and Kenneth Koch, 1995

Ed Keinholz, 1989

Larry Rivers' studio, 1984

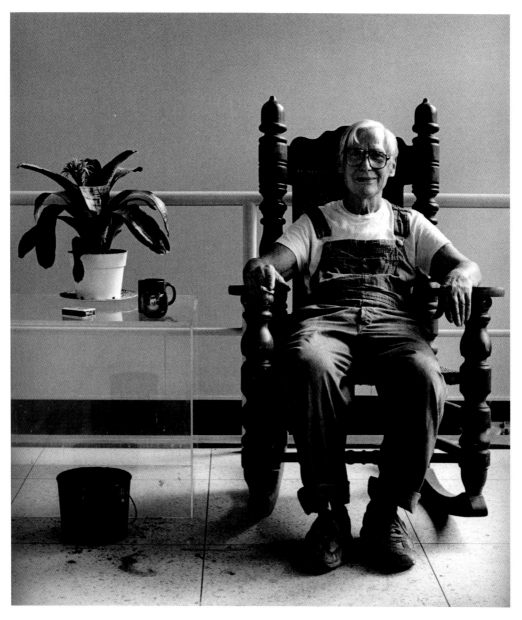

Willem de Kooning, 1984 Elaine de Kooning, 1985 Robert Rauschenberg, 1991

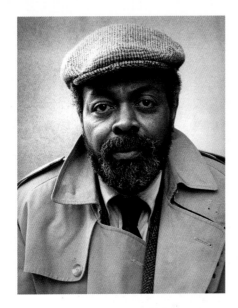

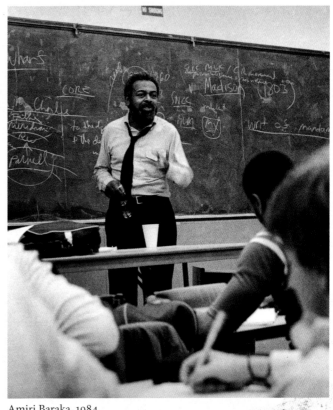

Amiri Baraka, 1984

Change is the Only Constant
Revolution the only Solution!

Amiri Baraka

GOOD! THEY THINK WE'RE AFRAID

HERE COME THE LEVELLERS
Lyrics of the Fug song

Sir Kenneth Newman, the Commissioner of Police for metropolitan London, who commands a force of 27,000, said he had intelligence reports that anarchists & Trotskyites had fomented the series of riots that has plagued Britain since violence erupted in an inner city area of Birmingham called Handsworth on Sept. 9.

NY Times, Oct. 8, 1985

"The anarchists and Trotskyists
Are out fomenting riots"
Sounds a little silly
But the stupid Brits will buy it.

Unemployment, apathy
No Future down the line
While our upper class Governors
Lead lovely lives of crime.

Some Kill with plastic bullets
Some with a plastic pen
Who's fooled by plastic music
Won't get fooled again!

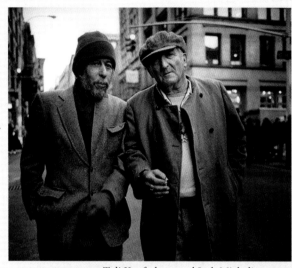

Tuli Kupferberg and Jack Micheline, 1997

& here come the Levellers
The Levellers, True Lev'lers
They dance on Greenham Common
With the Shelley Circling Revilers.

And I see Gen'ral Ludd
Laughing through the fire
While Ellie, Marx & Marley
Mix mem'ry & desire.

& here come the Lev'lers
The Lev'lers, the Lev'lers
They're plotting in the Common
With the crazy Yippie revilers.
And I see Gen'ral Ludd
He's dancing thru that fire
While Twiggy Marx & Marley
Mix politics & desire.

And here come the Lev'lers
The Dev'lers, The Revelers
To claim The urban wilderness
Before desire tire.

And here come the Levellers
True Levellers, those Revelers
to seed the heart of darkness
Before desire expires.

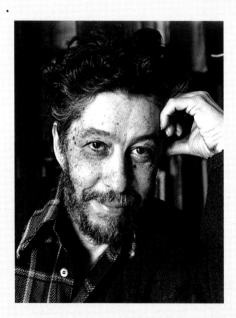

Tuli Kupferberg

Yes, I talk outloud to myself, whilst Photographers such as Weegee, Fred McDarrah, Bert Stern, Jerry Stoll, Hugh Bell, Ira Nowinski, André Lewis, Nico Van der Stam, Marion Kalter, Marc Riboud, William Klein, and countless hip and unhip paparazzis And you Chris Felver the nicest of them all because you do give copies, after promising!)

am
dyo

Ted Joans, 1984

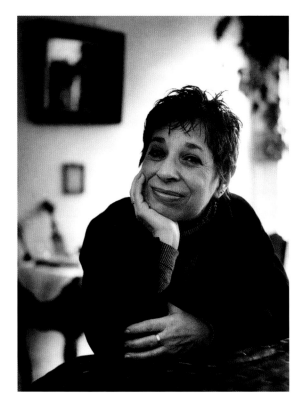

Yo, Spring!
We need weather, Baby
We need tulips, lilacs
dandelions in the grass
and your sweet Ass!

Hettie Jones, 1994

Satori

Shoppers sometimes smile
as they pass the store called GAP

but they seethe
like one of my poems

They speed along
 like the river near Jacob's Cave
when I was a kid
 w/ my parents.

And what is the Satori
I first heard about from the Beats?

I don't know
but I can hear its peaceful blissful breathing

Edward Sanders

The Fugs, 1995

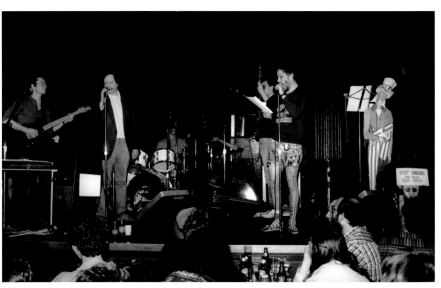

The Fugs, 1984

UNBUILDING
A BUILDING
STONE
BY STONE,
GOING
BACKWARDS,
EVERYONE I KNOW
IS JUST LIKE ME,
THEY'RE STUPID.

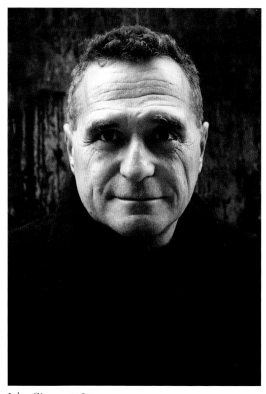

John Giorno, 1985

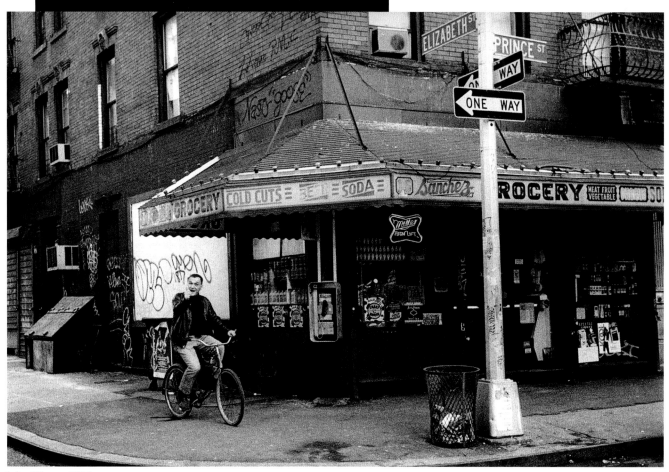

John Giorno, 1993

Janine Pommy Vega and John Sinclair, 2000

Visit me as you would a holy country
where the good crops grow as promised
and the separate thrones resemble
the waves of the sea.

We are the sparkling belt of Orion
We are the orange moon
 and the result of the sun's light
The eyes hold the jewels
The thighs the lotus
 Yes I'm beginning to see Design
 Andy Clausen

Andy Clausen, 2000

The restitution
 of the oculus
is the foundation
 of theology

Edward Sanders
by the creek
Woodstock, N.Y.

Ed Sanders, 1995

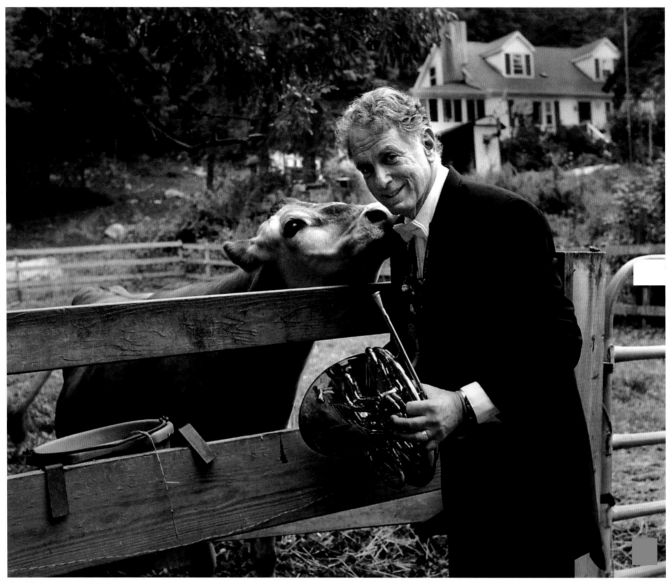

David Amram, 1999

David Amram, 1996

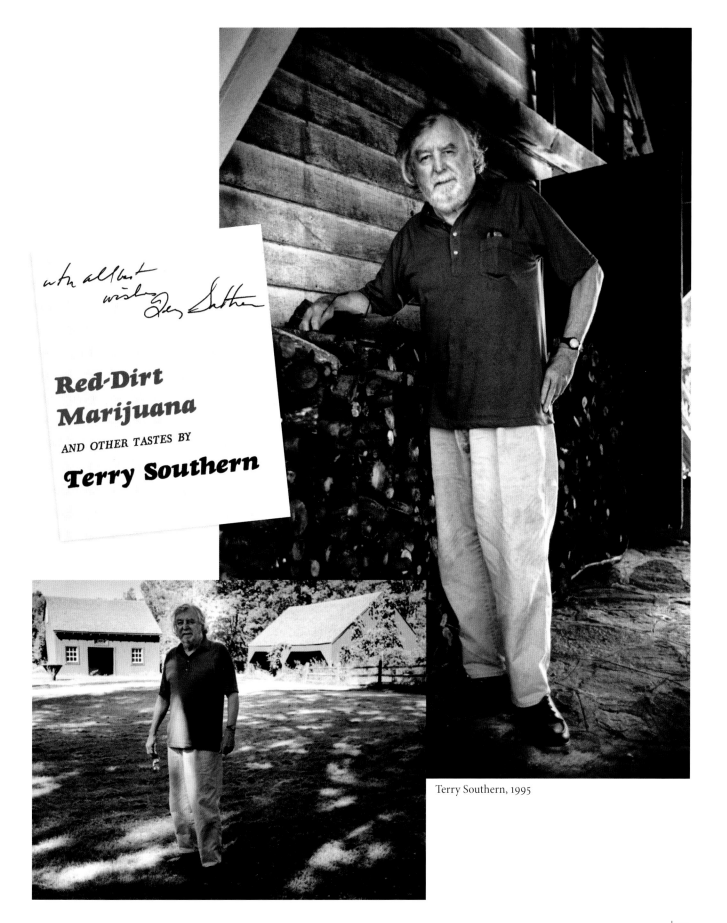

with all best wishes Terry Southern

Red-Dirt Marijuana

AND OTHER TASTES BY

Terry Southern

Terry Southern, 1995

beatgeneration

Glory Days in Greenwich Village

This Copy is for my Good Friend and
Fellow Beatnik, Photographer
Extraordinaire, Chris Felver
With Best Wishes for a Long and
Happy Career December 18, 1997

Fred W. McDarrah

FRED W. McDARRAH
GLORIA S. McDARRAH

Gloria S. McDarrah

Jonas Mekas, 1994

Fred McDarrah, 1994

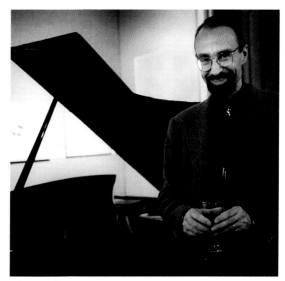

John Tytell, 1994

Ann Charters, 1982

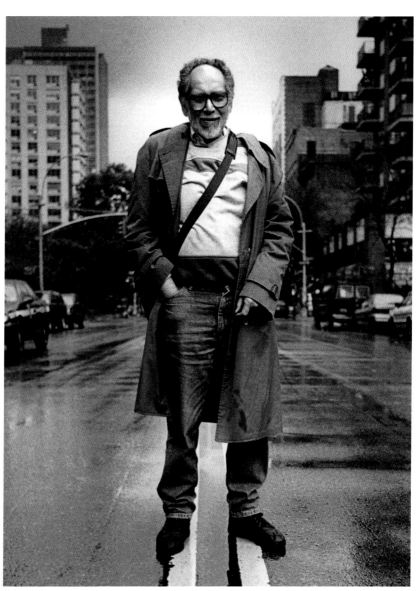

Al Aronowitz, 1994

Rudy Burckhardt, 1985

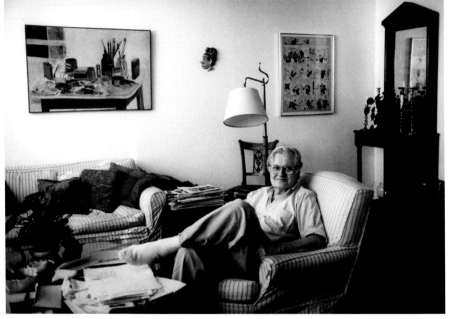

John Ashbery, 1995

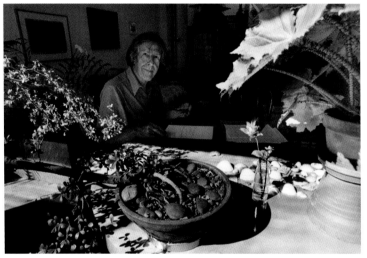

John Cage, 1985

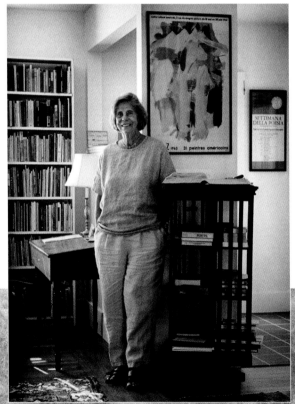

Barbara Guest, 1995

FRANK O'HARA
1926 — 1966

"Grace to be born and live
as variously as possible."

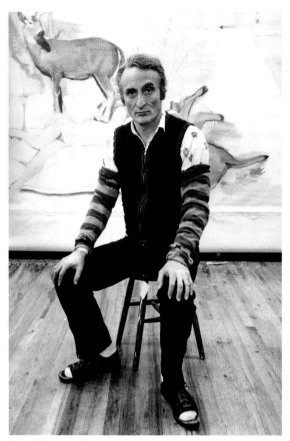

Larry Rivers, 1984

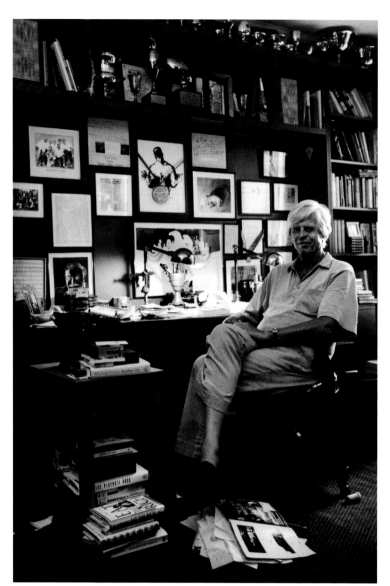

George Plimpton, 1998

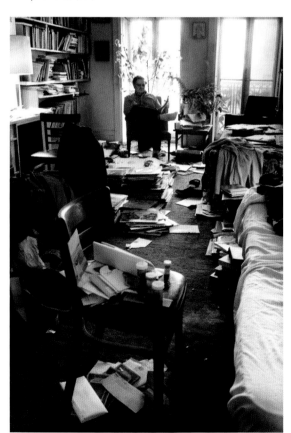

James Schuyler, 1985

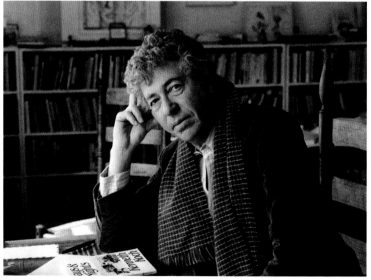

Kenneth Koch, 1984

I stayed in NYC for over a year until *The Poet Exposed* was published and then the confinement of the city finally put me back on the road. I was in LA when George Hermes returned from the American Academy in Rome. He encouraged me to apply for a fellowship. Since I had been working with painters, sculptors and writers, the European scene sounded enticing. A number of artists I knew were going to Documenta in Kassel, Germany and I decided to tag along. This was the beginning of my transition into working around Europe. One scene soon led to another, and I was granted a visiting artist residency at the American Academy in Rome. The city fit my mood – exhibitions were offered to me at several venues and always there were inroads and connections to the Beats.

A chance meeting with Ben Gazzara, who happened to be in Rome, renewed my interest in filmmaking. Frank O'Hara's friend, artist Mario Schifano, encouraged me by setting me up with a troupe, and we immediately started filming *Taken by the Romans*, a documentary featuring 23 Roman artists, narrated by Giovanni Carrandente, a curator of the Venice Bienale. My poetic sensibility was stirred while in Rome, and the next few years were spent traveling Europe, making portraits and another documentary, *In Celebration of Sculpture*, with British sculptor Tony Cragg.

At Shakespeare & Co. in Paris, Lawrence's long-time friend George Whitman always offered welcome lodging and camaraderie to "angels in disguise," with Ted Joans very often taking center stage during George's ritual Sunday afternoon teas. In the fall of 1993, the Pompidou Center hosted my exhibition *Regards Sur La Beat Generation*, a collection of my photographs and ephemera. This triggered my work back in the direction of the Beats. The Pompidou invited Robert Creeley to read on opening night, after which I screened my documentary, *West Coast: Beat & Beyond*. The installation was up for over a month, and during that time over 30,000 visitors from all over the world viewed the exhibition. I stayed in Paris until the exhibit closed, and by then knew first hand that there was an international audience hungry for the Beat perspective. It didn't take long for an American retrospective to come about once I returned to the States.

In 1994, New York University, in the heart of Greenwich Village staged a group show titled *Beat Art: Visual Works By and About the Beat Generation*. My environmental portraits and grid, *The Group Surrounding Allen Ginsberg*, blended with other historical photographs documenting the visual history of these innovative artists. Drawings, paintings, and sculptures by these seminal Beat writers focused still another lens on the

dimensions of Beat sensibility. The exhibition became a media feast of symposiums and poetry readings, stoking the city's cultural fire. The outsider had gone inside, and this was the beginning of academic recognition for the achievements of the Beats.

The dedication of the Allen Ginsberg Library at Naropa was celebrated later that summer, and involved everyone in the Beat canon. Tents were set up on the grounds for workshops and panel discussions. Every night the local high school auditorium was taken over with powerful performances. Cecil Taylor, Philip Glass, Amiri Baraka, Joanne Kyger, Michael McClure, Ray Manzarek, Ed Sanders, David Amram, and of course Gregory Corso were among the all-star cast. This was another media event, with visiting international scholars and historians in attendance, just the way Allen loved it. Most of my time at Naropa was spent filming Ferlinghetti's appearances on television/radio stations and bookstores for my documentary, *The Coney Island of Lawrence Ferlinghetti*. Whitney Museum curator Lisa Phillips attended the non-stop performances, and inspired by Robert Creeley's book of essays, she helped set the stage for a Whitney retrospective in New York.

The Beats' acceptance into mainstream culture occurred in 1995 when the Whitney Museum of American Art presented *Beat Culture and the New America, 1950-1965*. Time had defined the movement as a bonafide American phenomena. This was the recognition that all artists need, and it was happening "now," while most everyone was still strong. Across town, Ginsberg was teaching at Brooklyn College while his and Kerouac's "outsider" books had become required reading at colleges throughout the country. Seminars on the Beats became standard university fare.

THUS DID I, PONDERING OUR MYRIAD INSCRUTABLE DESTINIES HIDDEN IN TIME.... *lawrenceferlinghetti*

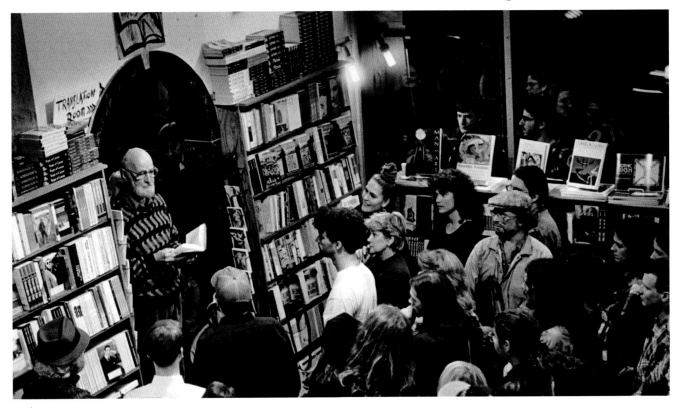

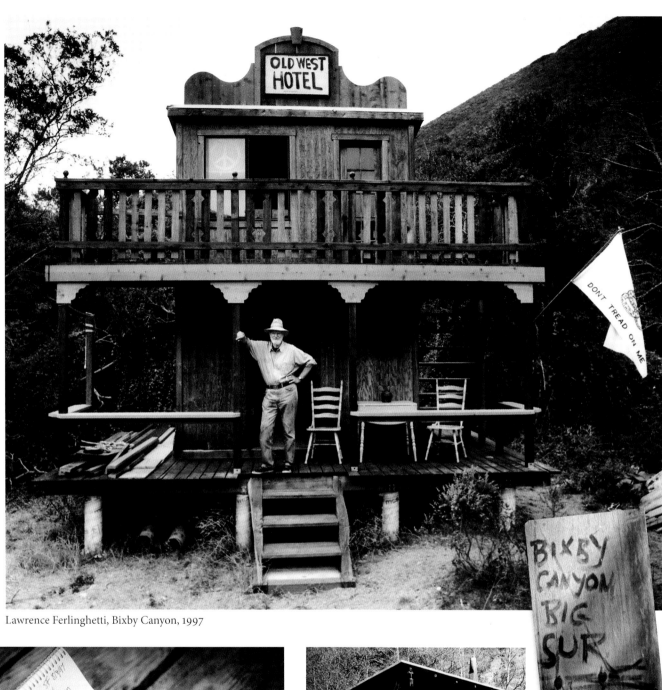

Lawrence Ferlinghetti, Bixby Canyon, 1997

Allen Ginsberg, 1990

Patti Smith, 1996

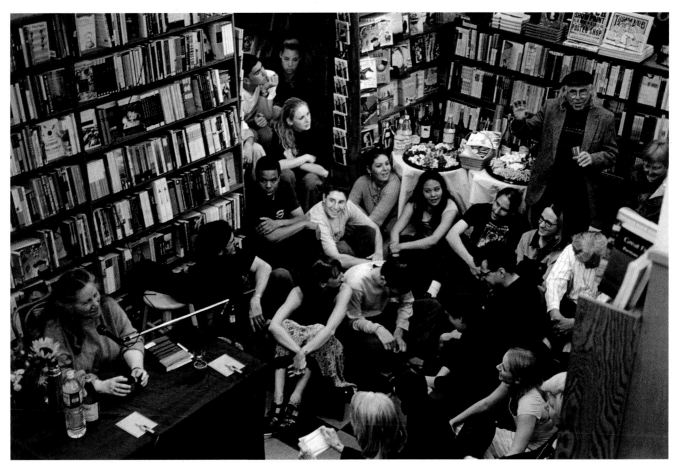

Diane di Prima, 1998

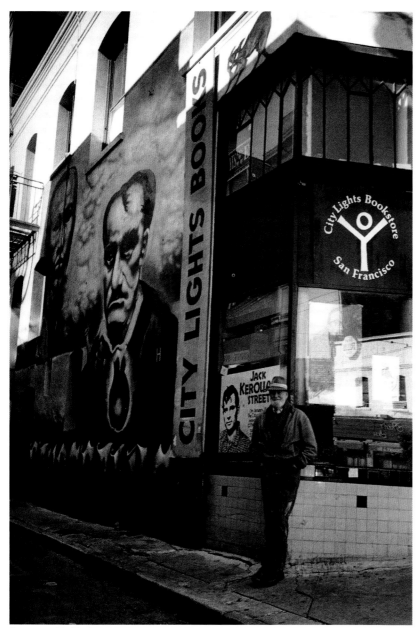

Lawrence Ferlinghetti, 1994

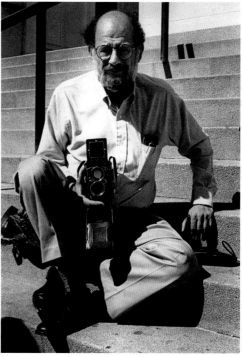

Allen Ginsberg, 1984

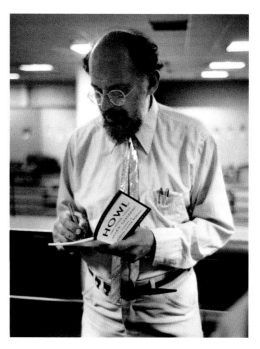

Allen Ginsberg — City Lights

The Face of a Poor Woman

I have the face of a poor woman
bitter, vindictive

Though somewhat enobled
by acts of deprivation from a

man, money, clothes, house.
All these we had

but taken away by time.
Now I have only dreams and ambition

to acquire what's given at birth.
A clear day, steady gait

and mail at the post-office
plus time to account for my face.

John Wieners

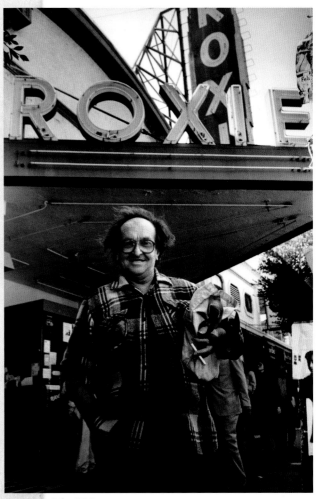

John Weiners, 1990

John Weiners, 1985

Clark Coolidge and David Meltzer, 1993

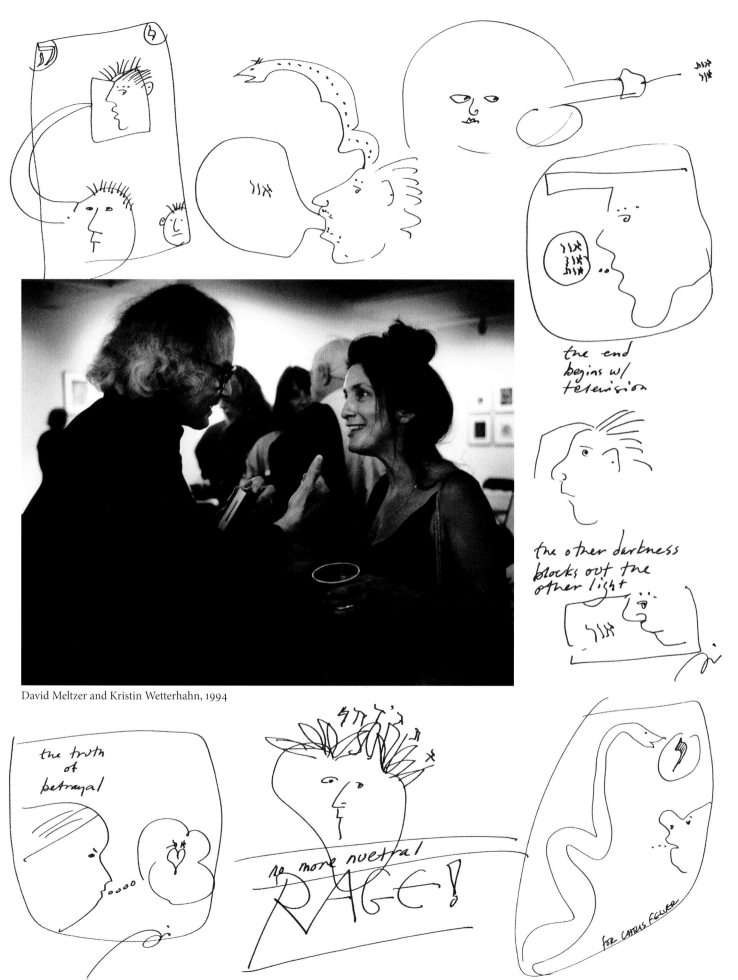

David Meltzer and Kristin Wetterhahn, 1994

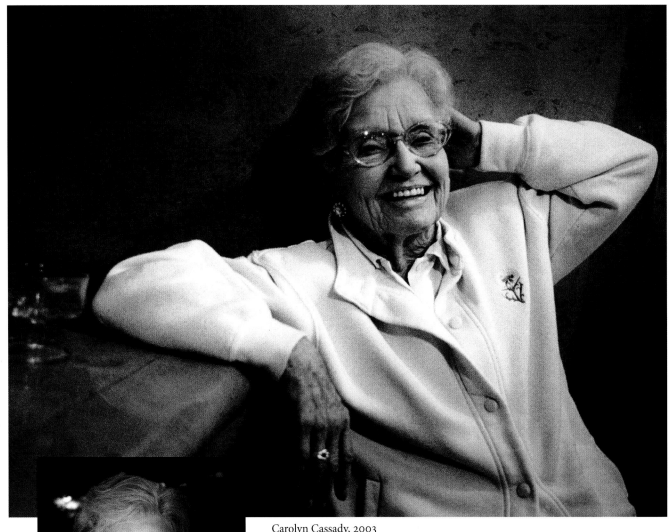

Carolyn Cassady, 2003

NEAL CASSADY ESTATE

TO KEEP ALIVE THE BEAT INSPIRATION OF
THE MAN AND THE MYTH

JAMICASSADY@YAHOO.COM

Jami, Carolyn, and John Cassady, 1998

The mind lets
thinkers win,
in the mind.

Bobbie Louise Hawkins

Alice Notley, 1985

Eileen Kaufman, 1982

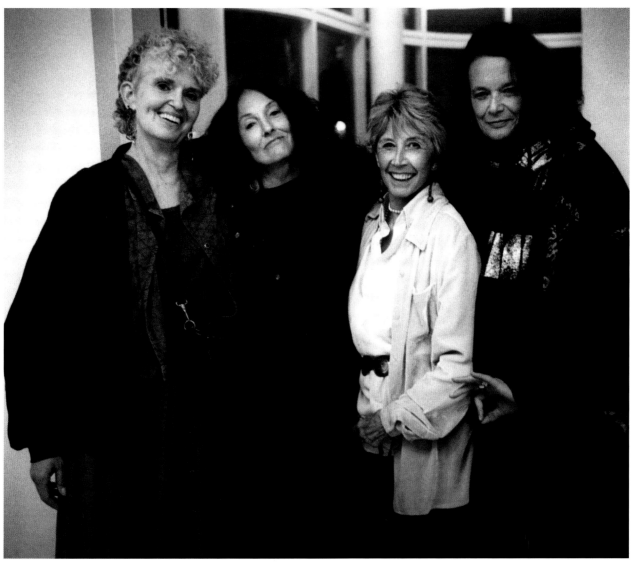

Janine Pommy Vega, Bobbie Louise Hawkins, Joanna McClure and Anne Waldman, 1996

The Question of Self-Publishing

For 25 years William Blake
 kept the copper plates for
 the <u>Songs of Innocence</u>

to print a copy or two on a need
& then he hand-painted the colors
 with Catherine's help

Walt Whitman helped set & print
 his own <u>Leaves of Grass</u>
 in the Brooklyn Vastness

Woody Guthrie
a mimeographed edition of his songs in '39

& Ginsberg mimeo'd some "Howl"s
 in '55
 & So it goes
 & goes so well

 Edward Sanders

Ed Sanders, 1985

Tom Clark, Ed Sanders and Duncan McNaughton, 1985

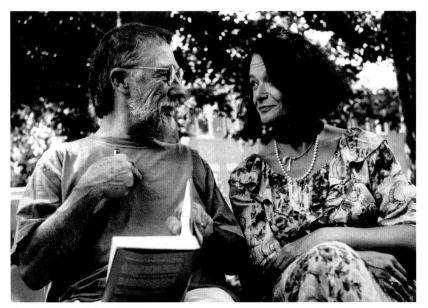

Gary Snyder and Anne Waldman, 1994

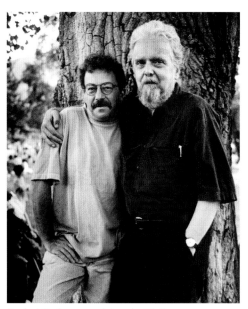

Andrei Codrescu and Anselm Hollo, 1994

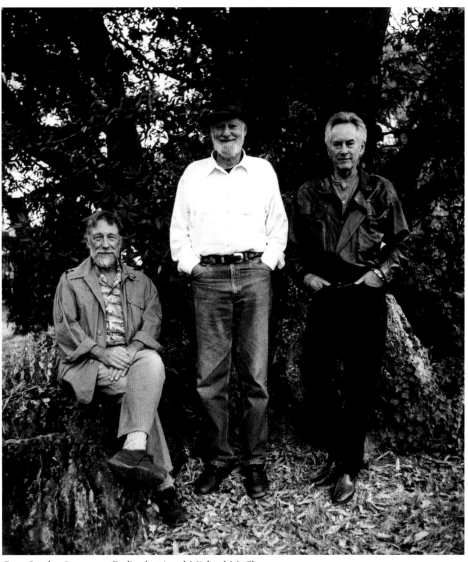

Gary Snyder, Lawrence Ferlinghetti and Michael McClure, 1995

Robert Hass and Michael McClure, 1996

THREE HAIKU

What voice,
what song, spider,
in the autumn wind?
—Bashō

*

The spring sea rising
and falling, rising
and falling all day.
—Buson

*

Even with insects—
some can sing,
some can't.
—Issa

—translated by Robert Hass

U.S. POET LAUREATE ROBERT HASS PRESENTS

WATERSHED
Environmental Poetry Festival
SATURDAY, MAY 17 • 10AM TO 6PM • FREE
GOLDEN GATE PARK AT THE BANDSHELL

FEATURING

MICHAEL McCLURE • ROBERT HASS • JOANNE KYGER • JOHN TRUDELL
AL YOUNG • MARY NORBERT KÖRTE with pianist ED REINHART • GENNY LIM • JIM DODGE
JERRY MARTIEN • BRENDA HILLMAN • SUSAN GRIFFIN • ELLERY AKERS • MARCIA FALK
MALCOLM MARGOLIN presents GLORIA ARMSTRONG, POMO POET & SAGE LAPENA, WINTU POET
VIOLIST MIMI DYE and AUTHOR JOAN OHANNESON perform HILDEGARD OF BINGEN
CELTIC MUSIC BY ALASDAIR FRASER & SKYEDANCE • TUVAN THROAT SINGER KOONGAR OOL-ONDAR
JUDY GOLDHAFT'S WATERWEB • ARTHUR OKAMURA'S WATERSHED STAGE • NATURALIST CLAIRE PEASLEE
ENVIRONMENTALISTS PETER BERG on URBAN ECOLOGY & KAREN PICKETT on HEADWATERS
WATERSHED KEEPERS KRISTINA WUSLICH & JAMES AVANT • URBAN FORESTER GUIDO CIARDI

FROM NOON 'TIL 5PM: HANDS ON NATURE ART ACTIVITIES,
RIVER VILLAGE LITERARY & ENVIRONMENTAL EXHIBITS, AND CHILDREN'S POETRY TENT
AND FROM 4:30PM 'TIL 6PM: ECOOPEN POETRY READINGS FOR ADULTS FROM THE MAINSTAGE
SECURE VALET BIKE PARKING PROVIDED BY SAN FRANCISCO BIKE COALITION

SPECIAL LIVE RADIO BROADCAST ON SEDGE THOMSON'S
WEST COAST LIVE • 10AM • KALW/FM 91.7

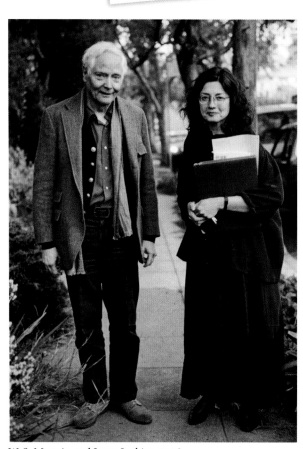

W. S. Merwin and Joyce Jenkins, 1998

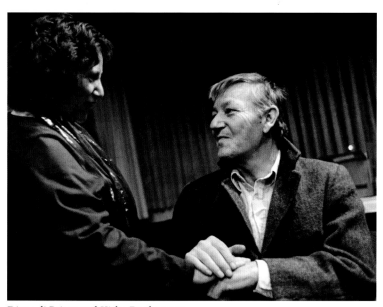
Diane di Prima and Kirby Doyle, 1990

That god creates
is of no importance
to those who
previously inhabitate.

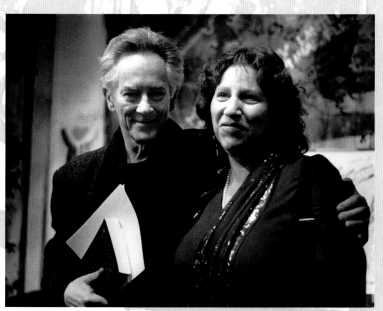
Michael McClure and Diane di Prima, 1990

DOUBLE Lion DHARMA

Non-Physics of Nothingness
TURNED INSIDE OUT LIKE A PROTEIN
PRESENCE ARISING FROM PRESENCE
MUTUALLY ARISING ARISING MUTUALLY
INTERPENETRATION of BLUE WILD FLOWERS

RED ROARS
STARVING BARE BONED MOTHERS & BABIES
Thoreau's thoughts about pond weeds
Uncountable Worlds at the Tip of an Eyelash
Coal, Steel, Cinnamon, Melted Together
INTO NADA
- all substance -
MOSS DREAMING OF VIOLETS
YELLOW VIOLETS WITH DARK CENTERS
IN PLAYGROUNDS AND BATTLEFIELDS
ORDINARY AS CHINCHILLA FUR ORDINARY AS GRASSHOPPERS
carved from the sound of the stream

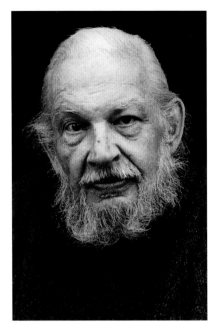

We open a door.
There is no road.
We take it.

--Philomene Long

Go Naked.
Take nothing.

--John Thomas

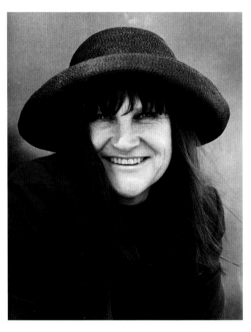

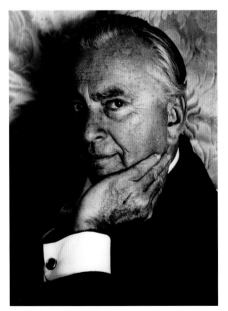

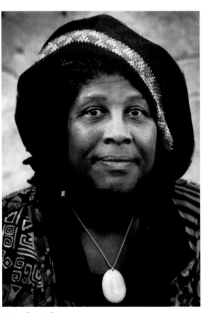

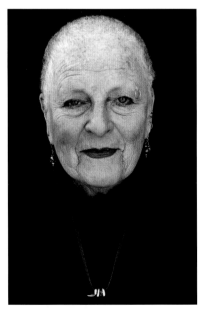

Gore Vidal, 1990 Wanda Coleman, 2000 Rachel Rosenthal, 1999

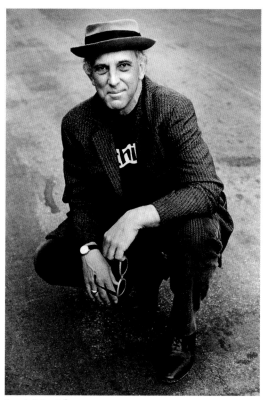

Guess I'm just
a lucky rebel,
leaning against the take-out counter,
watching the cool moon rise
above the car wash roof.

Lewis MacAdams

Lewis MacAdams, 2000

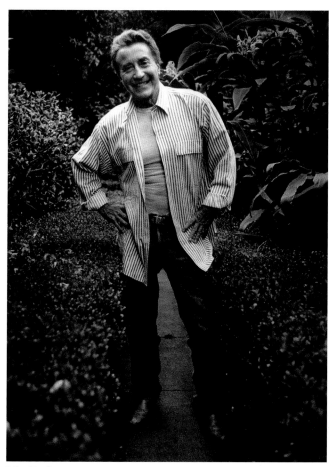

John Rechy, 1995

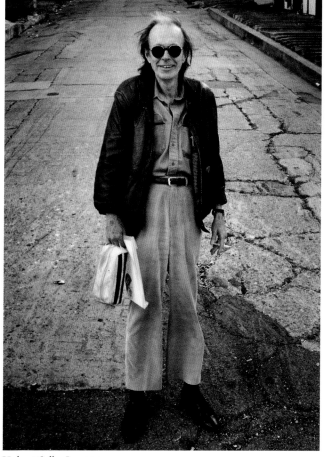

Hubert Selby Jr., 1995

Regards sur la Beat Generation

photographies de Christopher Felver

Les Revues Parlées
Littérature

janvier 1994

Centre Georges Pompidou

mercredi 5 18h	**Inauguration de l'exposition de Christopher Felver :** La « Beat Generation », photographies, poèmes, vidéo Petit foyer du 5 au 24 janvier 1994
19h	**Projection de la vidéo de Christopher Felver :** « West Coast: Beat and Beyond » En présence de l'auteur Suivie d'un débat sur la « Beat Generation » Avec François Buot, Alexis Bernier, Brice Matthieussent et Vincent Ostria Présenté par Gérard-Georges Lemaire

Poésie américaine

Robert Creeley, Photographie : Christopher Felver

Centre Georges Pompidou

Installation *Regards sur la Beat Generation*, 1994

Robert Creeley, 1994

George Whitman, 1990

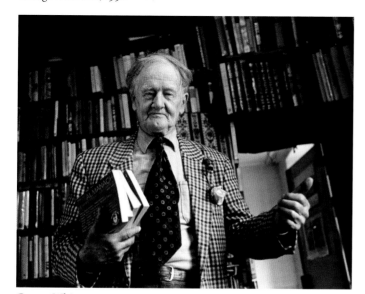

George Whitman, 1994

George Whitman and Sylvia Beach Whitman, 2004

BEAT

the OPENING preview

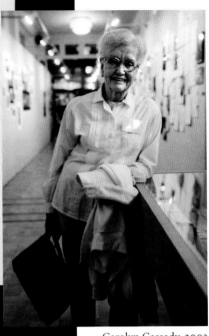

Carolyn Cassady, 2003

Allen Ginsberg by Elaine DeKooning and Jack Kerouac's paint box

Gregory Corso, 1994

THE BEAT GENERATION

LEGACY AND CELEBRATION
MAY 17 - MAY 22, 1994

HONORARY CO-CHAIRS:
Allen Ginsberg
Ann Charters

WITH
David Amram
Gordon Ball
Douglas Brinkley
Carolyn Cassady
Sam Charters
Gregory Corso
Art D'Lugoff
Edward de Grazia
Jean Erdman
Lawrence Ferlinghetti
Raymond Foye
Joyce Johnson
Hettie Jones
Jan Kerouac
Ken Kesey
Joanne Kyger
Robert LaVigne
Ray Manzarek
Fred W. McDarrah
Michael McClure
Jack Micheline
Gerald Nicosia
Barney Rosset
Ed Sanders
Michael Schumacher
David Stanford
Cecil Taylor
Hunter S. Thompson
John Tytell
Anne Waldman
Regina Weinreich

and others

Hal Chase, Jack Kerouac, Allen Ginsberg, William Burroughs, Riverside Drive, New York, 1944.

Join the reunion where it all began — Greenwich Village in New York City. NYU's School of Education invites you to celebrate the Beat Movement and its impact on American art and society. Open to artists, writers, critics, university faculty members, teachers of all levels, scholars, and students of popular culture.

 NEW YORK UNIVERSITY SCHOOL OF EDUCATION

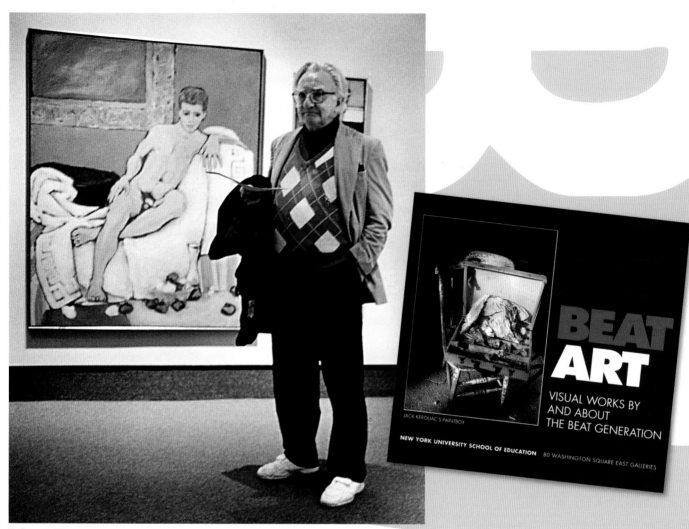

Robert LaVigne, 1994

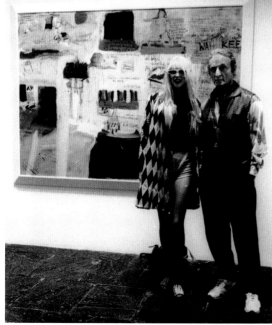

Phoebe Legere and Larry Rivers, 1996

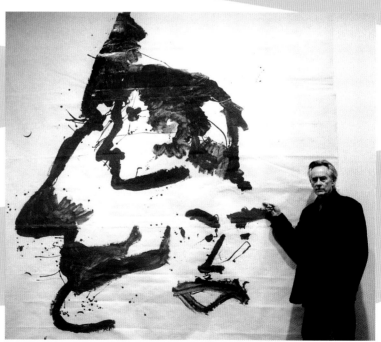

Michael McClure, 1996

Bruce Connor, 1987

Allen Ginsberg, Ray Manzarek, Bruce Connor and Michael McClure, 1996

Bruce and Jean Connor, 2000

© BRUCE CONNER

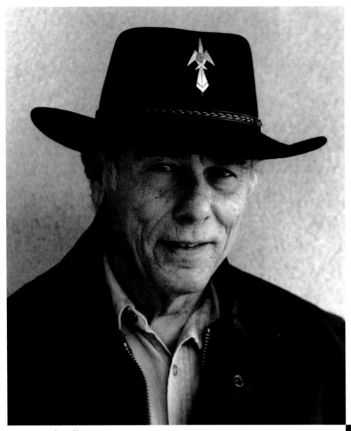

Dean Stockwell, 2006

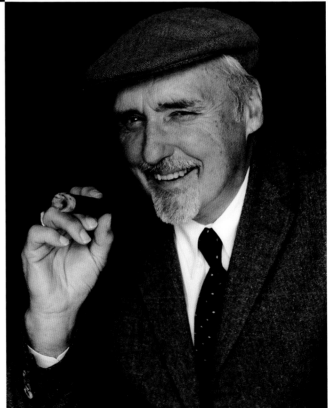

Dennis Hopper, 2000

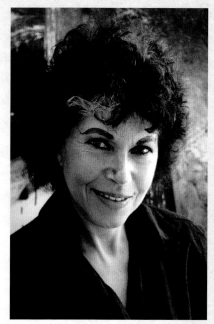

Jay DeFeo, 1986

at any other time!
— best wishes Chris and
a souvenir of the photo Session.
J. DeFeo

Joan Brown, 1986

BEAT CULTURE and the NEW AMERICA 1950-1965

Whitney Museum of American Art

George Herms, 1986

A TEASE HEAVEN
WELCOME

Wilder says :
That's the idea.

Year of The GRADITUDES

CLOCK TOWER

Monument To

UNKNOWN

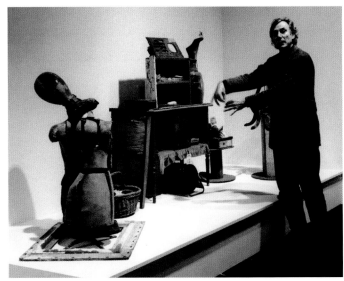

George Herms, 1995

George Herms, 2002

Lou Reed, 1997

WILLIAM S. BURROUGHS

DECEMBER 19 THROUGH JANUARY 24, 1988

TONY SHAFRAZI GALLERY

163 MERCER STREET, NEW YORK, NY 10012 212 925-8732

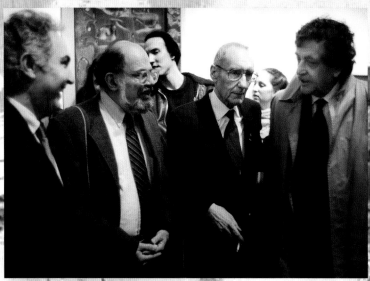

Tony Shafrazi, Allen Ginsberg, William S. Burroughs and Kurt Vonnegut, 1988

The Ocean is
wounded
The Voice of The
Ocean
WILL never
come back
never come
back
Who killed The
Whale? appel

Wounded Ocean
Wounded WAtck
deed wailing
water
deep red WAteR
The Ocean is
wounded
Like an iceberg
Rurnig with
Blood.

Karel Appel, 1990

**LOVE ME FOR THE FOOL
I AM
(the laughing angel-imbecile).
The thrill
of kissing you
is seeing me
reflected in your eyes.
We try for purity
but
still
we're glorious
blobs
of meat.
I worship you
like blood
or oil or wheat.
Our love is flawed
and swallowed
by the rush of time.
A mindless innocence,
they say,
is crime.
We dance on borrowed feet.**

—Michael McClure

Michael McClure, Amy Evans McClure and Gregory Corso, 1994

Tatum O'Neil and Gregory Corso, 1994

Gregory Corso and Harold Norse, 1994

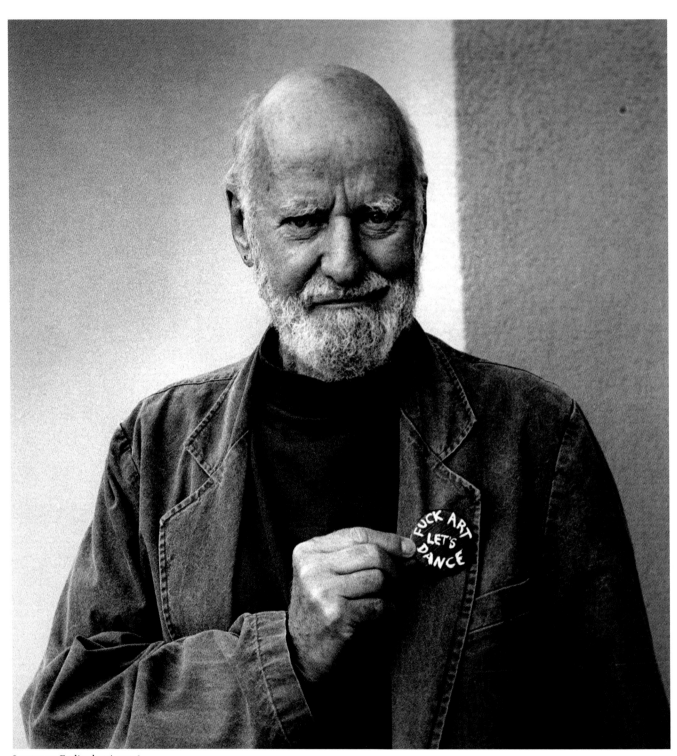

Lawrence Ferlinghetti, 1996

Lawrence Ferlinghetti at Ellis Island, 1994

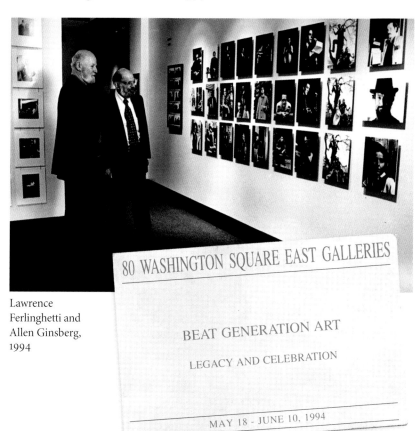

Lawrence
Ferlinghetti and
Allen Ginsberg,
1994

80 WASHINGTON SQUARE EAST GALLERIES

BEAT GENERATION ART

LEGACY AND CELEBRATION

MAY 18 - JUNE 10, 1994

Jack Micheline, 1994

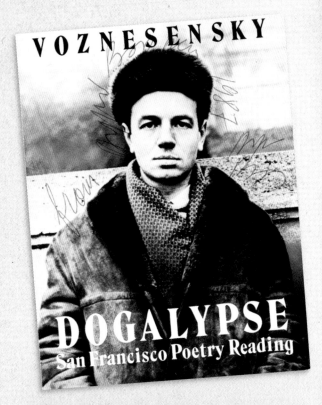

VOZNESENSKY

DOGALYPSE
San Francisco Poetry Reading

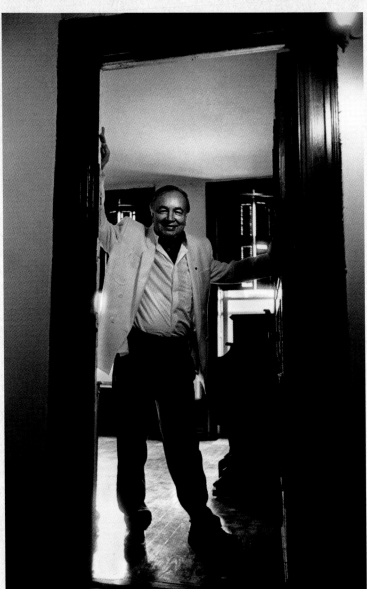

Andrei Vosnesensky, 1994

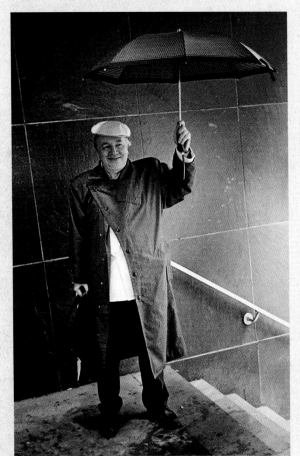

Andrei Vosnesensky, 1994

Andrei Vosnesensky and Lawrence Ferlinghetti, 1994

Countdown 10-9-8-7-1987

Nostalgia
for the present!

Andrei
Voznesensky

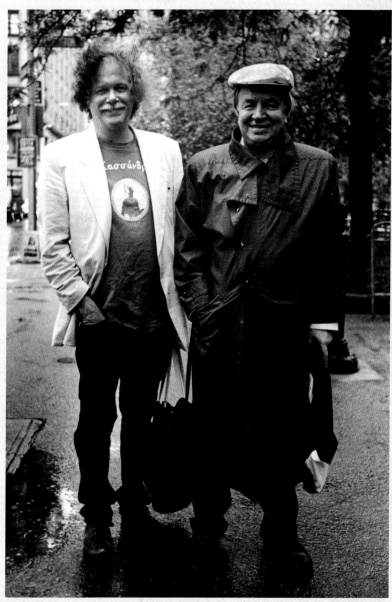

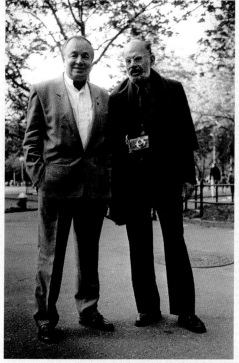

Andrei Vosnesensky and Allen Ginsberg, 1994

Ed Sanders and Andrei Vosnesensky, 1994

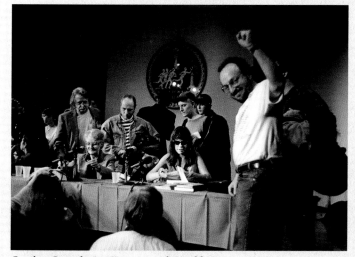

Carolyn Cassady, Jan Kerouac and Gerald Nicosia, 1994

Taylor Mead and Harold Norse, 1996

Carolyn Cassady, 1994

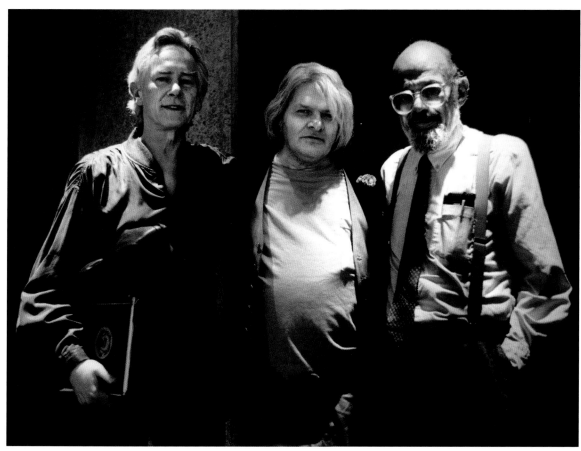

Michael McClure, Gregory Corso and Allen Ginsberg, 1995

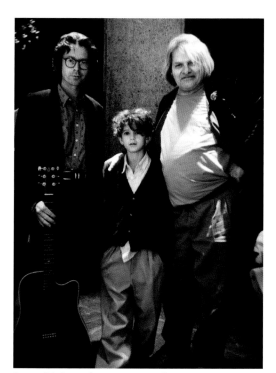

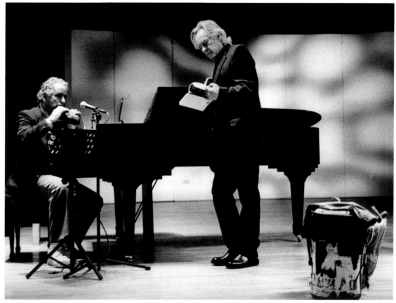

David Amram and Michael McClure, 1996

Steven Taylor, Adam Amram and Gregory Corso, 1995

Allen Ginsberg, 1994

Allen Ginsberg and Marc Ribot, 1995

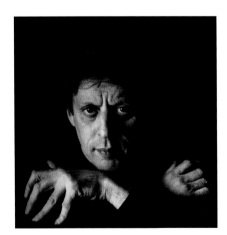

Philip Glass, 1994

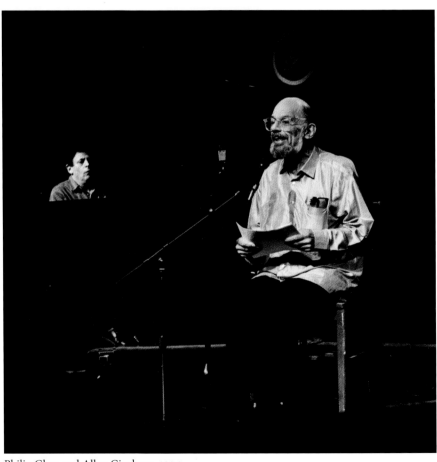

Philip Glass and Allen Ginsberg, 1994

Anne Waldman and Ed Sanders, 1994

Women whose senses I told you
be gentler to
t speech to same
in light of "cleansing" things
not the presidential "selected one's

[THINGS] SEEN

LONG LASTING

She finds a comrade. Now she beat
now she sings.

Here the
relati
center
between
death-th
other p
that th
the su
pers

On the
Strangle-this-dawn
page

Anne Waldman and Steven Taylor, 1994

Francesco Clemente and Gregory Corso, 1994

Jan Kerouac and Jack Micheline, 1994

Gary Snyder and Michael McClure, 1999

Joyce Johnson, Ted Joans and Hettie Jones, 1994

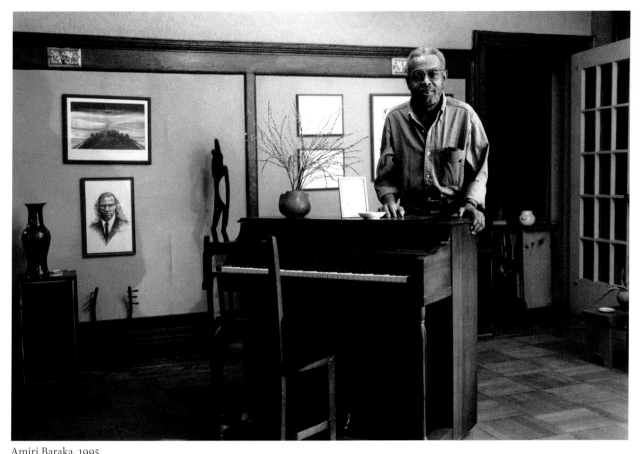

Amiri Baraka, 1995

gnathic (a)
gnathic pertaining
to the jaw
gK gnathos -
g'nathal

gnomon
an early astro-
-nomical instru-
-ment consisting
of a vertical
shaft
column -
for determining
the altitude of
the sun or the
latitude of a
position by
measuring the
the length of
its shadow
cast at noon
2 raised part
of a surfaced
that casts the
shadow —
3. geom The part
of a parallelogram
that remains
after a similar
parallelogram
has away
been taken

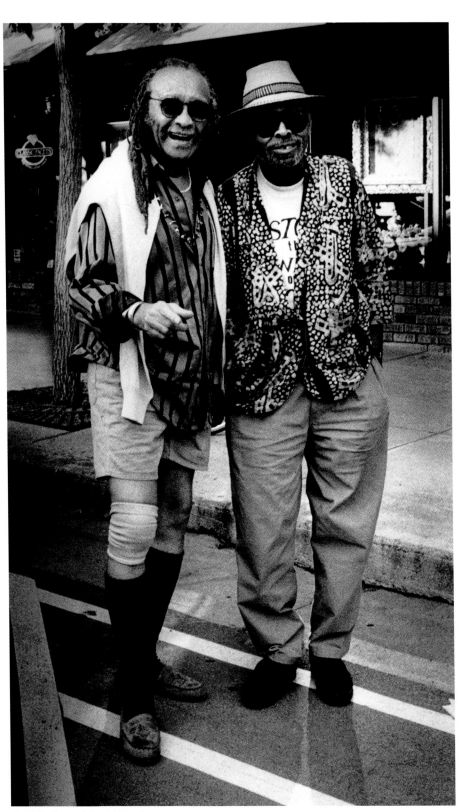

Cecil Taylor and Amiri Baraka, 1994

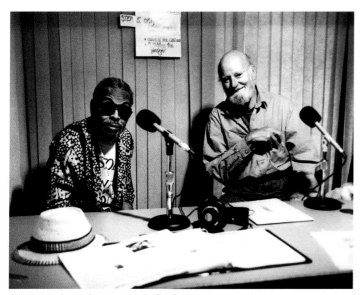

Amiri Baraka and Lawrence Ferlinghetti, 1994

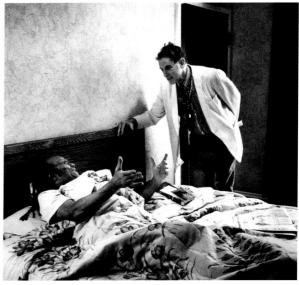

Cecil Taylor and David Amram, 1994

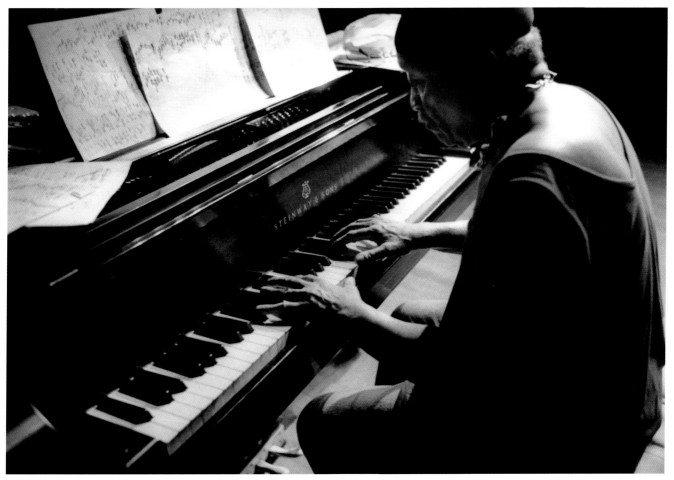

Cecil Taylor, 2001

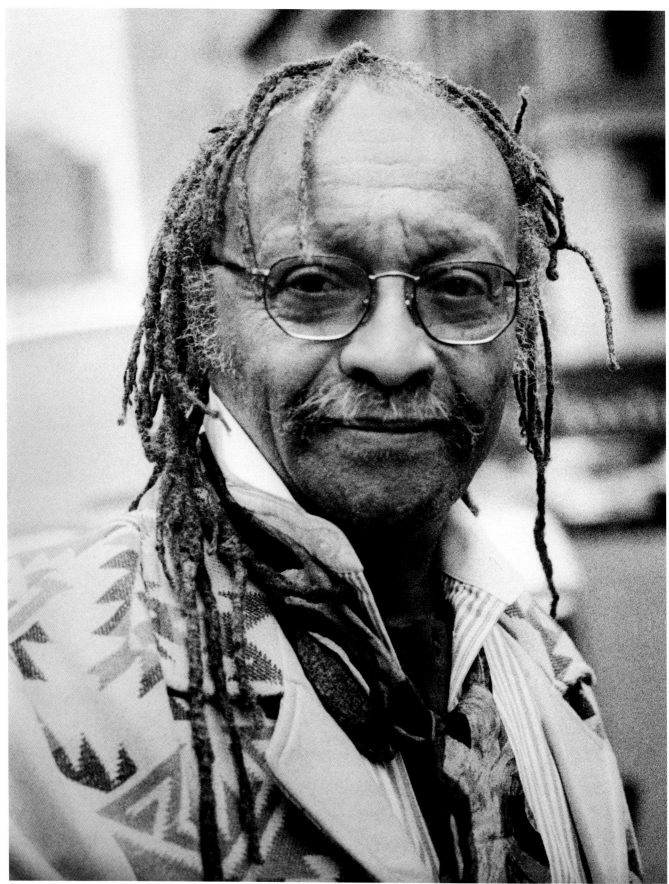

Cecil Taylor, 1998

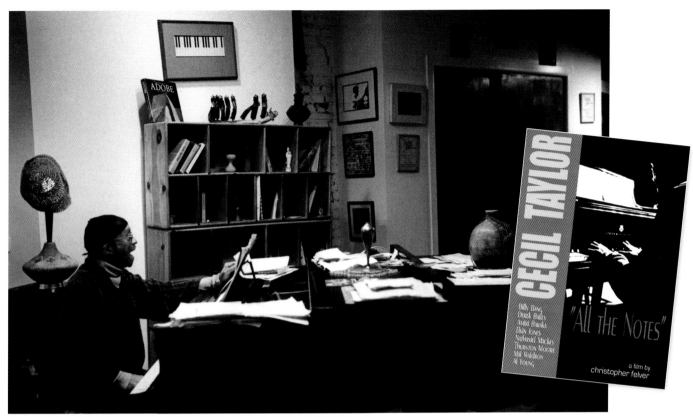

Cecil Taylor, 2002

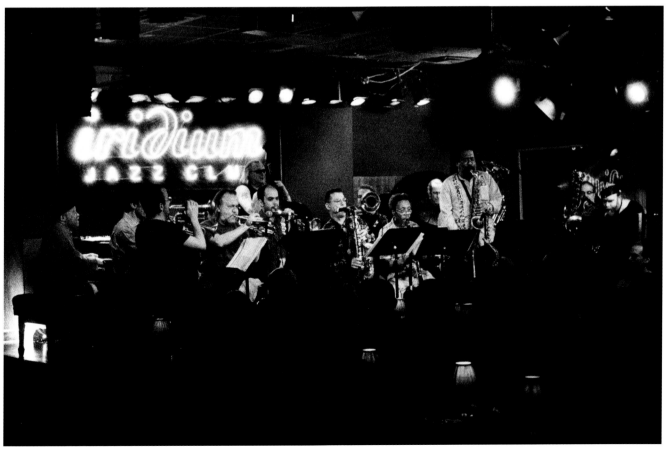

Orchestra Humane, 2004

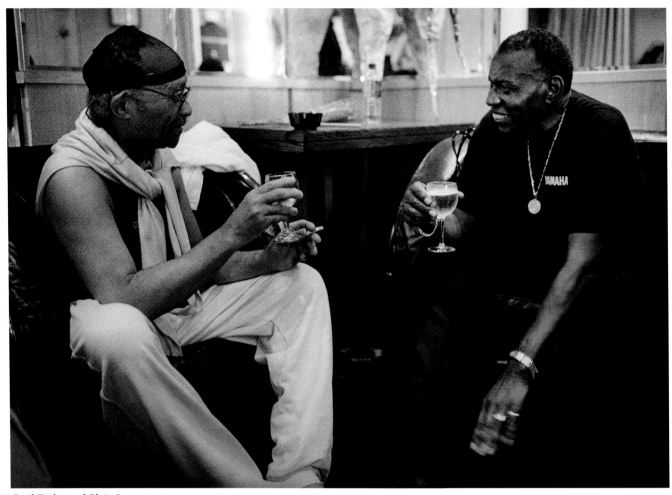

Cecil Taylor and Elvin Jones, 2000

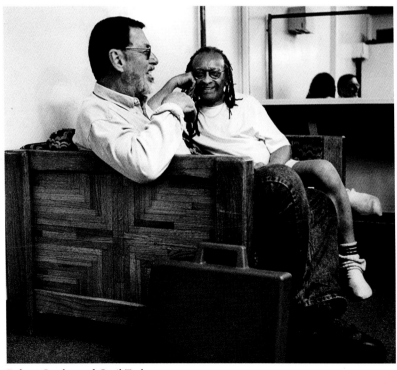

Robert Creeley and Cecil Taylor, 1994

Steve Lacy, 1999

David Amram and Alfred Leslie, 2000

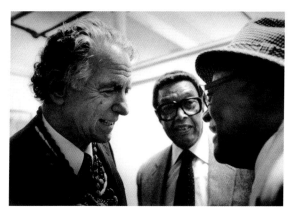

David Amram, Billy Taylor and Clark Terry, 2000

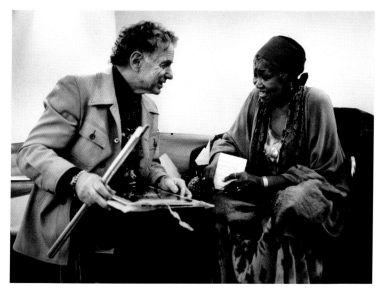

David Amram and Odetta, 2001

David Amram, 2000

Floyd Red Crow Westerman, David Amram and
Ramblin' Jack Elliott, 1996

David Amram and Ramblin' Jack Elliott, 1996

John Cassady and Ramblin' Jack Elliott, 1995

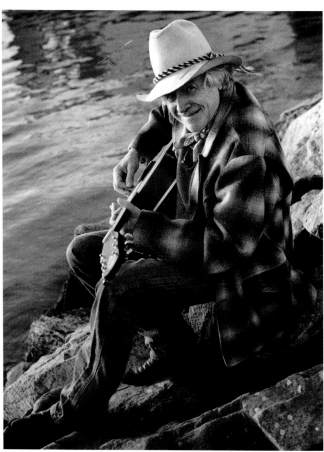

Ramblin' Jack Elliott, 2000

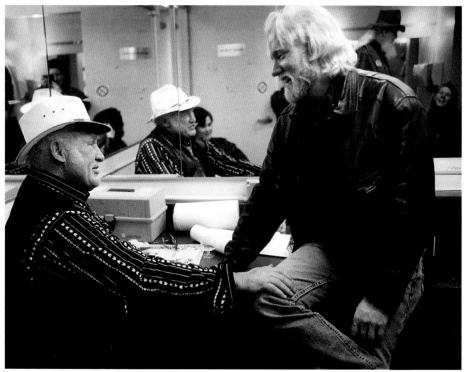

Ken Kesey and John Cassady, 1994

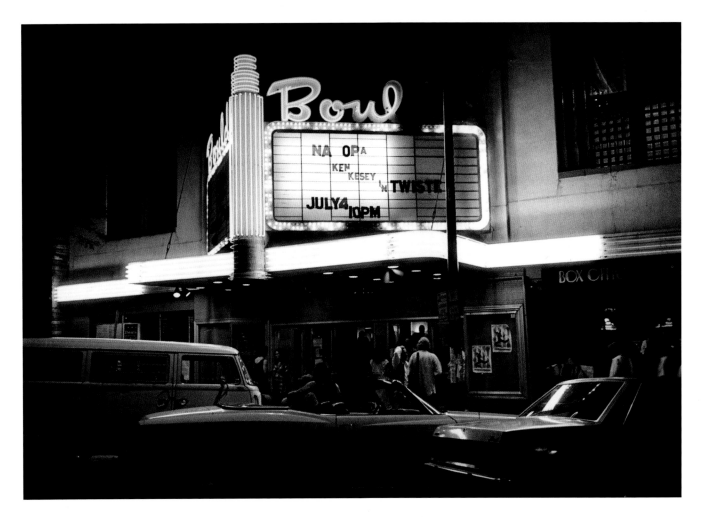

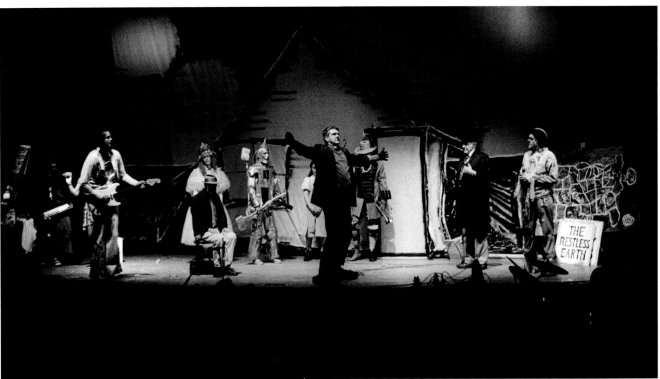

Ken Kesey's *Twister Performance*, 1994

they say Kesey's dead
_but never trust a prankster
even underground.
WAVY G

Wavy Gravy and Ken Babbs, 1998

Ken Kesey and Troupe, 1998

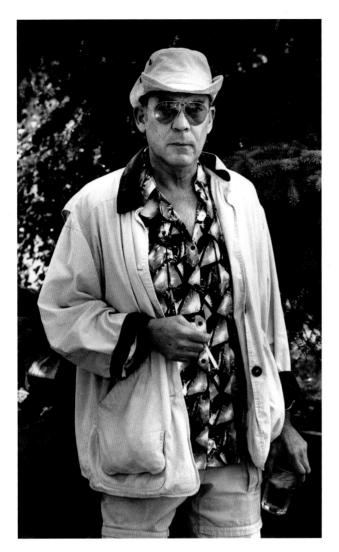

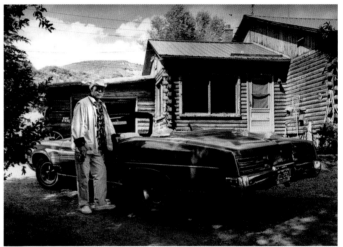

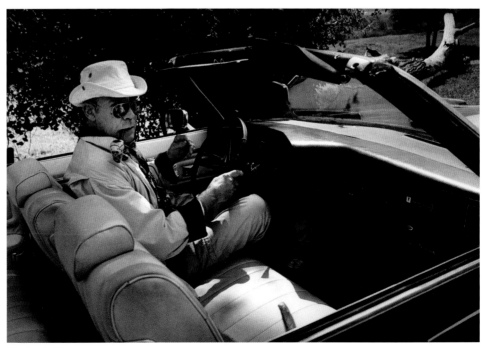

Hunter S. Thompson, 1994

it all began from:

the double heart that's piercing itself

Semper inadventicia Advenire

(pirate banner)

holes in the flesh, entrances into the underworld

the bottom of a heart or the head of a skunk

~ drops of blood or the tears of roses

in the distance.... the roar... of a motorcycle..

(skulls)

animals are hiding everywhere

the ears of cats

Every sword ends in a point because it's about to come

~ sperm from the sword

FROM THE BOOK OF CORRESPONDENCES

and so the pirate lovers went everywhere Acker

from the journals of Kathy Acker

Kathy Acker, 1994

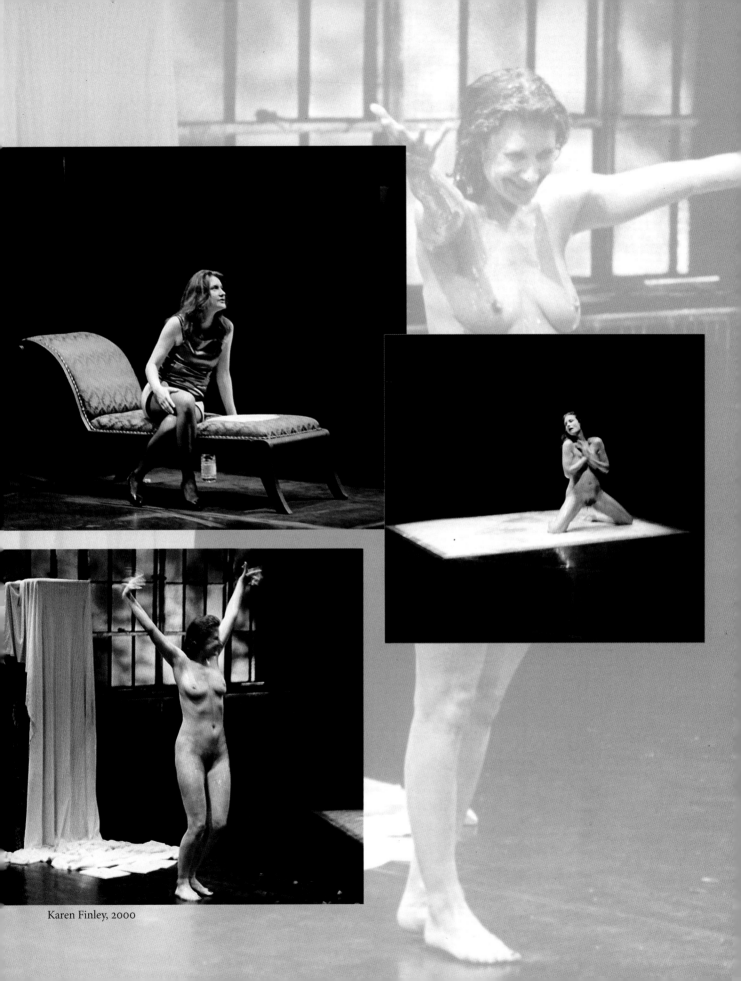

Karen Finley, 2000

Note for Song
(the)
On my minor she wrote,
 "Vaya con Dio"
Next to my photo of
 Delores del Rio

Jim Carroll
 '85

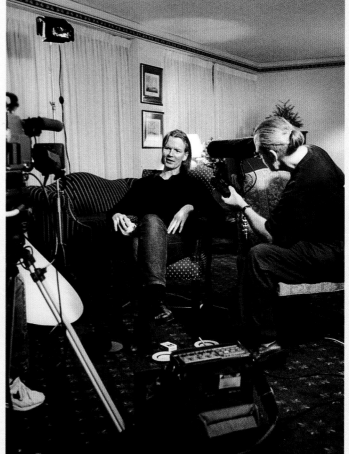

Jim Carroll, 1994

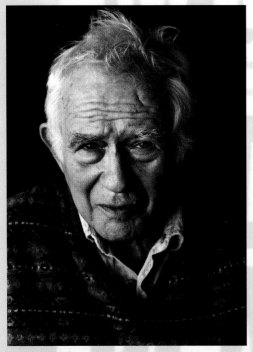

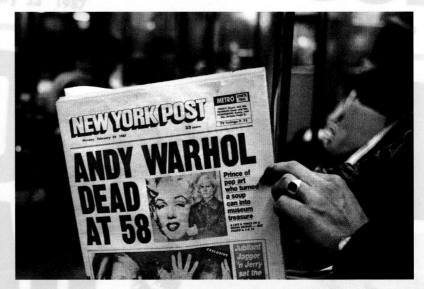

Norman Mailer, 2000

Taylor Mead, 1994

Grace Paley, 2001

Barney Rosset, 2000

Susan Sontag, 1995

Jill Krementz and Kurt Vonnegut, 1995

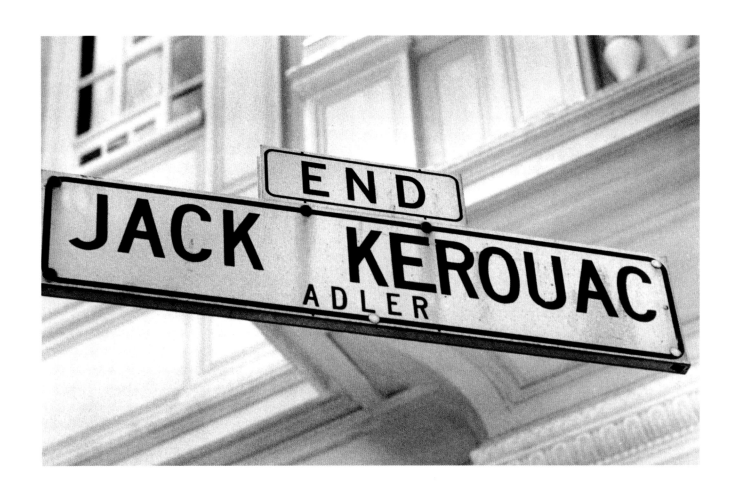

My journey with the Beats goes on. The poets and artists of that generation still fire my enthusiasm for being a fellow traveler with this tribe of angels and anarchists. Their style reflects that of an earlier era, when communication was done in person and in cafés. They lived by poetry and companionship much like minstrels in the spirit of 19th-century bohemian Paris and the streets and boulevards of 21st-century America. Their mantra speaks of the distance between mainstream culture and a society of visionaries. It decries disastrous consumer culture and honors the imaginative genius of the individual. Whitman's call to "heed the genius of the modern" challenges younger voices now to echo the prophetic *Howl*, re-inventing once more the meaning of "outsider culture." The Beat writers do not have the final word in *Beat*. With their passing, we are left to shape our own visions and create our own legacy.

Lawrence Ferlinghetti, 2002 County Sligo, Ireland, 2004

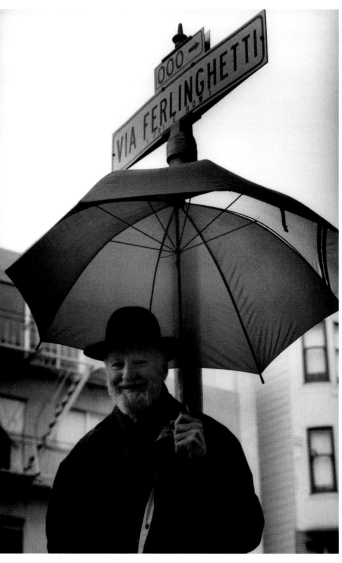

daniela ferraria ◯◯ arco d'alibert

CHRISTOPHER FELVER

RITRATTI DI ARTISTI

ROMA NEW YORK

The Coney Island of Lawrence Ferlinghetti

Fotografia
Chris Felver
Musica
Rick DePofi

LA BIENNALE DI VENEZIA

Plot outline
The film explores the life and times of Lawrence Ferlinghetti, the poet, painter, publisher and animator of the City Lights Bookstore. Ferlinghetti tells us about his life, recounts stories,

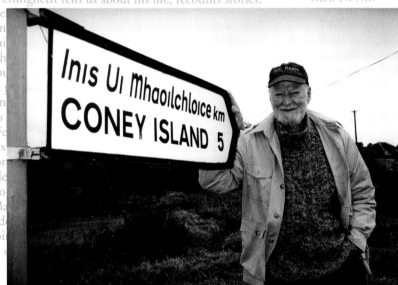

County Sligo, Ireland, 2004

Lawrence Ferlinghetti and Chris Felver, 2004

The author
Chris Felver is a photographer, documentary and filmmaker. He has had personals in the most important art galleries in the world, and has published quite a few volumes of his photographs. *The Poet Exposed* (1987, New York/San Francisco), *Portraits: The Beats at City Lights* (1989, Bremen) and *Beat* (1994, Paris) are only a few of the exhibitions intimately linked to his important work as chronicler of the Beat imaginary. He also co-wrote *Seven Days in Nicaragua Libre* with Ferlinghetti. His documentaries perfectly match his extremely sensitive photographic sense and his long-standing friendships with the likes of Ferlinghetti and John Cage, who are amongst the highest exponents of the world of art and culture. He now lives in California.

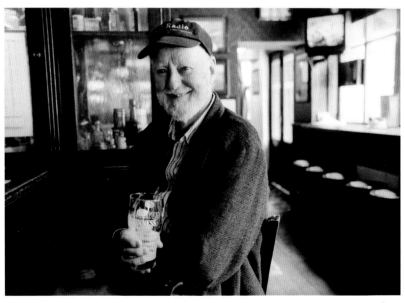

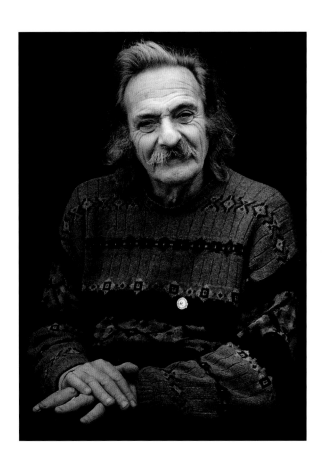

ONE DAY

one day I'm gonna give up writing
 and just paint
I'm gonna give up painting
 and just sing
I'm gonna give up singing
 and just sit
I'm gonna give up sitting
 and just breathe
I'm gonna give up breathing
 and just die
I'm gonna give up dying
 and just love
I'm gonna give up loving
 and just write

— JACK HIRSCHMAN

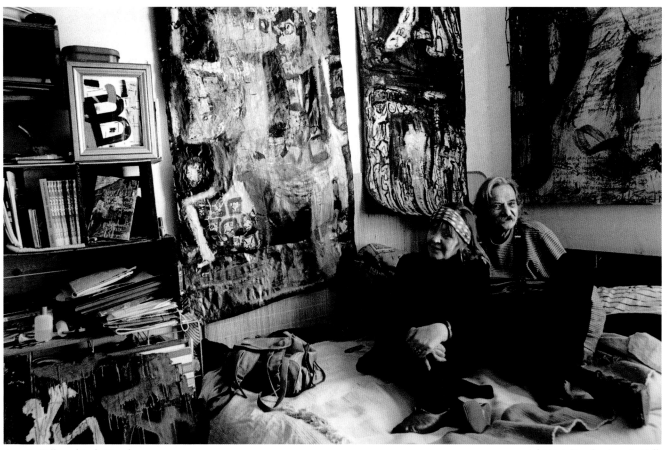

Agneta Falk and Jack Hirschman, 2001 *right:* Painting by Agneta Falk

The Allen Arcane

Old Woman Nature

naturally has a bag of bones
 tucked away somewhere.
 a whole roomfull of bones!
a scattering of hair and cartilage
bits in the woods.
A fox scat with hair and a tooth
 in it.
 a shellmound
 a bone flake in a streambank.
A purring cat, crunching
the mouse head first
 eating on down toward the tail —
the sweet old woman
calmly gathering firewood
 in the moon —

Don't be shocked,
She's heating you some soup!

on seeing Kurozuka at the Tokyo Kabuki-za VII:81
 Gary Snyder

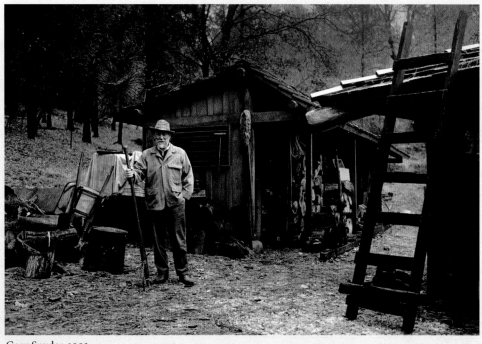

Gary Snyder, 1993

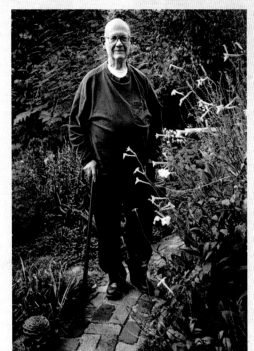

Philip Whalen, 1996

TARA

This bronze Tara this bronze lady
Represents that Lady of Heaven I now invoke,
That idea of wisdom that saves more than itself or me
All the universes,

Enlighten us! We murder each other in this night our eyes
 won't tell us anything but fear
All the universes all the probability tracks

IMMEDIATELY

Her hands form the mudra "Teaching the Law"
Explaining herself.
She also appears as a song, a diagram,
As a pile of metal images in the market, Katmandu
We seldom treat ourselves right.

ZENSHIN RYUFU
Philip Whalen

HAIKU FOR SATIE

On a dance in light
You run and play
There are none there — but stars.

(Philip Lamantia)

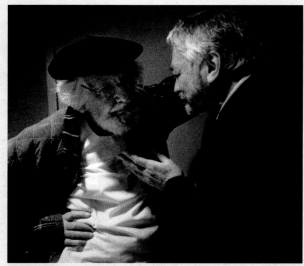

Ernesto Cardenal and Philip Lamantia, 2001

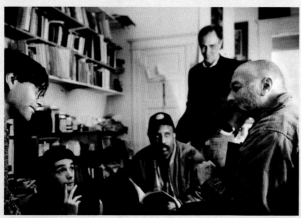

Philip Lamantia, 1998

Philip Lamantia, 2000

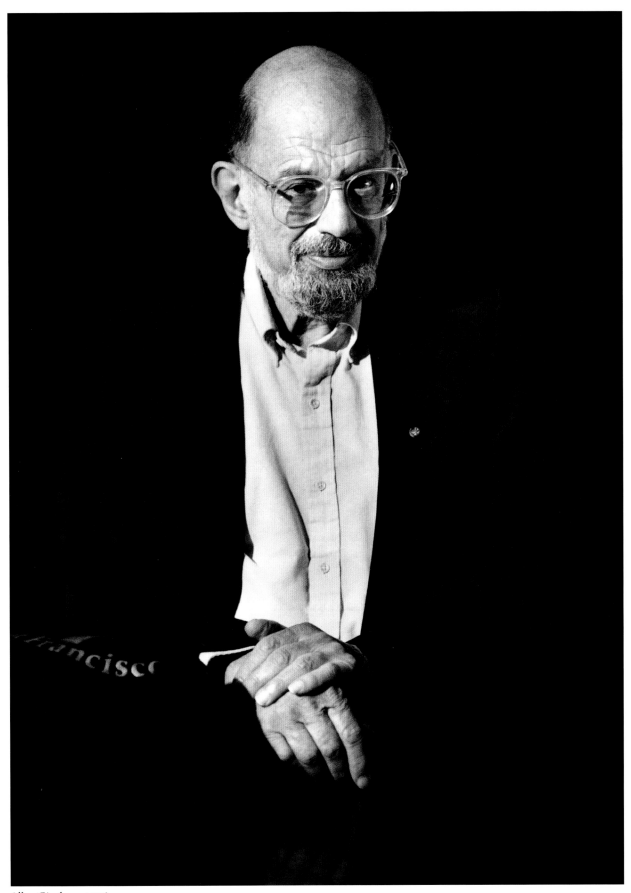

Allen Ginsberg, 1996

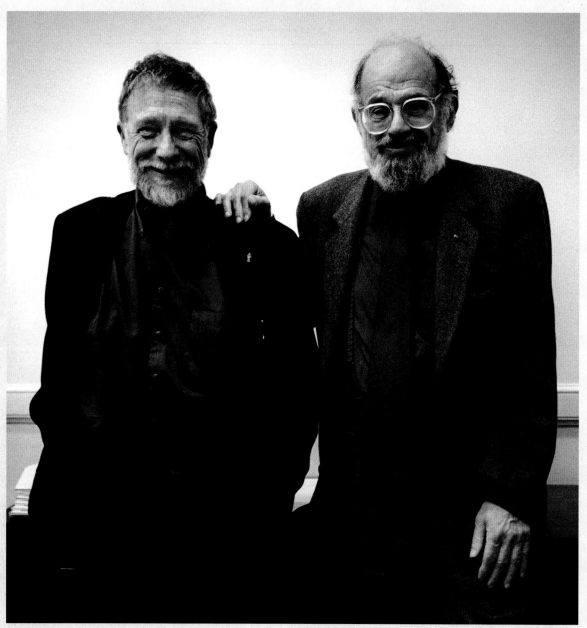

Gary Snyder and Allen Ginsberg, 1997

Czeslaw Milosz and Allen Ginsberg, 1997

In the half light of dawn
a few birds warble
under the Pleiades.

Allen Ginsberg

for Chris Felver

177

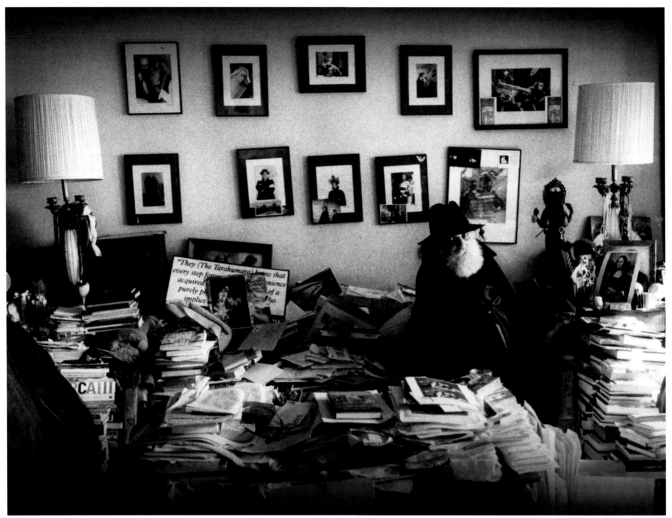

Ira Cohen, 2002

Judith Malina and Ira Cohen, 2002

I heard the Indian Sage
Say that there is no Time... I say:
There is Time because we are mortal,
There is Death because we are nothing
There is Love because we are crazy
And want to be happy forever
 Judith Malina

John Giorno, 2000

GIANTS OF THE NIGHT
A Concerto for Flute and Orchestra
David Amram

II
Andante Cantabile
(for Jack Kerouac)

espr. e ben legato

From the holy highway light
Together On the Road tonight
This song's for you Jack
This song's for you.

from the song written for the Finale
of a Musical Tribute to Jack Kerouac
by David Amram and friends.

It's beautiful to see the true part
of an era rediscovered, loved
and shared.

David Amram

Jack Kerouac's house, Orlando, Florida, 2000

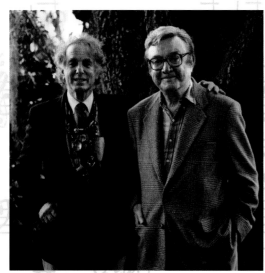

David Amram and Steve Allen, 2000

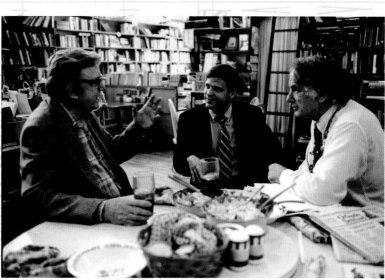

Steve Allen, Douglas Brinkley and David Amram, 2000

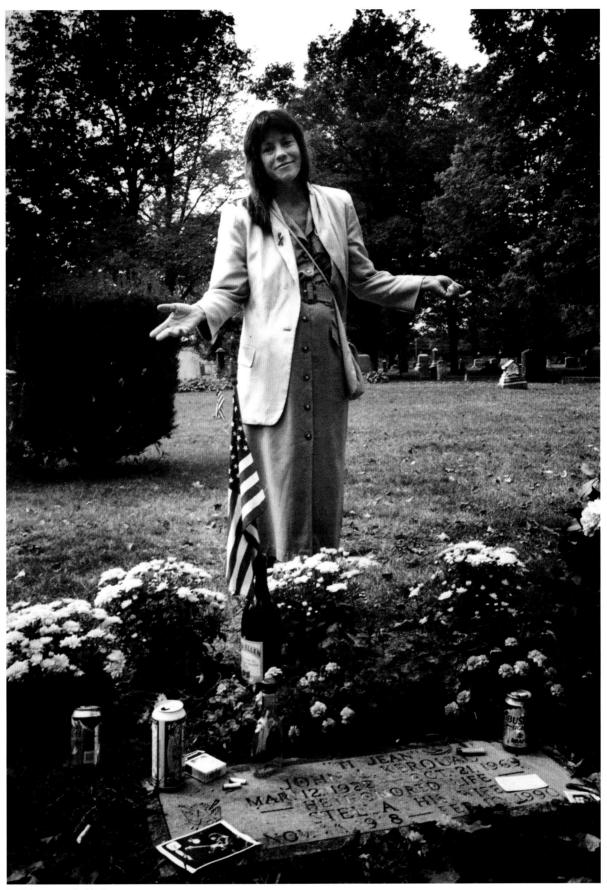

Jan Kerouac at Jack's Grave, 1994

Herbert Huncke, the Hipster Who Defined 'Beat,' Dies at 81

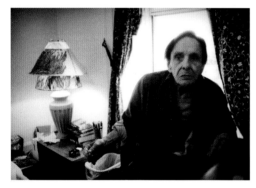

*Friends and the Estate of
Herbert E. Huncke
invite you to a memorial celebration
Saturday afternoon
November 30th, 1996
2:00 p.m.*

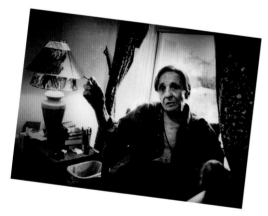

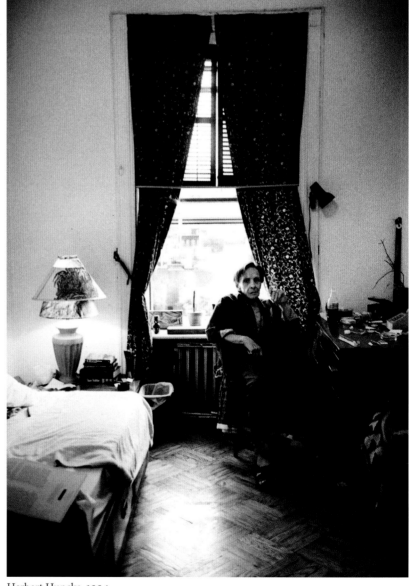

*A dissolute hero to
the likes of
Jack Kerouac and
Allen Ginsberg.*

Herbert E. Huncke

(1915-1996)

Herbert Huncke, 1994

NO VISITORS.

Bukowski

BUT THEY'VE LEFT US A BIT OF MUSIC
AND A SPIKED SHOW IN THE CORNER,
A JIGGER OF SCOTCH, A BLUE NECKTIE,
A SMALL VOLUME OF POEMS BY RIMBAUD,

A HORSE RUNNING AS IF THE DEVIL
WERE TWISTING HIS TAIL
OVER BLUEGRASS AND SCREAMING,
AND THEN,
LOVE AGAIN
LIKE A STREETCAR TURNING THE CORNER
ON TIME,
THE CITY WAITING,
THE WINE AND THE FLOWERS,
THE WATER WALKING ACROSS THE LAKE
AND SUMMER AND WINTER
AND SUMMER AND SUMMER
AND WINTER AGAIN.

CHARLES BUKOWSKI

HANK

BORN

AUGUST 16, 1920

PASSED AWAY

MARCH 9, 1994

SERVICES

3:00 P.M.
MONDAY, MARCH 14, 1994
GREEN HILLS MORTUARY CHAPEL

OFFICIATING

MONK ON

INTERMENT

GREEN HILLS MEMORIAL PARK

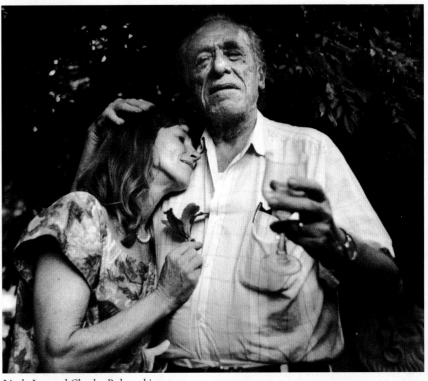

Linda Lee and Charles Bukowski, 1991

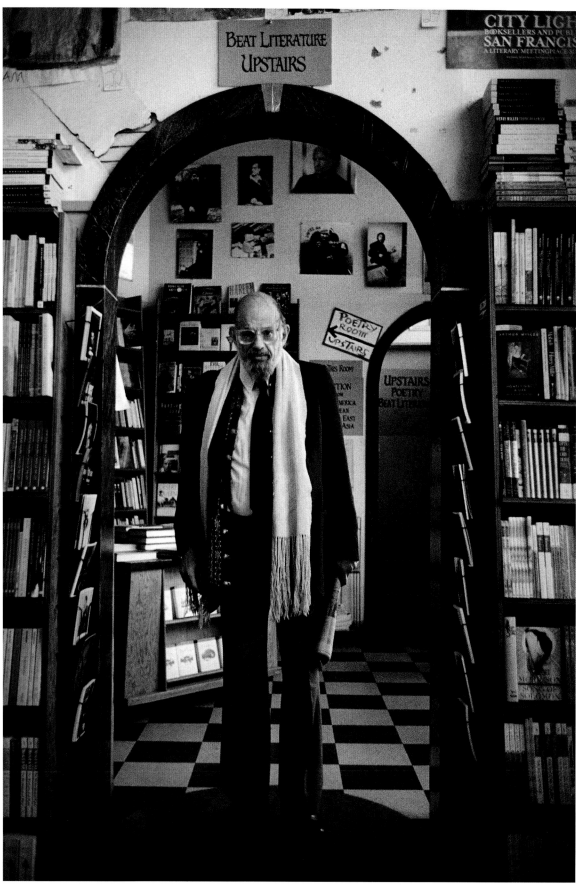

Allen Ginsberg, 1996

Allen Ginsberg, Master Poet Of Beat Generation, Dies at 70

By WILBORN HAMPTON

Allen Ginsberg, the poet laureate of the Beat Generation whose "Howl" became a manifesto for the sexual revolution and a cause célèbre for free speech in the 1950's, eventually earning its author a place in America's literary pantheon, died early yesterday. He was 70 and lived in the East Village, in Manhattan.

He died of liver cancer at his apartment, Bill Morgan, a friend and the poet's archivist, said.

Mr. Morgan said that Mr. Ginsberg wrote right to the end. "He's working on a lot of poems, talking to old friends," Mr. Morgan said on Friday. "He's in very good spirits. He wants to write poetry and finish his life's work."

William S. Burroughs, one of Mr. Ginsberg's lifelong friends and fellow Beat, said that Mr. Ginsberg's death was " a great loss to me and to everybody."

"We were friends for more than 50 years," Mr. Burroughs said. "Allen was a great person with worldwide influence. He was a pioneer of open-ness and a lifelong model of candor. He stood for freedom of expression and for coming out of all the closets long before others did. He has influence because he said what he believed. I will miss him."

As much through the strength of his own irrepressible personality as through his poetry, Mr. Ginsberg provided a bridge between the Underground and the Transcendental. He was comfortable in the ashrams of Indian gurus in the 1960's as he had been in the Beat coffeehouses of the preceeding decade.

A ubiquitous presence at the love-ins and be-ins that marked the drug oriented counterculture of the Flower Children years. Mr. Ginsberg was also in the vanguard of the political protest movements they helped spawn. He marched against the war in Vietnam, the C.I.A. and the Shaw of Iran, among other causes.

Peter Orlovsky, 1997

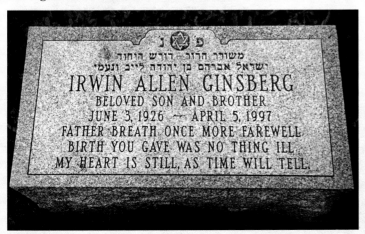

Snapped in the past
seen in the present
—fades... fades in the future
—Who knows?
The Pyramids may
dwindle ere

for Chris Felver Gregory Corso

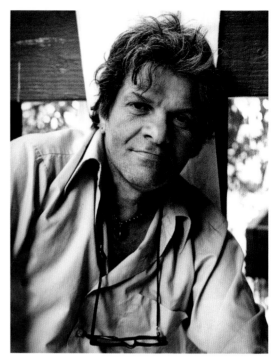

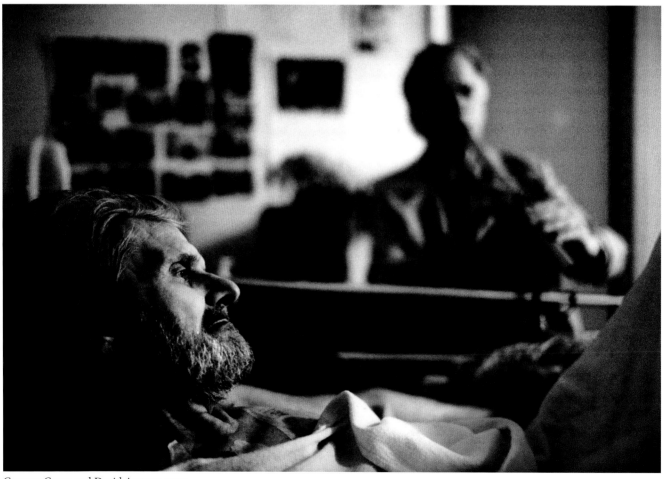

Gregory Corso and David Amram, 2001

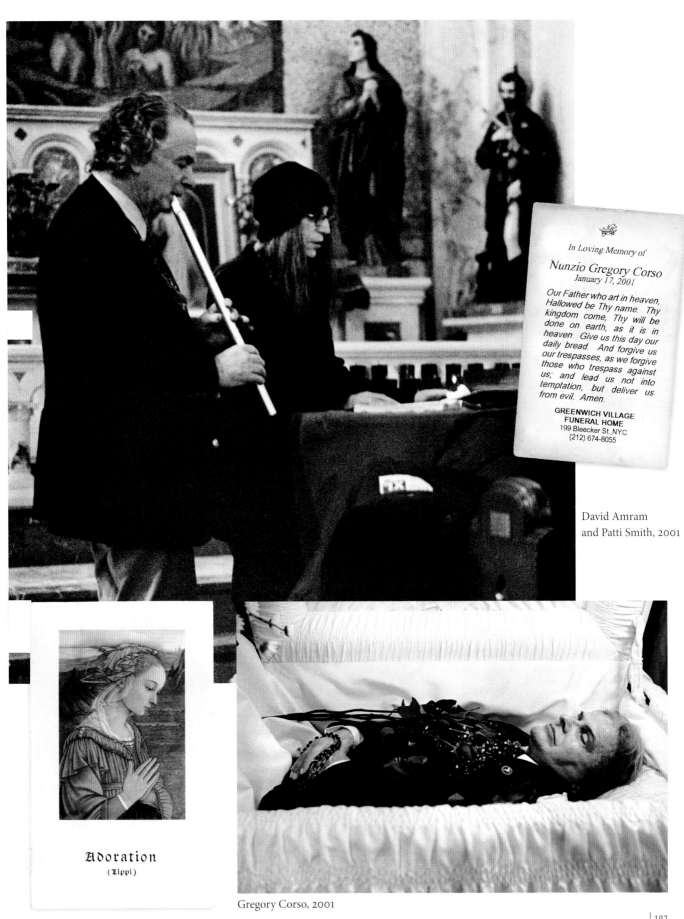

In Loving Memory of

Nunzio Gregory Corso
January 17, 2001

Our Father who art in heaven,
Hallowed be Thy name. Thy
kingdom come, Thy will be
done on earth, as it is in
heaven. Give us this day our
daily bread. And forgive us
our trespasses, as we forgive
those who trespass against
us; and lead us not into
temptation, but deliver us
from evil. Amen.

**GREENWICH VILLAGE
FUNERAL HOME**
199 Bleecker St.,NYC
(212) 674-8055

David Amram
and Patti Smith, 2001

Adoration
(Lippi)

Gregory Corso, 2001

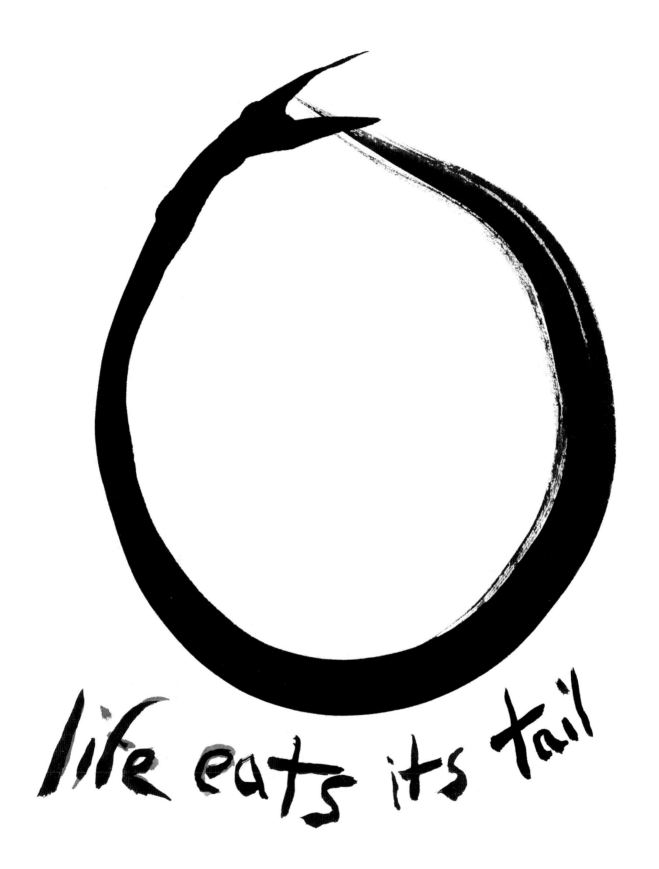

life eats its tail

BIOGRAPHIES

KATHY ACKER b. 1945, New York, NY. Studied poetry with Jerome Rothenberg, lived in London, taught at the San Francisco Art Institute. Published numerous novels, including as *Blood and Guts in High School, Young Lust* and *Kathy Goes to Haiti. Requiem*, a three-act opera commissioned by the American Opera Project, is her final work. Died 1997.

STEVE ALLEN b. 1921, New York, NY, raised in Chicago, IL. Authored fifty-two books and appeared in hundreds of films and television shows. Interviewed Jack Kerouac on his television show in 1959 and accompanied him on piano for the album *Poetry for the Beat Generation*. Died 2000.

DAVID AMRAM b. 1930, Pennsylvania. Started jazz/poetry readings in 1957 at New York's Circle in the Square with Jack Kerouac and others. Wrote music for beat film *Pull My Daisy*. Picked by Leonard Bernstein as New York Philharmonic composer in residence. Wrote concertos, chamber music, operas and film scores for *Splendor in the Grass* and *The Manchurian Candidate*. Commissioned by flutist James Galway to write a concerto for flute and orchestra, *Giants of the Night* (2002). Author of *Vibrations: The Adventures and Musical Times of David Amram* (1968) and *Offbeat: Collaborating with Kerouac* (2002).

KAREL APPEL b. 1921, Amsterdam. Painter and sculptor influenced by folk, primitive and children's art. A founder of CoBrA Group (stands for the artists' home cities of Copenhagen, Brussels, Amsterdam) in 1948. Collaborated with Allen Ginsberg and Gregory Corso on a series of visual poems in 1982. Died 2006.

AL ARONOWITZ b. 1928, New Jersey. Called himself "the blacklisted journalist." In 1960, was first to recognize the Beats as a literary movement in his twelve-part *New York Post* series. Influenced by Allen Ginsberg and affiliated with Bob Dylan, who introduced him to the Beatles. Wrote about interviewing Neal Cassady in jail.

JOHN ASHBERY b. 1927, Rochester, NY. Poet, playwright, novelist and prominent member of the New York School. Art critic for *Newsweek* and *New York* magazines and editor of *Art News*. Author of over twenty books of poetry, his 1976 poetry collection, *Self-Portrait in a Convex Mirror*, won the National Book Award, National Book Critics Circle Award and the Pulitzer Prize. The first English-language poet to win the Grand Prix de Biennales Internationales de Poésie. A MacArthur Fellow, former Chancellor of The Academy of American Poets and recipient of the Bollingen Prize, Ruth Lilly Poetry Prize and Lenore Marshall Poetry Prize.

KEN BABBS b. 1936. One of Ken Kesey's famous Merry Pranksters, a prime mover of the 1960s counterculture: hippies, happenings, acid tests and psychedelic music. Met Ken Kesey in 1958 at Stanford graduate school and collaborated on various projects for forty-three years. Immortalized in books and films, he writes about it all in the 1989 book, *On the Bus*.

ED BALCHOWSKY b. 1916. Painter, poet, one-handed pianist and raconteur who lost an arm as an anti-fascist volunteer in the Abraham Lincoln Brigade during the Spanish Civil War. Both written about and painted by poet Jack Micheline in his famous "painted poem" room at the Abandoned Planet Bookstore, San Francisco. Died 1989.

AMIRI BARAKA (LeRoi Jones) b. 1934, Newark, NJ. Graduated from Howard University, served in Air Force, then moved to Greenwich Village. His Obie Award-winning play *Dutchman* was published in 1964. Writer of poetry, prose, essays and plays. Started Totem Press, publisher of Gary Snyder, Philip Whalen and Jack Kerouac. Coeditor of avant-garde literary magazine *Yugen* with Hettie Jones, and coeditor with Diane di Prima of *The Floating Bear* newsletter. Author of *The LeRoi Jones/Amiri Baraka Reader* (1991, second edition 1999), *Transbluesency: The Selected Poetry of Amiri Baraka 1961–1995* and *Tales of the Out & the Gone* (2006).

TED BERRIGAN b. 1934, Providence, RI. New York School poet, lived in New York. Collaborated with poets and artists, including Ed Sanders, Anne Waldman, Tom Clark and Joe Brainard. Edited and published *C Magazine* and C Press books. His 1964 book, *The Sonnets*, was re-issued in 2000. Taught at the University of Michigan, Yale and Naropa. *The Collected Poems of Ted Berrigan* (University of California Press, 2005) published posthumously. Died 1983.

STAN BRAKHAGE b. 1933, Kansas City, MO. Made over three hundred avant-garde films. Directed the five-minute silent film, *Full Cast and Crew for Two: Creeley/McClure* (1965). Made two-minute black and white film, *Chinese Series* (2003), using saliva and a fingernail to create patterns on the film. Author of *Telling Time: Essays of a Visionary Filmmaker* (2003). Died 2003.

RICHARD BRAUTIGAN b. 1935, Tacoma, WA, lived in Oregon and Montana. Decided at seventeen to be a writer. Moved to San Francisco in the mid-1950s and published *Trout Fishing in America* at twenty-five, which has sold over three million copies. Wrote ten novels, a book of short stories and nine books of poetry, including *Confederate General in Big Sur*. Committed suicide, Bolinas, 1984.

DOUGLAS BRINKLEY b. 1961, Atlanta, GA. Historian and director of the Eisenhower Center for American Studies at the University of New Orleans. Collaborated with historian Stephen Ambrose and edited and wrote the introduction to the letters of Hunter S. Thompson. Author of numerous books, including *Rosa Parks (2000), Tour of Duty: John Kerry and the Vietnam War (2004), The World War II Memorial: A Grateful Nation Remembers (2004), National Geographic Visual History of the World (2005), The Great Deluge: Hurricane Katrina, New Orleans, and the Mississippi Gulf Coast (2006)* and *Windblown World: The Journals of Jack Kerouac 1947–1954* (2004).

JAMES BROUGHTON b. 1913, Modesto, CA. Poet and avant-garde filmmaker, his films on love, sex, the human body and dreams include *The Pleasure Garden* (1953), *Dreamwood* (1972) and *Devotions* (1983). His last films were made with lifelong companion Joel Singer. His books include *Packing Up for Paradise: Selected Poems 1946–1996* (Black Sparrow Press), *Making Light of It* (City Lights Books, 1992) and *Graffiti for the Johns of Heaven* (Syzygy, 1982). Died 1999.

JOAN BROWN b. 1938, San Francisco, CA. Pre-eminent California artist, considered a prodigy, affiliated with the 1950s Bay Area Figurative School and work of Elmer Bischoff, David Park and Richard Diebenkorn. Lived at Jay DeFeo's flat in 1957. Innovator in the 1960s funk art,

assemblage and ephemeral/found art scene with Bruce Conner and sculptor Manuel Neri. Died 1990 in India.

CHARLES BUKOWSKI b. 1920, Germany, raised in Los Angeles, CA. Poet and fiction writer. *Flower, Fist and Bestial Wail* (1959) was his first book, followed by many others, including *Burning in Water, Drowning in Flame: Selected Poems 1955–1973, At Terror Street and Agony Way, Love is a Dog from Hell: 1974–1977* and the novels *Post Office* (1971) and *Pulp* (1994). Published more than forty-five books of poetry and prose in his lifetime. Wrote screenplay for *Barfly* (1987), a Barbet Schroeder film. Died 1994.

LINDA LEE BUKOWSKI (née Beighle) b. 1945, raised in Bryn Mawr, PA. Ran the Dewdrop Inn health-food restaurant in Redondo Beach, where she met Charles Bukowski after a poetry reading in 1976. Together for eighteen years, they married in 1985. Appeared in the acclaimed documentary film, *Bukowski: Born Into This* (2002).

RUDY BURKHARDT b. 1914 Photographer, filmmaker, painter and writer who collaborated with poets; on film projects with John Ashbery, Kenneth Koch, Alice Notley, Ron Padgett and David Shapiro; on books with Edwin Denby, Vincent Katz and Simon Pettet. Honored in 1987 with a Museum of Modern Art retrospective of over sixty of his short films, and in 1997 with a retrospective at Institut Valencia d'Art Modern, Spain. Best known for his images of New York City. Died 1999.

WILLIAM S. BURROUGHS b. 1914, St. Louis, MO, to a prominent family (his grandfather invented an adding machine). Graduated 1936 from Harvard, traveled extensively. Met Jack Kerouac and Allen Ginsberg in New York in 1944. In 1951, accidentally shot and killed his wife, Jane Vollmer, in Mexico City. Early novels include *Junky* and *Naked Lunch*. Developed montage and cut up method of writing with Byron Gysin. Lived in Paris and Tangiers. Later works include *Cities of the Red Night* and *The Western Lands*. Died 1997.

JOHN CAGE b. 1912, Los Angeles, CA. Composer of experimental avant-garde works. Studied with Schönberg and wrote music for dance companies, especially

Merce Cunningham. At Black Mountain College collaborated with Cunningham and painter Robert Rauschenberg. Wrote innovative poetry. His 1952 work, with a performer sitting silently before a piano, *4'33"* (four minutes, thirty-three seconds) stirred controversy. Died 1992.

ERNESTO CARDENAL b. 1925, Nicaragua. Studied with Thomas Merton at Gethsemani Monastery in Kentucky. Declared an outlaw for political activity by the Somoza regime in 1957, became a Roman Catholic Priest in 1965. After Sandinista victory, named Nicaraguan Minister of Culture (1979–1988). His long opus, *Cosmic Canticle* (2002), was translated by John Lyons.

JIM CARROLL b. 1950, New York, NY. Grew up on the Lower East Side, moved to Upper Manhattan, and began a journal eventually published as *The Basketball Diaries* in 1978. A prolific author, poet, musician, band leader and spoken word artist. Performed with Patti Smith, Ray Manzarek, Keith Richards and Lou Reed.

CAROLYN CASSADY (née Robinson) b. 1923. While studying for an M.A. at the University of Denver, she met Neal Cassady, Jack Kerouac and Allen Ginsberg. Married Neal Cassady in 1948 and had three children. Appears as a character in numerous Beat period works. Author of *Off the Road* (1990), a memoir of those times.

JOHN ALLEN CASSADY b. 1951, San Francisco, CA, raised in Los Gatos and Santa Cruz. Son of Neal and Carolyn. A musician/guitar player, he is father of Jami Neal Cassady, born 1975.

ANN CHARTERS b. 1936, Connecticut. Became interested in the Beats after hearing Ginsberg read "Howl" in 1956. Author of *Kerouac: A Biography* (1973), the first scholarly biography of Jack Kerouac. Editor of *The Portable Beat Reader* (1992). Professor at the University of Connecticut and photographer of the Beats.

NEELI CHERKOVSKI b. 1945, Santa Monica, CA. Edited *The Black Cat Review* while in high school. Poetry books include *Animal, Elegy for Bob Kaufman* and *Leaning Against Time*, which received a PEN/Josephine Miles Award. Wrote a critical memoir, *Whitman's Wild Children* (1988)

and biographies of Charles Bukowski and Lawrence Ferlinghetti. Writer-in-residence at New College of California, San Francisco.

DON CHERRY b.1936. Frequent collaborator with saxophonist Ornette Coleman, John Coltrane and Thelonious Monk. Innovator, composer and constant experimenter in the 1960s and '70s with Indian and African music. Considered a father of multicultural "world music." Lived and played avant-garde jazz in Europe. Died 1995.

TOM CLARK b. 1941, Chicago, IL. Received a B.A. from the University of Michigan and an M.A. from Cambridge. New York School poet, editor, writer, critic and artist. Poetry editor of *The Paris Review* (1963–1973). Author of biographies on Jack Kerouac, Charles Olson, Robert Creeley and Ed Dorn. Collaborated with Anne Waldman on *Zombie Dawn* (2002). Author of numerous poetry books, most recently *Light and Shade: New and Selected* (2006). Teaches at New College of California, lives in Berkeley.

ANDY CLAUSEN b. 1943, Belgium, raised in Oakland, CA. Neo-Beat poet, lecturer and teacher at Naropa. Author of *Fortieth Century Man: Selected Verse 1966–1996*. Worked with Allen Ginsberg on *Poems for the Nation: A Collection of Contemporary Political Poems* (2000).

FRANCESCO CLEMENTE b. 1952, Naples. Italian abstract figurative painter, studied architecture and seminal member of Italian *transavanguardia*. Multicultural influences from travels, especially to India. Moved to New York in 1981. Part of art scene including Andy Warhol and Basquiat. Illuminated poems of Robert Creeley, Allen Ginsberg and John Wieners. Publisher of Hanuman Books with Raymond Foye.

NINA CLEMENTE b. 1981, Italy, raised in New York, NY. Daughter of Francesco and Alba Clemente. Graffiti artist Keith Haring created an empty scrapbook for her seventh birthday called *Nina's Book of Little Things* (the color facsimile is now a children's book).

ANDREI CODRESCU b. 1946, Romania. Emigrated to the US in 1966. *Alien Candor: Selected Poems: 1970–1996* published by Black Sparrow Press. Received an NEA

Fellowship, ACLU Freedom of Speech Award and Peabody Award. Editor of *Exquisite Corpse* literary magazine, author of the autobiography, *The Hole in the Flag* (1992) and the novel, *The Blood Countess*. Professor of English at Louisiana State University.

IRA COHEN b. 1935, New York, NY, to deaf parents. Went to Morocco in 1961, wrote the *Hashish Cookbook*, lived and wrote in Katmandu. Photographic series on mylar of counterculture icons: William S. Burroughs, Jimi Hendrix, etc. Friend of Harold Norse, Robert LaVigne and Byron Gysin. Made *Paradise Now*, a film of 1968 Living Theater tour. Author of *Poems from the Akashic Record* (2001).

WANDA COLEMAN b. 1946. Poet and fiction writer, author of eight books published by Black Sparrow Press, including *Bathwater Wine* (1998). Also appears on many CDs. Influential on the Los Angeles poetry scene as cohost with husband, poet/visual artist Austin Straus, of *The Poetry Connexion* on Pacifica radio (1981–1992).

JESS (COLLINS) b. 1923, Long Beach, CA. Worked at Hanford Atomic Energy Project until a nightmare about world destruction motivated him to move to San Francisco. Studied with Clyfford Still and Hassel Smith at the San Francisco Art Institute. A painter, he called himself "Jess" and made elaborate collages called "paste-ups." Gay rights activist and companion of Robert Duncan from 1951–1988. Cofounder of the avant-garde King Ubu Gallery. Died 2004.

BRUCE CONNER b. 1933, Kansas. High school friend of Michael McClure. A leading figure in the international assemblage/found art movement. Printmaker, painter, photographer and filmmaker. Moved to San Francisco in the 1950s. His breakthrough film, *A Movie* (1958) is a collage of found footage. Influenced by the atomic bomb, notably in *Bombhead* (1989). Exhibits include the Whitney Biennial (1997) and *2000 BC: The Bruce Conner Story Part II*.

CLARK COOLIDGE b. 1939, Providence, RI. Poet and jazz drummer, moved to San Francisco in 1967 to join David Meltzer's Serpent Power band. Lived in the Berkshires, Manhattan, Cambridge, San Francisco and

Rome, now lives in Petaluma, California. Author of *The Book of Stirs*, *Now It's Jazz* (a collection of writing on jazz and Jack Kerouac), *Bomb* (with photo collages by Keith Waldrop), *On the Nameways*, *Alien Tatters* and *Far Out West*.

GREGORY CORSO b. 1930, Greenwich Village, NY. Spent childhood in foster homes, placed in a boy's home for two years after running away. Spent three years in prison, where he learned to write and read widely in the classics. Met Allen Ginsberg and Jack Kerouac in 1950. Was first published in 1954 in the *Harvard Advocate*. His first book, *The Vestal Lady on Brattle and Other Poems* (1955), was underwritten by Harvard and Radcliffe students. Worked as a laborer, newspaper reporter and merchant seaman. Lived in France, wrote the anti-nuclear poem *Bomb* (1958), went to San Francisco. Author of *Gasoline* (City Lights Books, 1958), *The Happy Birthday of Death* (1960), *Long Live Man* (1962), *Elegiac Feelings American* (1970), *Herald of the Autochthonic Spirit* (1981) and *Mindfield, New and Selected Poems* (1989). Died 2001.

ROBERT CREELEY b. 1926, Massachusetts. Taught at Black Mountain College in North Carolina, SUNY Buffalo and Brown University. Associated with Charles Olson in the Black Mountain School of Poetry, and editor of the *Black Mountain Review*. Published more than sixty books of poetry, prose, essays and interviews, including *The Collected Poems of Robert Creeley, 1975–2005, Selected Poems; For Love* and *The Island*. Influenced countless young poets. Awarded the Lannan Lifetime Achievement Award, Frost Medal, Shelley Memorial Award, Bollingen Prize, two Guggenheims and two Fulbrights. Member of American Academy of Arts and Letters. Taught at SUNY Buffalo for many years and was distinguished professor at Brown University when he died in 2005.

THE DALAI LAMA b. 1935, Tibet, into a peasant family as Lhama Dhondrub. Was recognized at age two as the reincarnation of the Thirteenth Dalai Lama and enthroned in 1940 as His Holiness the Fourteenth Dalai Lama. Educated in Tibet, received doctorate of Buddhist philosophy (1959). Head of State, and spiritual leader of the Tibetan people, was forced into exile in India after the 1960 Chinese takeover

of Tibet. Has visited forty-six countries. Awarded 1989 Nobel Peace Prize.

RAM DASS (Richard Alpert) b. 1931, Boston, MA. Received a B.A. from Tufts, an M.A. from Wesleyan and a Ph.D. from Stanford. Taught at Harvard from 1958–1963 where he was dismissed for LSD experiments with Timothy Leary. Started the Hanuman Foundation in 1974 to work with prisoners and the dying. A spiritual leader and prolific author of the million-copy best seller, *Be Here Now*. Suffered a stroke in 1997. Was the subject of the film, *Ram Dass Fierce Grace* (2002).

JAY DeFEO b. 1929. Painter and central figure of the 1950s avant-garde art and poetry scene in the Bay area, which included Bruce Conner, Michael McClure and Allen Ginsberg. Her most famous work, *The Rose*, weighs one ton, measures eight feet by eleven feet, and was created in seven years (1959–1966). The Bruce Conner film, *The White Rose*, documents moving the piece from her studio. Retrospective at the Whitney Museum in 2004. Died 1989.

LILLIAN DODSON b. 1931. Long Island painter, sculptor, furniture maker and potter. Married to painter Stanley Twardowicz, they were friends of Jack Kerouac in Northport. Her works are in both private and institutional collections. Lectured and taught extensively, especially ceramics. Teaches at Hofstra University.

WILLEM de KOONING b. 1904, Rotterdam. Abstract expressionist painter and sculptor who melded the abstract and figurative. Studied art, moved to the US in 1926, worked as commercial artist and house painter, met Arshile Gorky and Jackson Pollock. Central to the New York School, he married painter Elaine Fried in 1942. Taught at Black Mountain and Yale. Noted for 1950s series of women and Montauk series. Received the Presidential Medal of Freedom in 1964. Died 1997.

ELAINE de KOONING b. 1918. Studied at Manhattan's Leonardo da Vinci school, met Willem de Kooning. *Elaine and Bill* by Lee Hall postulates that art, sex and alcohol fueled their forty-six year long "open marriage." An art critic for *ArtNews* and an abstract expressionist painter also noted for figurative portraits of her contemporaries, including poets Frank O'Hara,

Allen Ginsberg, dancer/choreographer Merce Cunningham and President John F. Kennedy. Died 1989.

DIANE di PRIMA b. 1934, Brooklyn, NY. Dropped out of Swarthmore College and moved to Greenwich Village. Corresponded with Ezra Pound and was a friend of Allen Ginsberg. Coeditor with LeRoi Jones (Amiri Baraka) of *Floating Bear*. Cofounder of the New York Poets Theatre and Poets Press. Lived at Timothy Leary's Millbrook Community, moved to California. Author of over forty books of poetry and prose, including *Revolutionary Letters*, *Loba* and *Recollections of My Life as a Woman*. Received Northern California Book Reviewers' Fred Cody Lifetime Achievement Award (2006). Lives in San Francisco.

EDWARD (ED) DORN b. 1929, Villa Grove, IL. Studied at Black Mountain College (B.A., 1956) with Robert Creeley. His first book, *The Newly Fallen* was published in 1961. Went to England on a Fulbright Scholarship in 1965. Influenced by the American West, his masterpiece is the long, four-part poem *Gunslinger* (1975). Taught at University of Colorado from 1977 until his death in 1999.

JENNIFER DUNBAR DORN Collaborated with her husband Ed Dorn as coeditor of *Rolling Stock*, the literary newspaper, at the University of Colorado, Boulder (1981–1991).

KIRBY DOYLE b. 1932. North Beach. Poet and performer. Lived in Digger communes. Was a friend of Lew Welch, Diane di Prima, Peter Coyote and Tisa Walden. Author of *Lyric Poems* (City Lights Books, 1988); he was also published by Deep Forest Press. Wrote the cult novel *Happiness Bastard*. Died 2003.

ROBERT DUNCAN b. 1919, Oakland, CA. A poet whose major works include *Bending the Bow*, *The Opening of the Field*, *Roots and Branches* and *Groundwork: Before the War/ In the Dark*, bringing together his last two collections of poetry. Taught at Black Mountain College. Was assistant director of The Poetry Center at San Francisco State College and cofounder, with Diane di Prima, of the New College Poetics Program in San Francisco. Received a Guggenheim in 1963. Died 1988.

LAWRENCE DURRELL b. 1912, Darjeeling, India. Educated in English schools. An Anglo-Irish novelist and playwright he was best known for *The Alexandria Quartet*. Moved to Paris and met Henry Miller, shared a forty-five year friendship and correspondence. Moved to Corfu in 1935 and served as a press attaché during World War II. Died 1990.

DON EDWARDS b. 1939. Known as "The Minstrel of the Range" since the early 1960s, a singer and composer of traditional American West cowboy/folk music. Often performs at cowboy poetry gatherings. Won an INDIE for collected works, *Saddle Songs* (1998).

RAMBLIN' JACK ELLIOT b. 1931, Brooklyn, NY. At fourteen, he saw Gene Autry and ran away to join the rodeo. Collaborated with Woody Guthrie. Was involved in the Greenwich Village scene with Allen Ginsberg and Gregory Corso. Recorded the album *Kerouac's Last Dream*. Wandered and performed in Europe and America, influenced Bob Dylan. A participant in Cowboy Poetry Gatherings since 1985. Won a Grammy for *South Coast* in 1996 and received a National Medal of Arts Award in 1998.

WILLIAM EVERSON b. 1912, Sacramento, CA. Visited Thomas Merton at the Abbey of Gethsemani in Kentucky. A conscientious objector in World War II, he learned hand-set printing during his service and moved to San Francisco. Was associated with Kenneth Rexroth and the San Francisco Renaissance. Entered the Dominican Order (1951-1969), and became known as Brother Antoninus. Published over fifty books of poetry. Taught at UC Santa Cruz where he started Lime Kiln Press. Died 1994.

AGNETA FALK b. 1946, Stockholm. Worked in political theater in Stockholm, moved to London and continued in community theater. From 1992–1999, coedited *Word Hoard*, promoting writing and organizing poetry events. Artist, painter, poet, editor and teacher noted for verbo-visual art works. Author of *It's Not Love, It's Love*, a bilingual edition published in Italy. Lives and works in England and San Francisco. Married to Jack Hirschman.

LAWRENCE FERLINGHETTI b. 1919, Yonkers, NY, to Italian-Portuguese Sephardic

parents. Officer in World War II. Journalism school at University of North Carolina, M.A. Columbia, Ph.D. Sorbonne, then settled in San Francisco. Poet, painter, publisher, political activist and cofounder of City Lights Books in 1953. In an historic court case, challenged the government's attempt to censor Allen Ginsberg's *Howl*, which he published. His book of poetry, *A Coney Island of the Mind*, sold over a million copies. The first Poet Laureate of San Francisco, he appeared as Lorenzo Monsanto in Jack Kerouac's *Big Sur*. Author of a dozen books, including plays and two novels. *Americus, Book I* received the Northern California Book Award (2005). Honors include the *Los Angeles Times* Robert Kirsch Lifetime Achievement Award, the first Literarian Award (2005), the National Book Award, and the Commandeur de l'Ordre des Arts et des Lettres from the French government (2006).

KAREN FINLEY b. 1956, Illinois. A performance artist based in New York and San Francisco, she graduated from the San Francisco Art Institute (1980). Author of *Shock Treatment* (City Lights Books, 1990). Lost a 1998 Supreme Court decision in NEA vs. Finley, which allows denial of grants for art considered indecent. An organizer of the Scream Out war protest in New York (2003), recipient of the Guggenheim Award.

RAYMOND FOYE b. 1957, Lowell, MA. Editor and creator with Francesco Clemente of Hanuman Books, publishers of forty-nine miniature books by writers including Jack Kerouac, John Ashbery and Patti Smith's *Woolgathering* (1992). Edited *Unknown Poe* for City Lights Books and two John Weiners collections for Black Sparrow Press. Curated *The Heavenly Tree Grows Downward* at the James Cohan Gallery in New York (2003).

ROBERT FRANK b. 1924, Zurich. Photographer and filmmaker, photojournalist and world traveler, he toured the US on a Guggenheim Fellowship in 1954, resulting in the photography book, *The Americans* (1958), with an introduction by Jack Kerouac. Collaborated with Alfred Leslie, David Amram and Jack Kerouac on the film *Pull My Daisy*. Retrospectives at the National Gallery of Art in Washington and Tate Gallery in London.

THE FUGS Ed Sanders, Ken Weaver and Tuli Kupferberg cofounded this band in 1965 in New York City. Attracted large audiences with satirical anti-Vietnam war songs such as "Kill for Peace." Performed with Allen Ginsberg, Gregory Corso, Janis Joplin and other counterculture icons. Recorded, performed and produced albums, with a fifteen year break, for forty years. In 1994, they released *The Real Woodstock Festival* CD.

RALPH GIBSON b. 1939, Los Angeles, CA. A photographer, he studied at San Francisco Art Institute. Assistant to Dorthea Lange and Robert Frank. Used black and white, abstracted, geometric and high contrast images. Interested in the expressive potential of photography books, he started Lustrum Press in 1969, publishing many of his own works.

DIZZY GILLESPIE (John Birks Gillespie) b. 1917, South Carolina. Was exposed to his father's band music as a child. Attended Laurinburg Institute in North Carolina on a music scholarship. Moved to Philadelphia in 1935. Trumpeter, band leader and composer, he joined Charlie Parker's band in 1945, which took jazz into the bebop era. Wrote the jazz classics *A Night in Tunisia* and *Manteca*, incorporating Cuban and African elements into his compositions. Died 1993.

ALLEN GINSBERG b. 1926, Newark, NJ. Attended Columbia University and met Jack Kerouac, William S. Burroughs, Neal Cassady and Herbert Huncke, the nucleus of the Beat movement. Prolific poet, writer, performer, traveler, Jew and Buddhist, tireless teacher, leader of the counterculture. Professor at Brooklyn College. Cofounder with Anne Waldman of the Jack Kerouac School of Disembodied Poetics at Naropa. Peter Orlovsky was his lifelong companion. His masterwork, *Howl and Other Poems* was published by City Lights Books, 1956. "Howl," the cry of a generation, was first read at the Six Gallery, San Francisco (1955). Numerous books of poetry and prose followed, including *Reality Sandwiches* (1963), *White Shroud: Poems 1980–1985* (1986), *Cosmopolitan Greetings: Poems 1986–1992* (1994) and *Death & Fame: Poems 1993–1997* (1999), and two collections of his own photographs, including *Kaddish and Other Poems*

(1961) written for his mentally ill mother, Naomi. Won the 1974 National Book Award for *The Fall of America, Poems of These States* (1973). A member of the American Academy of Arts and Letters. Awarded the medal of Chevalier de l'Ordre des Arts et Lettres by the French minster of culture. Died 1997.

JOHN GIORNO b. 1936, New York, NY. Associated with Andy Warhol and starred in his movie, *Sleep*. Involved with using technological innovations in poetry: Started Dial-A-Poem and Giorno Poetry Systems which produced the spoken word audio anthology *Cash Cow 1965–1993*. An AIDS activist.

PHILIP GLASS b. 1937, Baltimore, MD. Played violin at six, flute at eight. Graduated from the University of Chicago at nineteen, and went to New York to study at the Juilliard School. Influenced by composers Charles Ives and Harry Partch, he scored Robert Wilson's *Einstein on the Beach* and *Hydrogen Jukebox* with libretto by Allen Ginsberg based on Ginsberg's poetry. Also composes operas, works with dancers such as Twyla Tharp and performs with The Philip Glass Ensemble. World premiere of *Symphony No. 7* at the John F. Kennedy Center for Performing Arts in Washington, DC (2005).

ARI GOLD b. 1970, to author Herb Gold and his wife Melissa. Actor, writer and director, he grew up in San Francisco and went to Columbia University. Named one of *Filmmaker* Magazine's "25 Faces to Watch" in independent film. Won a Student Academy Award for *Helicopter*, his short on his mother's death in a helicopter crash with Bill Graham. Ukulele player for his "Hawaiian-Appalachian glam rock" band, The Honey Brothers. (*Village Voice*).

HERBERT GOLD b. 1924, Ohio. Novelist and travel writer, author of over eight books. Knew Allen Ginsberg, Jack Kerouac and David Amram. Although not "Beat" himself, he wrote a memoir of those times in *Bohemia* (1994). His first novel was *Birth of a Hero* (1951) and his most acclaimed was *The Man Who Was Not With It* (1956). Published *Haiti—Best Nightmare on Earth* (2001). Lives and works in San Francisco.

CAROLINA GOSSELIN b. 1938, Quebec. Featured in the "Bandaged Poet Series" with photographs by Ira Cohen, her companion.

WAVY GRAVY (Hugh Romney) b. 1936, New York, NY. A performer, author and activist clown, his group, the Hog Farm, ran a free kitchen and provided security at the Woodstock Music Festival. Cofounder of Seva, a charity combating blindness in the Third World. Codirector of Camp Winnarainbow, teaching performance skills to children and adults. Author of *Something Good For A Change: Random Notes On Peace Thru Living*. Has a Ben & Jerry's Ice Cream flavor named for him.

BARBARA GUEST b. 1920, North Carolina. Graduated from UC Berkeley, moved to New York, and was befriended by poets and painters of the New York School. Poems published by Hettie Jones and Diane di Prima in *The Floating Bear* and *Yugen*. Wrote reviews and articles, many for *ArtNews*. Author of more than twenty books of poems, a novel, a collection of essays and *Herself Defined: The Poet H.D. and her World*, the definitive biography of the imagist poet. Received the Robert Frost Medal from Poetry Society of America. Died 2006.

LOU HARRISON b. 1917, Portland, OR. Composer, poet, painter, teacher and calligrapher, he studied with Henry Cowell, Arnold Schoenberg and worked with John Cage. Moved to New York, conducted the premiere of Charles Ives *Symphony No. 3* and wrote the opera *Rapunzel* while on a residency at Black Mountain College. Moved to Aptos and taught at San Jose State, where he designed and built gamelans with his partner, William Colvig. Received a Rockefeller and two Guggenheim Fellowships. Died 2003.

HOWARD HART b. 1927, Cincinnatti, OH. Traveled in France, lived in New York. A poet, he studied with Leonard Bernstein and performed his first jazz/poetry readings with Jack Kerouac, David Amram and Philip Lamantia at Circle in the Square, New York City. Wrote theater and book reviews for *The Village Voice*. Author of *Beauty* (City Lights Books, 1988) and *One Third Inn* (Deep Forest, 2001). Collaborated with his companion, poet/publisher Tisa Walden. Died 2002.

BROTHER PATRICK HART. Secretary to Thomas Merton, he devoted his life to the literary works of Merton, editing seven volumes of Merton's *Journals* and coediting *The Intimate Merton: His Life from His Journals*. Received an honorary doctorate from Bellarmine University. Lives at Gethsemani Monastery in Kentucky where he celebrated the Golden Anniversary of his monastic profession in 2004.

ROBERT HASS b. 1941, San Francisco, CA. Influenced by the San Francisco literary scene, received Ph.D. in English from Stanford. Author of four books of poems, *Field Guide* (selected by Stanley Kunitz, Yale Younger Poets Award, 1973), *Praise* (1979), *Human Wishes* (1989) and *Sun Under Wood* (1996). Co-translator of poetry collections with Nobel Laureate Czeslaw Milosz, edited and translated *The Essential Haiku* (1994). *Twentieth Century Pleasures: Prose on Poetry* (1984) won the National Book Critics Circle Award for Criticism. A chancellor of The Academy of American Poets and professor at UC Berkeley, he received a MacArthur Grant and was US Poet Laureate from 1995–1997.

BOBBIE LOUISE HAWKINS b. 1930, Texas. Studied in England, Japan and New Mexico. Married to Robert Creeley. Author of fifteen books of prose and poetry, she is also an actor, artist, illustrator and playwright who often performs with Rosalie Sorrels. Her paintings and collages were exhibited at Gotham Book Mart (1974). Awarded an NEA Fellowship. Teaches at Naropa in Boulder, Colorado.

GEORGE HERMS b. 1935, Woodland, CA. Assemblage artist and avant-garde junk sculptor who also makes mixed media collages, drawings and paintings. First solo show in 1957. Has shown in dozens of solo and group exhibits. Was a friend to many of the Beats he portrayed in his works. Started The LOVE Press in the 1960s and produced woodcuts of poems by Michael McClure, Diane di Prima, Jack Hirschman and others. Recipient of the Prix de Rome. Retrospective at Santa Monica Museum of Art (2005).

JACK HIRSCHMAN b. 1933, New York, NY. Taught at UCLA, was fired because of his opposition to the Vietnam War, and moved to North Beach, San Francisco in 1973. Was active in the Union of Left Writers and a member of the Communist Labor Party. Has translated over fifty-five books from nine languages and published more than a hundred books of poems, essays and translations, including *Front Lines: Selected Poems* (City Lights Books, 2002). *The Arcanes 1972–2006*, was published in a 1000-page, English edition by Multimedia Edizioni. In 2006 he was declared the fourth Poet Laureate of San Francisco.

DAVID HOCKNEY b. 1937, England. Went to New York in 1961, met Andy Warhol and Dennis Hopper and traveled extensively. Attracted by the lifestyle and freedom, he moved to California. Wrote *David Hockney* (1976), a book about his work, and was subject of film, *A Bigger Splash*. Incorporates poetry into his work and uses photos and new technologies as a painter, photographer, printmaker, author and set designer for operas such as the *Magic Flute* and *Turandot*. Lives in the Los Angeles area.

ABBIE HOFFMAN b. 1936, Worcester, MA. Cofounded Youth International Party (Yippies) and was one of the Chicago Seven, who were arrested and accused of rioting at the 1968 Democratic Party Convention in Chicago. Arrested for possession of cocaine in 1973, he fled when faced with a mandatory life sentence. Went to prison in 1980. Upon release he continued his work as an activist and writer. Committed suicide in 1989.

ANSELM HOLLO b. 1934, Helsinki, Finland. A prolific poet and translator, he translated Allen Ginsberg's *Howl* into Finnish. More than thirty books of his poetry and translations have been published. In 2001, poets and critics associated with the SUNY at Buffalo POETICS listserv elected Hollo to the honorary position of anti-laureate, in protest to the appointment of Billy Collins as US Poet Laureate. Taught at Naropa University, Boulder, Colorado, and other colleges and universities.

JOHN CLELLON HOLMES b. 1926, Holyoke, MA. In New York City he met and used the characters of Allen Ginsberg, Jack Kerouac and Neal Cassady in his novel, *GO* (1952). His 1952 essay, "This is the Beat Generation," was the birth announcement for a new generation. Lifelong friend of Jack Kerouac, he was first to read the manuscript of *On the Road*. A social commentator, writer of poetry, essays and novels, he taught at Bowling Green, Yale, Brown and the University of Arkansas, where he developed the Creative Writing Program. Died 1988.

DENNIS HOPPER b. 1936, Dodge City, KS. Moved to California, at thirteen started acting at the Shakespearean Old Globe Theater in San Diego. A film actor, he appeared with James Dean in *Rebel Without a Cause* (1955) and *Giant* (1956). Studied with Lee Strasberg at The Actor's Studio in New York. Directed and acted in the independent, anti-establishment film *Easy Rider* (1969) with Peter Fonda. Oscar nomination for Best Supporting Actor in *Hoosiers* (1986), directed *Colors* (1988) and played Bruno Bischofberger role in *Basquiat* (1996).

HERBERT HUNCKE b. 1915, Massachusetts, raised in Chicago. Addicted to drugs as a teenager, drifted about, a petty criminal and settled in New York in 1940. Times Square hustler and heroin addict, he introduced William S. Burroughs to heroin and involved Allen Ginsberg in a theft charge that led to Ginsberg's psychiatric commitment and Huncke's incarceration. Participated in Kinsey's sex study, involved with Janine Pomy Vega, appears as Elmer Hassel in Kerouac's *On the Road*. Wrote *Huncke's Journal* (1965) and his autobiography *Guilty of Everything* (1990). Died 1996.

JOYCE JENKINS b. 1952, Michigan. Poet, author of *Portal* with introduction by Carolyn Kizer (1993). Has poem in Berkeley's Poetry Walk sidewalk. Since 1978, has been editor, then editor/publisher, of *Poetry Flash*, a poetry review and literary calendar for the West. Has presented *Poetry Flash* reading series with Richard Silberg since 1982 and the Watershed Environmental Poetry Festival with Mark Baldridge (a collaboration with Robert Hass) since 1996. Director/codirector of the San Francisco International Poetry Festival in 1978 and 1980. American Book Award (1994), National Poetry Association Award (1995), Bay Area Book Reviewers Publishing Award (1997) and PEN/Josephine Miles Lifetime Achievement Award (2006).

TED JOANS (Theodore Jones) b. 1928, on a riverboat in Cairo, IL. Father was a riverboat entertainer who left him in Memphis, at age twelve, with only a trumpet. Influenced by Langston Hughes, Charlie Parker and in 1951 joined the Greenwich Village scene, reading regularly at cafés. Became a surrealist painter, trumpeter and jazz poet. Author of *Teducation: Selected Poems*, with introduction by Gerald Nicosia (Coffee House Press, 1999). His jazz poems are collected in *Black Pow-Wow*. Lived in Paris, Seattle and Timbuktu. Artist Laura Corsiglia was his last great love and collaborator. Died in Vancouver, BC, 2003.

JOYCE JOHNSON (née Glassman) b. 1935, Queens, NY. Met Jack Kerouac in 1957 on a date arranged by Allen Ginsberg. A publishing company executive, in 1983 she wrote the first book to focus on Beat-era women, *Minor Characters*, which won the National Book Critics Circle Award. Published letters from her relationship with Kerouac, *Door Wide Open*, (2000). Lives in New York, writing and making personal appearances.

HETTIE JONES (née Cohen) b. 1934. Poet and author, she worked for *The Record Changer* jazz magazine where she met LeRoi Jones (Amiri Baraka) in Greenwich Village. They married, had two children, and divorced in 1968. Cofounded the literary magazine *Yugen*, publisher of Denise Levertov, Philip Whalen and Diane di Prima. *How I Became Hettie Jones,* a memoir of her marriage to Jones and the New York Beat scene, was published in 1997. Lives in New York where she is active in writing workshops for prisoners.

ELVIN JONES b. 1927, Michigan, to a musical family. Decided by thirteen to be a drummer. Enlisted in US Army in 1946 and served as a stagehand. Discharged in 1949, he became part of the Detroit music scene. An innovative percussionist, he backed visiting jazz greats Charlie Parker and Miles Davis, and moved to New York where he played with Charles Mingus, Cecil Taylor and John Coltrane. Recorded *A Love Supreme* and *Coltrane 'Live' at the Village Vanguard*. Died 2004.

BOB KAUFMAN b. 1925, New Orleans, LA. Ran away at thirteen and worked as a Merchant Marine for twenty years, met fellow seaman, Jack Kerouac, and moved to San Francisco in 1958. Became famous for his street jazz poetry performances from the late 1950s to 1970s, influenced by Charlie Parker. His first published poem, *Abomunist Manifesto* was printed as a broadside by City Lights (1959). Cofounder of *Beatitude*, a poetry magazine. Was often arrested and suffered periods of withdrawal. Eventually became a Buddhist. Wrote *Golden Sardine* and *Solitudes Crowded With Loneliness*, *The Ancient Rain Poems 1956–1978* published by New Directions (1981). Died 1986.

EILEEN KAUFMAN b. 1922. Part of the North Beach Beat scene, married Bob Kaufman in 1958. Worked on *Beatitude* literary magazine and prepared Kaufman's first collection of poems for publication by New Directions. Transcribed much of Kaufman's oral street poetry into written form. Worked as a journalist, writing about rock music for the *Los Angeles Free Press*, *Oracle* and *Billboard*.

JACK KEROUAC b. 1922, Lowell, MA, into a working-class, French-Canadian, Roman Catholic family. Attended Columbia University in New York City on an athletic scholarship but broke his leg. Was influenced by Thomas Wolfe, met writers and characters like Allen Ginsberg, William S. Burroughs, Herbert Huncke and Neal Cassady and formed the nucleus of the Beat movement. Novelist, poet and artist who famously chronicled his adventures in *On the Road* (1957). A Catholic with a Buddhist streak, he was also an alcoholic and described his own disintegration in the novel, *Big Sur* (1962). Died 1969.

JAN KEROUAC b. 1952, Albany, NY. Daughter of Jack Kerouac, she grew up in New York's Lower East Side, traveled extensively in Mexico and South America in her teens and early twenties, and returned to live with her mother Joan Haverty Stuart in Oregon in the late 1970s. Wrote the critically acclaimed autobiographical novels *Baby Driver* (1981) and *Trainsong* (1988). Died 1996.

KEN KESEY b. 1935, La Junta, CO. Raised in Oregon. Received a Woodrow Wilson Fellowship to attend the Creative Writing Program at Stanford where he met Timothy Leary and participated in psychedelic drug experiments. Worked as an orderly at a VA hospital, the basis for his novel *One Flew Over the Cuckoo's Nest* (1962), made into a film by Milos Forman starring Jack Nicholson (1975). A 1964 book tour for *Sometimes a Great Notion* took the form of a cross country bus trip with his friends, aka the Merry Pranksters, with Neal Cassady driving. *The Electric Kool Aid Acid Test* by Tom Wolfe novelized their adventures. Died 2001.

ED KIENHOLZ b. 1927, Fairfield, WA. Briefly attended college before moving to Los Angeles in 1955. He and Nancy Reddin, his wife and collaborator, created found object assemblage sculptures and tableaux that were also satirical anti-establishment social commentaries. Traveled the world seeking treasures to incorporate into art and worked at studios in Idaho, Houston and Berlin. Died in Idaho, 1994.

RAHSAAN ROLAND KIRK b. 1936, Ohio. He studied at Ohio State School for the Blind, where at twelve he was playing both saxophone and clarinet in the school band. His style is based in the American jazz tradition; he worked with Charles Mingus in 1961 on the album *Oh Yeah*. In 1963, he started touring internationally with his own quartet, playing either tenor sax or manzello. Performed until his death in 1977.

KENNETH KOCH b. 1925, Cincinnati, OH. Interested in poetry as a child. Served with the US Army in the Philippines during World War II and attended Harvard on the G.I. Bill. Taught at Columbia University and wrote groundbreaking books about teaching children to write poetry. He collaborated with many artists, especially on books illustrated by Larry Rivers. Received a Guggenheim Award in 1961. Wrote *On the Great Atlantic Rainway: Selected Poems 1950–1988,* published by Knopf (1994). Awarded the Bollingen Prize (1995). Died 2002.

PAUL KRASSNER b. 1932, Brooklyn, NY. Became an atheist at thirteen when the atomic bomb was dropped on Japan. Radical journalist, satirist, founder and editor of the leftist publication, *The Realist*. Cofounder with Abbie Hoffman and Jerry Rubin of the Youth International Party, The Yippies. One of the Chicago Seven,

he was tried for disrupting the Democratic National Convention in Chicago in 1968. Author of *Confessions of a Raving, Unconfined Nut* and *Murder at the Conspiracy Convention and Other American Absurdities.*

JILL KREMENTZ b. 1940. Noted for hundreds of intimate photographs of writers. Author of a series of educational children's books published by Knopf featuring *A Very Young Skater, Very Young Dancer* and others dealing with feelings and adversities, such as *How it Feels to be Adopted*. Married author Kurt Vonnegut in 1979. Solo show at Hartford's Mark Twain House, 2004.

SEYMOUR KRIM b. 1922, New York, NY. Writer, poet, essayist, social commentator and part of the "New Journalism" movement, with articles published in *Partisan Review* and *Village Voice*. In 1960, he edited the anthology, *The Beats*. Wrote the introduction to Jack Kerouac's *Desolation Angels* and his own memoir, *Notes of a Nearsighted Cannoneer*, among other books. Taught at Columbia, received a Guggenheim Fellowship, 1976. Committed suicide 1989.

TULI KUPFERBERG b. 1923. Counterculture poet, cartoonist and cofounder with Ed Sanders of 1960s anarchist rock band The Fugs, recently revived with two recordings on the New Rose label. Author of over twenty books, including *1001 Ways to Beat the Draft* and *1001 Ways to Live Without Working*. Publisher of *Birth* and producer of "Revolting News" on Cable TV. Lives and works in New York's Soho.

JOANNE KYGER b. 1934, Vallejo, CA. Lived as a child in China, Florida, Detroit and Honolulu. Educated at Santa Barbara College. Moved to San Francisco in 1957 and connected with other poets, including Jack Spicer and Robert Duncan. Traveled in Japan with then husband Gary Snyder. Went to India with Snyder, Allen Ginsberg and Peter Orlovsky. Wrote *Strange Big Moon: Japan and India Journals 1960–1964* (2000). Author of more than twenty books of poetry and prose, her first book was *The Tapestry and the Web* (1965). A Zen Buddhist, she lives in Bolinas, teaches at San Francisco's New College, and Naropa in Colorado.

STEVE LACY b. 1934, New York, NY. A musician, composer and teacher, he started performing as a teenager playing Dixieland revival in the 1950s, then played free jazz with Cecil Taylor, accompanied by pianist Mal Waldron and singer/violinist Irene Aebi. Moved to Italy in 1967, then to Paris in 1969. Awarded MacArthur Fellowship in 1992. Died 2004.

PHILIP LAMANTIA b. 1927, San Francisco, CA. Only child of Sicilian Catholic immigrants. Began writing Surrealist poetry at sixteen, traveled to New York City, and met André Breton, who declared he was "a voice that rises once in a hundred years." In New York he also met Allen Ginsberg, Howard Hart and Jack Kerouac. Appears as the character David D'Angeli in Kerouac's *Desolation Angels*. Reader in 1955 at the famed Six Gallery event in San Francisco, where Ginsberg first performed "Howl." In 1997, City Lights published *Bed of Sphinxes: New and Selected Poems 1943–1993*. Died 2005.

ROBERT LaVIGNE b. 1928, St. Maries, ID. Moved to San Francisco in 1951. Painter, illustrator, Obie Award-winning theater designer and art director at Auerhahn Press, he also created posters, illustrations and graphic arts for Allen Ginsberg, and designed the cover for John Weiners' *Hotel Wentley Poems*. His large nude painting of his friend, Peter Orlovsky, impressed Allen Ginsberg, who promptly fell in lifelong love with Orlovsky. Appears as the character Rene Levesque in Jack Kerouac's *Desolation Angels*.

TIMOTHY LEARY b. 1920, Massachusetts. Received a Ph.D. from UC Berkeley in 1950. Taught at Berkeley and lectured at Harvard. Researched psilocybin in Mexico and performed experiments with legal LSD, hoping to find a cure for alcoholism. Dismissed from Harvard and imprisoned on drug charges. He broke out of jail, was recaptured in 1974 and freed in 1976. Associated with Weather Underground and Black Panthers. Author of over thirty-five books, including *Start Your Own Religion* (1967), *The Politics of Ecstasy* (1968), *Your Brain is God* (1988) and *Evolutionary Agents* (2004). Died 1996.

PHOEBE LEGERE New York-based singer, composer, songwriter, interdisciplinary performer and visual artist. She plays piano, guitar, violin, accordion and harmonica, and sings with a greater than four-octave voice. An influential member of the downtown performance scene in the 1980s and 1990s, she now focuses on experimental forms. Debuted as a composer at Carnegie Hall in 1987. Her best known song is "Marilyn Monroe" from the film *Mondo New York* (1988). Appears in the film, *The Naked Brothers Band* (2005).

ALFRED LESLIE b. 1927, New York, NY. A filmmaker and painter, he began exhibiting in 1947. Co-directed *Pull My Daisy* with Robert Frank, the 1959 Beat-era short film featuring Jack Kerouac, Allen Ginsberg, Peter Orlovsky, Larry Rivers, Richard Bellamy and David Amram. The film was selected for the National Film Registry by the Library of Congress. Founding editor of *The Hasty Papers*, an art and literary magazine. His video, *The Cedar Bar*, premiered at the London Film Festival in 2002.

DENISE LEVERTOV b. 1923, England. Leading poet who was first published in *Poetry Quarterly* at seventeen. A civilian nurse in London during the bombings in World War II. Her first book of poetry was *The Double Image* (1946). Married an American, moved to the US and was influenced by the Black Mountain poets Robert Duncan, Charles Olson and Robert Creeley. Some of her work was published in the 1950s *Black Mountain Review*. She received the Lenore Marshall Prize for *The Freeing of the Dust* (1975). Published more than twenty books of poetry, four books of prose, and translations. Taught at Stanford University (1982–1993) and spent her last decade in Seattle. Died 1997. *The Letters of Robert Duncan and Denise Levertov* (Stanford University, 2003) have been widely reviewed.

JOHN LOGAN b. 1923, Iowa. Poet who wrote in the confessional style, he was married, divorced and had nine children. He abandoned Catholicism, but religious and metaphysical concerns were lifelong themes, beginning with his first book, *A Cycle for Mother Cabrini* (1955). Poetry editor of *The Nation* and Professor at SUNY Buffalo, 1966–1985. Honors include a Rockefeller Grant, Guggenheim Fellowship, a Zabel Award and Lenore Marshall Poetry Prize. Died 1987.

PHILOMENE LONG b. 1940, Greenwich Village, NY. A poet and film director, she collaborated with Allen Ginsberg on

the film *The Beats: an Existential Comedy*. Directed seven films, including *The California Missions* with actor Martin Sheen. Author of eight books, including *The Queen of Bohemia* and coauthor of *The Ghosts of Venice West* and *Bukowski in the Bathtub* with her husband and great love, poet John Thomas. Named Poet Laureate of Venice in 2005.

LEWIS MacADAMS b. 1944, Texas. Graduated from Princeton where he ran poetry readings. Poet, journalist and author of a dozen books of poetry including *The River, Books 1, 2 & 3*. Twice World Heavyweight Poetry Champion. Directed documentary films including *What Happened to Kerouac?* His work of cultural history is *Birth of the Cool: Beat, Bebop and the American Avant-Garde* (Simon & Schuster, 2001). Twenty years ago he started Friends of the Los Angeles River as a forty-year art project to bring the Los Angeles River back to life. Currently writing a biography of *Rolling Stone* founder Jann Wenner.

NORMAN MAILER b. 1923, New Jersey. Grew up in Brooklyn, served during World War II, then attended the Sorbonne. An innovator of the nonfiction novel form. Cofounder of *The Village Voice* and author of over forty books, he became famous at twenty-five with *The Naked and the Dead*. A Hollywood scriptwriter in the late 1940s, and anti-establishment essayist in the 1950s, he wrote a controversial book, *The White Negro* (City Lights, 1957). Jailed for anti-Vietnam war activities. Ran for Mayor of New York in 1969. Received two Pulitzer Prizes, one for *Armies of the Night* (1968), a nonfiction book about an anti-Vietnam war march on the Pentagon that won the National Book Award.

JUDITH MALINA b. 1926, Germany. Grew up in the US. Theater and film actor, writer and director who cofounded The Living Theatre in 1947 with her husband, Julian Beck, which staged dramas by writers including Gertrude Stein, Kenneth Rexroth and John Ashbery. Legal harassment entailed frequent moves. When Beck died in 1985, Malina continued leading workshops with Hanon Reznikov. A film actor, she had small roles in *Dog Day Afternoon* (1975), *The Addams Family* (1991) and *Household Saints* (1993),

and appeared in an episode of *The Sopranos* (2006).

RAY MANZAREK b. 1939, Chicago, IL. Graduated from UCLA film school where he met Jim Morrison. They founded the legendary rock band *The Doors* with Manzarek on keyboard from 1965 to 1973. Performs with poet Michael McClure and, since 2001, plays and tours with Riders On The Storm (formerly the Doors of the 21st Century). Author of *Snake Moon* (2006), a novel and Civil War ghost story, *Poet in Exile: A Journey into the Mystic* (2001) and his autobiography, *Light My Fire* (1998). A producer and movie director, lives with his wife Dorothy in Napa.

FRED W. McDARRAH b. 1926, Brooklyn, NY. A long-term picture editor and photographer for *The Village Voice*, he captured over five thousand images of the countercultural revolution with portraits of icons like Bob Dylan, Yoko Ono, John Lennon, Andy Warhol and Allen Ginsberg. Received a Guggenheim Award and two Page One Awards and has exhibited at the Whitney and Guggenheim Museums.

KAYE McDONOUGH b. 1943, Pittsburg, PA. Lived for many years in San Francisco, where she worked as a typesetter and started Greenlight Press, publishing Jack Micheline, Neeli Cherkovski and H.D. Moe. City Lights published her play, *Zelda: Frontier Life in America: a Fantasy in Three Parts* (1978). Gregory Corso is the father of her son, Nile.

MICHAEL McCLURE b. 1932, Kansas. Studied at the University of Wichita and the University of Arizona. First met Ginsberg at a party for W.H. Auden in 1955. The same year McClure read at the Six Gallery in San Francisco, alongside Ginsberg's first reading of "Howl." Cowriter of Janis Joplin's hit song, "Mercedes Benz." Author of the controversial play *The Beard* (winner of two Obies), and over thirty books of poetry, novels and essays. Honors include another Obie for *Josephine the Mouse Singer*, a Guggenheim, an NEA and a Rockefeller for playwriting. Poetry includes *Rain Mirror* (1999). Northern California Book Award winner for *Touching the Edge: Dharma Devotions from the Hummingbird Sangha* (1999), *Huge Dreams: San Francisco and Beat Poems* (1999), *Simple Eyes* (1994),

Rebel Lions, Selected Poems (1986), *September Blackberries* (1974) and *Dark Brown* (1967). Wrote about the Beats and eco-consciousness in *Scratching the Beat Surface: Essays on New Vision from Blake to Kerouac* (1982, new edition 1994) and *Lighting the Corners: On Art, Nature, and the Visionary* (1993). Performs poetry accompanied by Ray Manzarek on piano. Mystic Fire released *Love Lion*, a video of their collaboration. *Third Mind*, a documentary film about their collaboration, premiered at the Los Angeles County Museum in 1998.

AMY EVANS McCLURE San Francisco-based visual artist and sculptor who often works in ceramics, creating clay figures rooted in the myth and history of the East and West. Created the cover designs for *Rain Mirror* and *Lighting the Corners* by Michael McClure, her husband, and has designed poetry books for O Books, Oakland and other publishers.

JOANNA McCLURE (née Kinnison) b. 1930, Arizona. Raised in the desert near Oracle, then lived in Guatemala, returning to the US to attend the University of Arizona where she met Michael McClure, whom she later married. Moved to San Francisco in 1954, where she started writing poetry and studying child development. Her book *Wolf Eyes* (1974) is a poetic spiritual autobiography.

DUNCAN McNAUGHTON b. 1942. Received his Ph.D. from SUNY Buffalo. Influenced by Charles Olson and Ezra Pound. Often refers to mythic systems and incorporates languages such as Greek, Spanish and Arabic into his poetry. Friend of Philip Whalen, Joanne Kyger and Francesco Clemente. Has published twelve books of poetry, including *Capricci* and *Valparaiso*.

TAYLOR MEAD b. 1924, Detroit, MI. Poet and performer, star of Andy Warhol's 1968 film, *Lonesome Cowboy*. Won an Obie for his performance in Frank O'Hara's play, *The General Returns from One Place to Another*. His unpublished poetry notebooks, *Son of Andy Warhol*, are excerpted on the Internet. Performed with the Lower East Side All Stars at HOWLFEST, the fiftieth anniversary celebration of Allen Ginsberg's poem "Howl" in 2005. Lives and works in New York.

JONAS MEKAS b. 1922, Lithuania. His anti-Nazi activism left him a perpetual expatriate. After arriving in the US in 1949, he helped to develop "underground cinema" with films such as *The Brig*. Also a poet in his native Lithuanian language, publisher of *Film Culture* magazine and the diarist of a monumental visionary journal, he is a founding Director of the American Film Archives in New York City.

DAVID MELTZER b. 1937, Rochester, NY. Grew up in Brooklyn, moved to California as a teen. Poet, jazz guitarist and Cabalist scholar, he arrived in San Francisco about 1957 and began reading poetry with jazz maestros Pony Poindexter and Leo Wright in The Jazz Cellar. Fronted Serpent Power in the 1960s, a psychedelic band recorded by Vanguard and Capitol. Poetry books include *No Eyes: Lester Young* (Black Sparrow, 2002), *Beat Thing,* an extended poem on the life and times, (La Alameda, 2004) and *David's Copy, Selected Poems* (Penguin, 2005). Edited thematic anthologies, including *Birth: An Anthology of Ancient Texts, Songs, Prayers, and Stories* (1981), *Death: An Anthology of Texts, Songs, Charms, Prayers, and Stories* (1984), and the controversial anthologies, *Reading Jazz* (1996) and *Writing Jazz* (1999). Edited a collection of interviews, *San Francisco Beat: Talking with the Poets* (City Lights Books, 2001) and is coeditor of *Shuffle Boil* music magazine. Taught writing at Vacaville Prison, now a core faculty member of the Poetics Program at New College of California.

SARAH MENEFEE b. 1946, Chicago, IL. Poet, cultural organizer. Studied at New College of California. A homeless advocate, she was arrested in 1991 for giving away food without a permit. Has worked with Union of Left Writers and has a close friendship with Jack Hirshman. Author of *The Blood about the Heart* and *i'm not thousandfurs*, a work translated into Italian. Lives in San Francisco.

THOMAS MERTON'S GRAVE Located in Kentucky at the Trappist Monastery of Gethsemani where the monk, poet, theologian, pacifist and photographer lived. After his death in 1968, Merton enthusiasts continued reading his writings and have established the International Thomas Merton Society to catalogue and preserve his work.

W.S. MERWIN b. 1927, New York, NY. Son of a Presbyterian minister, he wrote hymns as a child. Studied creative writing at Princeton where he did postgraduate work in Romance languages. Worked as a tutor in France, Portugal and Majorca from 1949 to 1951. Author of more than fifteen books of poetry, including *Migration* (2005), winner of the National Book Award. *The Carrier of Ladders* (1970) won the Pulitzer Prize and *A Mask for Janus* (1952), selected by W.H. Auden, won the Yale Younger Poets Award. Translator of Latin, Spanish and French poetry, he has published nearly twenty books of translations, including *Dante's Purgatorio* (2000), plays and four books of prose, including *The Lost Upland* (1992), his memoir of life in the south of France, and *The Folding Cliffs: A Narrative of 19th-century Hawaii* (1998). Received Guggenheim and Rockefeller Fellowships, the Lenore Marshall and Bollingen Poetry Prizes, the Tanning Prize for mastery in the art of poetry and the Ruth Lilly Poetry Prize. He lives on Maui, Hawaii.

JACK MICHELINE (Harvy Martin Silver) b. 1929, the Bronx, NY. Traveled to educate himself and became a poet and painter in Greenwich Village. First book of poetry was *River of Red Wine* (1958), with an introduction by Jack Kerouac. Moved to San Francisco but still traveled often. Was a poet of the streets, reading his poetry aloud and speaking for the down and out. Wrote twenty books, including his final work *Sixty-seven Poems for Downtrodden Saints* (1997). Died 1998.

CZESLAW MILOSZ b. 1911, Lithuania. Polish poet, studied in Vilnius. Cofounded the avant-garde literary group Zagary in 1931 and worked for Polish Radio in the 1930s. Witnessed the Nazi destruction of Warsaw. After World War II he was a diplomat for the Polish communist government, moved to Paris and received political asylum. He published *The Captive Mind* (1953), *The Seizure of Power* (a novel) and won the Prix Littéraire Européen. In 1960, he began teaching Slavic Languages and Literature at UC Berkeley. Many of his poetry books were both translated and/or co-translated by Robert Hass and Robert Pinsky. *Selected Poems, 1931–2004* and *Legends of Modernity: Essays and Letters from Occupied Poland, 1942–1943* were published posthumously (2006). Received a

Guggenheim (1976), Neustadt International Prize for Literature (1978) and the Nobel Prize (1980). Died in Poland, 2004.

WADDIE MITCHELL b. 1950, Elko, NV. Was raised on a ranch and quit school at sixteen to be a real life cow puncher and ranch hand, storyteller and poet. In 1984, he helped organize the first National Cowboy Poetry Gathering now held each year in Elko, then became a writer and performer. Teaches at the University of Wyoming.

JACK MUELLER b. 1943, St. Louis, MO. Poet and author of *Prussian Blue, Traces* and *The Paramorphs*, he has lived in New Orleans and San Francisco. Director of The Art and Science Museum in McAllen, Texas, during late 1990s. Lives in the Colorado Rockies where he performs his poetry.

NAROPA UNIVERSITY Formerly known as Naropa Institute, a private, nonprofit, nonsectarian liberal arts university in Boulder, Colorado, founded by the Buddhist teacher Rinpoche in 1974. It is the first accredited Buddhist college in the Western world, characterized by its unique Buddhist educational heritage. The Jack Kerouac School of Disembodied Poetics, cofounded by Allen Ginsberg and Anne Waldman at Naropa Institute in 1974, administers the summer, undergraduate and graduate writing programs. In 1994, a week-long tribute to Allen Ginsberg, "Beats and Other Rebel Angels," was held and Allen Ginsberg's photographic archives were exhibited. Participants featured included Anne Waldman, Gregory Corso, Lawrence Ferlinghetti, David Dellinger, Amiri Baraka, Phillip Glass, Ken Kesey, Jack Collom, Robert Creeley, Marianne Faithfull, Ed Sanders, Gary Snyder, Sharon Olds, Bobbie Louise Hawkins, Anselm Hollo, Keith Abbott, Steven Taylor, Meredith Monk, David Amram, Dennis Brutus, Galway Kinnell, Francesco Clemente, Michael McClure and Cecil Taylor. In 1982, On the Road, The Jack Kerouac Conference, also featured Ferlinghetti, Amram, McClure, Snyder and Corso, and was joined by William S. Burroughs, Robert Frank, Ted Berrigan, Diane di Prima, Timothy Leary, Abbie Hoffman and Andrei Voznesensky.

ROBERT NEWROCK b. 1936, Freedom, PA. Was a Merchant Marine and became an

abstract expressionist painter and sculptor. Attended The Art Student's League of New York on a Ford Foundation Grant. Recipient of a Rockfeller Grant.

GERALD NICOSIA b. 1949, Illinois. Cultural historian, activist and poet, he wrote *Memory Babe*, a definitive biography of Jack Kerouac. A former draft resister, he published a comprehensive study of Vietnam veterans in *Home to War: A History of the Vietnam Veterans' Movement*. Author of a book of poetry, *Love, California Style*. He lives in Northern California, where he is studying the death penalty for a book about Mumia Abu-Jamal. Travels and lectures about the Beats, veterans, the death penalty and social justice.

HAROLD NORSE b. 1916, the Bronx, NY. A poet, he received his M.A. from New York University and was secretary to W.H. Auden. *The Undersea Mountain* (1953) was his first book. Lived at the Beat Hotel in Paris. Formed friendships with Tennessee Williams, James Baldwin, William S. Burroughs and Allen Ginsberg. Author of *Memoirs of a Bastard Angel* (1989) and *In the Hub of the Fiery Force: Collected Poems 1934–2003*. Moved to California in 1968 and now lives in San Francisco.

ALICE NOTLEY b. 1945, Bisbee, AZ. Grew up in Needles, California. Graduated from Barnard College and received her M.F.A. from the University of Iowa. A second-generation New York School poet, she has published over twenty books. *How Spring Comes* (1981) won a San Francisco State University Poetry Center Book Award, and *Disobedience* (2001) won the International Griffin Poetry Prize. Married poet Ted Berrigan in 1972 and had two sons, Anselm and Edmund. Widowed in 1983, she married British poet Douglas Oliver. Lives in Paris, where she makes visual art, writes and edits *Gare du Nord* magazine.

ODETTA b. 1930, Birmingham, AL. Was raised in California and studied music at Los Angeles City College. In 1953, she went to New York where musicians such as Harry Belafonte and Pete Seeger included her in the musical scene. A guitarist, singer and virtuoso rhythmic hand clapper, she performed many times at the Newport Folk Festival, Carnegie Hall and at the March on Washington in 1963. Her 1999 album,

Blues Everywhere I Go, was nominated for a Grammy.

FRANK O'HARA b. 1926, Baltimore, MD, raised in Massachusetts. Served in the Navy and attended Harvard and the University of Michigan, where he received the prestigious Hopwood Award. Worked for fifteen years at the Museum of Modern Art in New York City, where he wrote poems at lunch time. Published eight books of poetry, including *Lunch Poems* (City Lights Pocket Poets, 1964) and *Meditations in an Emergency* (1956), and two books on art. *Collected Plays* (1971) was published after his death. Wrote reviews for *ArtNews* and essays on painting and sculpture. Inspired by painters Larry Rivers, Jackson Pollock and Jasper Johns, he was at the center of the New York School, which included poets John Ashbery and Kenneth Koch. Sought to recreate in words the works these artists created, and collaborated with painters to make poem-paintings. Killed in a sand buggy accident on Fire Island, 1966.

TATUM O'NEAL b. 1963, Los Angeles, CA. Daughter of actor Ryan O'Neal. A child star, she won an Oscar for Best Supporting Actress in *Paper Moon* (1974). Has appeared in dozens of roles since then, including the counterculture film *Basquiat* (1996). Wrote about her turbulent life and career in her autobiography *A Paper Life* (2004). She continues acting, recently in the film *My Brother* (2005).

PETER ORLOVSKY b. 1933, New York, NY. Dropped out of high school, was a medic in the US Army during the Korean War, then became an artist in San Francisco. In 1954, he met Allen Ginsberg, his companion for forty years, through painter Robert LaVigne. Ginsberg encouraged him to write. Author of *Straight Hearts Delight: Love Poems and Selected Letters* (1980) and *Clean Asshole Poems & Smiling Vegetable Songs* (City Lights Pocket Poets, 1978). Reads his poetry and continues to be an activist, involved in anti-nuclear, anti-war, pro-marijuana and gay rights issues.

GRACE PALEY b. 1922, the Bronx, NY. Graduated from Hunter College and studied at the New School. Short story writer, poet, feminist and peace activist, she cofounded the Greenwich Village Peace Center in 1961. Short fiction

collections are *The Little Disturbances of Man (1959)*, *Enormous Changes at the Last Minute* (1974) and *Later the Same Day* (1985); Published three collections of poetry. Recipient of a Guggenheim and an NEA. Taught at Sarah Lawrence College, Columbia University and other colleges. Named the first New York State writer by Governor Mario Cuomo in 1989. She lives in New York City and Vermont.

NANCY JOYCE PETERS b. 1936, Pacific Northwest. Once a librarian at the Library of Congress, she began working at City Lights Books in 1971; she is now editor-in-chief of City Lights Books and edits the *City Lights Review*. Coauthor with Lawrence Ferlinghetti of *The Literary World of San Francisco: A Pictorial History of Its Beginnings to the Present Day*. Also a poet, author of *It's in the Wind* (1977). Widow of Philip Lamantia. Lives in San Francisco.

GEORGE PLIMPTON b. 1927, New York, NY. Editor, literary patron, actor, writer and participatory journalist, in 1953 he joined *The Paris Review* and became its first editor-in-chief, interviewing emerging writers including Ernest Hemingway, Philip Roth and Jack Kerouac. In 1963, he wrote *Paper Lion* about playing football with the Detroit Lions, then *Open Net* on attempting ice hockey and *The Bogey Man* on golf. Involved in politics, he was present at the Robert Kennedy assassination in Los Angeles. He appeared in over fifteen films and television shows. A member of the American Academy of Arts and Letters. Died 2003.

DAN PROPPER b. 1937, Coney Island, NY. A poet and translator, he studied at The New School with Stanley Kunitz, then traveled to San Francisco and Denver. His long poem *Fable of the Final Hour* was published by Seymour Krim in the 1960s anthology *The Beats*. Author of *For Kerouac in Heaven* (1980). Died 2003.

SUN RA (Herman Poole Blount) b. 1914, Birmingham, AL. Encouraged early on by his high school music director. Moved to Chicago where he played piano, arranged music and toured with B.B. King. A jazz band leader and composer of outer-space-themed "cosmic jazz," he started the band Arkestra. During the late 1950s Arkestra began wearing Egyptian or science fiction costumes while playing. They moved to

New York, toured internationally and performed at the Pyramids in Egypt in 1971. His large number of recordings include *Greatest Hits: Easy Listening for Intergalatic Travel* and *Space is the Place*. Though he declared himself from Saturn, he lived in Philadelphia and experimented with electronic music as a composer and performer until his death in 1993.

JAMI CASSADY RATTO b. 1950. Daughter of Neal Cassady, she appears frequently in Jack Kerouac's books. Knew Allen Ginsberg and Ken Kesey. Married with one daughter, lives near Santa Cruz and sometimes appears at poetry events.

ROBERT RAUSCHENBERG b. 1925, Port Arthur, TX. Studied pharmacy at University of Texas in Austin, was drafted into the Marines and served at a San Diego hospital. A painter of mixed media whose works include photos, silk screens, furniture and sculpture, he began what would become an artistic revolution with artists such as dancer Merce Cunningham and composer John Cage at Black Mountain College in the early 1950s. Moved to New York, where his love of popular culture and rejection of the too serious aspects of abstract expressionism led him to find a new way of painting, and used unusual materials including found objects and technology. First solo exhibition at the Leo Castelli Gallery in 1958. Large retrospective at Guggenheim Museum in 1997. Lives and works at his studio in Captiva, Florida.

JOHN RECHY b. 1934, El Paso, TX. A writer who often portrays the dark side of the gay lifestyle, *City of Night* (1963), based on his early experiences, was controversial when published. It was named one of the twenty-five all time best gay novels by the Publishing Triangle in New York. *The Sexual Outlaw: A Documentary* was named by the *San Francisco Chronicle* as among the 100 best non-fiction books of the century. Also a playwright, *Tigers Wild* was performed off Broadway (1986–1987) and produced in L.A. as *The Fourth Angel,* starring Sarah Jessica Parker. His one-act play, *Momma As She Became—But Not As She Was,* has been widely anthologized and performed. First novelist to receive the PEN USA West Lifetime Achievement Award, he also received The Publishing Triangle's William Whitehead Lifetime Achievement

Award. Teaches writing at the University of Southern California.

LOU REED b. 1942, Long Island, NY. Played in bands while in high school. Attended Syracuse University where he was mentored by poet Delmore Schwartz, who taught him the value of simple street vernacular. Moved to New York City, where he worked as a songwriter and became founding member of the band Velvet Underground in 1965. Worked with Andy Warhol producing mixed media happenings. Songs like "Walk on the Wild Side" led to his 1990s induction into the Rock and Roll Hall of Fame.

MARC RIBOT b. 1954, Newark, NJ. Moved to New York City in 1978. An avant-garde guitarist influenced by his mentor, Haitian guitarist Frantz Casseus, he played with Allen Ginsberg and Elvis Costello. Leader of the band *Los Cubanos Postizos,* he also plays with his trio *Ceramic Dog* and group *Spiritual Unity.*

SUSANNA RICKSON Third wife of poet William Everson, whom she met as Brother Antoninus in 1965 when he counseled her at Saint Albert's Priory in Berkeley. After nearly twenty years there, he left the Dominican Order in 1969, reverted to William Everson, and married Rickson. They were divorced in 1993 after twenty-two years of marriage. They lived near Santa Cruz, California.

LARRY RIVERS b. 1923, the Bronx, NY. Declared unfit for military service in 1943, he worked as a saxophonist in New York then attended the Juilliard School of Music. Began painting in 1945. A figurative painter and sculptor, he worked with air brushes and spray cans. He was also affiliated with abstract expressionism and pop art. Friend of Willem de Kooning and Jackson Pollock, he collaborated with the New York School, and Beat writers and poets. Died 2002.

RACHEL ROSENTHAL b. 1926, Paris, France, of Russian parentage. Studied in Paris and New York with Hans Hoffmann and Merce Cunningham. An interdisciplinary solo performer, her technique is called DbD, "doing by doing." Moved to California in 1955, where she created the experimental Instant Theatre, performing and directing for ten years. A leading figure in the L.A. Women's Art Movement in

the 1970s, she cofounded Womanspace, among other projects. Since 1975, Rosenthal has focused primarily on creating new works, and writing, performing and teaching. The Rachel Rosenthal Company, based in Los Angeles, formed in 1989. Received an Obie (1989) and the *L.A. Weekly* Theater Career Achievement Award (1997).

BARNEY ROSSET b. 1922, Chicago, IL. Served in World War II. Produced the feature film *Strange Victory* in 1958. Moved to New York in 1951 and purchased Grove Press, turning it into a controversial alternative press, publishing William S. Burroughs, Allen Ginsberg, Lawrence Ferlinghetti and Jack Kerouac. Promoted Beat authors, fought many censorship lawsuits and finally won the right to publish Henry Miller, D.H. Lawrence and William S. Burroughs. The Supreme Court, in a landmark 1964 decision, affirmed his free speech right to publish Miller's *Tropic of Cancer.* Introduced Americans to a range of writers, including Samuel Beckett, Jean Genet, Eugène Ionesco and Harold Pinter. Married abstract expressionist painter Joan Mitchell in Paris in 1949 and divorced in 1952. Awarded the French title Commandeur de l'Ordre des Arts et des Lettres in 1999.

EUGENE RUGGLES b. 1936, Michigan. A poet influenced by the work of Galway Kinnell, Walt Whitman and Robinson Jeffers, he held numerous jobs as a gardener and seaman. His book, *The Lifeguard in the Snow* (University of Pittsburgh Press, 1977), received the Great Lakes Colleges Association Award and was nominated for a Pulitzer Prize. His poems were published in *The New Yorker, Poetry, The Nation, The Paris Review, Hudson Review* and *Poetry Northwest.* Lived in San Francisco's North Beach and organized several landmark poetry readings. Spent his last years in Petaluma, California. Died 2004.

ED SANDERS b. 1939, Kansas City, MO. Graduated from New York University in 1964 with a degree in the classics. In 1965, he cofounded, with Tuli Kupferberg, the satirical folk-rock band *The Fugs.* Invented original musical instruments, including the "talking tie." Published *F**k You: A Magazine of the Arts* and wrote *The Family* (1971), a profile of the Manson Family

and account of the Tate murders. In 1975, published *Tales of Beatnik Glory,* short fiction on 1960s Greenwich Village (new edition, 2005), and opened Peace Eye Bookstore. A poet, he lectures on poetry pursued as investigative journalism in the tradition of Charles Olson. Published *Investigative Poetry* (City Lights, 1976). His books include *America: A History in Verse* (covers 1940–70, two volumes, 2000, 2002) and *1968: A History in Verse* (1997). Received a Guggenheim, NEA Award and an American Book Award for his collected poems, *Thirsting for Peace in a Raging Century* (1988). Lives in Woodstock, New York, where he publishes *Woodstock Journal,* a community newspaper.

JAMES SCHUYLER b. 1923, Chicago, IL. Attended Bethany College, served in US Navy during World War II and moved to Manhattan in the late 1940s where he worked for NBC and met W.H. Auden. Moved to Italy in 1947 where he lived in Auden's apartment and worked as his secretary, briefly attended the University of Florence, then moved back to New York. Poet, critic for *ArtNews* and staff member at the Museum of Modern Art. Associated with Frank O'Hara, John Ashbery (with whom he wrote a novel, *A Nest of Ninnies*), Kenneth Koch, Barbara Guest and other central poets of the New York School. His poems are accessible as journal entries. Books of poetry included *Freely Espousing* (1969), *What's For Dinner?* (1978), *Just the Thing: Selected Letters of James Schuyler* (1994) and *Collected Poems* (1995). Received a Guggenheim Fellowship and Pulitzer Prize for *The Morning of the Poem* (1981). Died 1991.

GEORGE SCRIVANI b. 1948, New York, NY. Editor, translator and cofounder (with Raymond Foye and Francesco Clemente) of Hanuman Books. Friend of Gregory Corso. Edited *Collected Writings of Willem de Kooning.* Translated Italian writer Alberto Savinio's 1918 travelogue/wartime diary, *The Departure of the Argonaut,* with illustrations by Clemente, for Petersburg Press. Lives in San Francisco.

PETE SEEGER b. 1919, Patterson, NY. A folk musician, he played music with Woody Guthrie and Leadbelly. Was called before the House Un-American Activities Committee and blacklisted in the 1950s.

Started a musicians union. Active in the anti-Vietnam War movement, he continues music-based political and environmental activism from his home in the Hudson River Valley.

HUBERT SELBY, JR. b. 1928, New York, NY. Dropped out of school at fifteen. Became addicted to drugs while recovering from radical lung surgery. Wrote *Last Exit to Brooklyn* (Grove Press, 1960) which was banned in England and Italy for its graphic depiction of sex and drugs. It was made into a movie in 1989. Taught writing at the University of Southern California. Died 2004.

TONY SHAFRAZI Iranian artist who protested the Vietnam War in 1974 by spray painting "Kill All Lies" on Picasso's painting *Guernica* (though not permanently damaged). Now an influential New York art dealer and gallery owner, one of the first to exhibit graffiti art. A full length nude portrait parody of Shafrazi was painted by Julie Harvey.

JOHN SINCLAIR b. 1941, Flint, MI. Detroit poet, 1968 manager of the MC5 and leader of the White Panther Party from 1968–1969. Cofounder of the Artists Workshop Press and the underground paper *Fifth Estate.* Sentenced to ten years for giving two joints to undercover narcs, he wrote *Guitar Army* and *Music & Politics* (with Robert Levin) while in prison. In 1971, John Lennon and Yoko Ono presented a "Free John Now" rally in Ann Arbor. Three days later, the Michigan Supreme Court released him. Recorded several poetry and jazz albums with the Blues Scholars (formed in 1982). Moved to New Orleans in 1991, assembled a new Blues Scholars and joined WWOZ radio. *Offbeat* Magazine's readers' poll voted him the most popular DJ from 1999–2003. Moved to Amsterdam in 2004 and continues to tour, record and host a radio show, which is streamed live online.

CLADYS JABBO SMITH b. 1908, Pembroke, GA. Started his career at seventeen with Harry Marsh in Philadelphia. A trumpet great in the 1920s and 1930s, he was considered a rival of Louis Armstrong. Played with Charlie Johnson and Duke Ellington in New York and Chicago, and settled in Milwaukee. Died 1991.

PATTI SMITH b. 1946, Chicago, IL, raised in New Jersey. Poet and singer/songwriter, she was part of the New York City punk scene associated with Andy Warhol, Allen Ginsberg and William S. Burroughs. Met lifelong friend Robert Mapplethorpe while working in a bookstore. Rock journalist for *Creem* magazine in the late 1960s. Spent the early 1970s painting, writing and reading poetry at St. Mark's Poetry Project and elsewhere, and began performing rock music with guitarist Lenny Kaye. In 1975, The Patti Smith Group released *Horses,* produced by John Cale (The Velvet Underground), a powerful debut. *Easter* (1978), featuring the hit single "Because the Night," cowritten with Bruce Springsteen, was commercially successful and reached #13 on Billboard's Hot 100. Married Fred "Sonic" Smith of the proto-punk MC5. From the 1980s through the early 1990s, lived with her family near Detroit. Her husband died of a heart attack in 1994. Returned to New York and toured briefly with Bob Dylan in 1995. Her latest release, *Horses Horses,* was a live performance at the Meltdown Festival in London (2005). Wrote *Auguries of Innocence: Poems* (2005), the foreword to *An Accidental Biography: The Selected Letters of Gregory Corso* (2005) and fourteen other books. Named Commandeur de l'Ordre des Arts et des Lettres by the French Ministry of Culture in 2005.

GARY SNYDER b. 1930, San Francisco, CA. Grew up in the Northwest near Puget Sound. Met Lew Welch and Philip Whalen while at Reed College. Went to Japan to study Buddhism in 1950s. Briefly married to Joanne Kyger. Appears as Japhy Ryder in Jack Kerouac's *Dharma Bums* and Jarry Wagner in *Desolation Angels.* Read at the legendary Six Gallery event where Ginsberg first read "Howl," San Francisco, 1955. Studied Zen Buddhism in Japan for twelve years. Poet and author of over fifteen books, he received the Pulitzer Prize for *Turtle Island* (1974), a Guggenheim Fellowship, the Bollingen Prize, the *Los Angeles Times* Robert Kirsch Lifetime Achievement Award and the Mountains & Plains Booksellers Association Poetry Award (1997). *No Nature: Selected Poems,* was a finalist for the National Book Award (1992). Ecological writings include *The Practice of the Wild* (1990) and *A Place in Space: Ethics, Aesthetics, and Watersheds*

(1996). *Mountains and Rivers Without End,* his forty-year epic begun in 1956, was published in 1996. Taught literature and wilderness thought at the University of California, Davis. Has lived since 1970 in the watershed of the South Yuba River in the foothills of the Sierra Nevada, in Northern California.

CARL SOLOMON b. 1928, the Bronx, NY. Met Allen Ginsberg while in Rockland Hospital; the poem "Howl" was inspired by him and subsequently dedicated to him. Worked as an editor at Ace Books, first published *Junkie* by William S. Burroughs, but rejected Kerouac's single-roll manuscript of *On the Road.* Published his memoirs in the 1966 book *Mishaps, Perhaps.*

SUSAN SONTAG b. 1933, New York, NY. Raised in Tucson, attended high school in Los Angeles, CA. Received B.A. from the University of Chicago, did graduate work at Harvard, St. Anne's College, Oxford and the Sorbonne. Author of four novels, a collection of short stories and eight books of nonfiction, including *Against Interpretation*, *On Photography, Illness as Metaphor, Where the Stress Falls* and *Regarding the Pain of Others.* Also a director of films and plays, she saw herself as a fiction writer, though she was best known as a public intellectual and essayist. Antiwar and human rights activist, President of PEN America Center 1987–1989. Received the National Book Award for her novel *In America* (2000), the National Book Critics Circle Award for *On Photography* (1978) and a MacArthur Grant. In 1992, she received Italy's Malaparte Prize and was named Commandeur de l'Ordre des Arts et des Lettres by the French Ministry of Culture in 1999. Died 2004.

TERRY SOUTHERN b. 1924, Texas. Novelist, short story writer and essayist who wrote the screenplay for *Dr. Strangelove* and *Easy Rider.* Part of the Paris postwar literary movement, he hung out with Beat writers in Greenwich Village. Coauthor of the controversial 1958 novel *Candy:* The 1968 film adaptation starred Marlon Brando, Richard Burton and Walter Matthau. The 1969 adaptation of his novel *The Magic Christian* starred Peter Sellers and Ringo Starr. In the 1980s, he wrote for *Saturday Night Live* and taught screenwriting at Columbia University. Died 1995.

FRANCES STELOFF b. 1887, Sarasota Springs, FL. Moved to New York City as a young woman and opened the Gotham Book Mart on 47th Street in 1920. The bookstore became a center of literary activity, selling modern experimental works and banned books. A memoirist, book collector and publisher, she befriended major literary figures and sponsored book events. Died 1989.

DEAN STOCKWELL b. 1936, North Hollywood, CA. Played Gregory Peck's son in the 1947 film, *Gentlemen's Agreement.* Successful acting career in both film and television, star on Hollywood Walk of Fame and nominated for an Academy Award. Appeared in films including *Blue Velvet* (1986), *Paris, Texas* (1984), and *Married to the Mob* (1988). Guest starred on *Star Trek: Enterprise,* received an Emmy nomination for his role in *Quantum Leap* and now has a recurring role on *Battlestar Galatica.* Also an artist working with digital photography and collage in the style of his late friend, artist Wallace Berman.

DR. BILLY TAYLOR b. 1921, North Carolina, into a musical family. A jazz pianist, composer, arranger and educator, he studied classical piano as a child. Headed to New York City in 1942, played with Art Tatum, Charlie Parker and Billie Holliday. Recorded numerous albums, formed his own record label, Taylor Made, and toured with the Billy Taylor Trio. Hosted National Public Radio's *Billy Taylor's Jazz at the Kennedy Center* and other TV and radio programs. Received an Emmy for his feature on Quincy Jones and two Peabody Awards. Founder of the Jazzmobile outreach program, his books include *Jazz Piano: A Jazz History* (1983) and *The Billy Taylor Collection* (1999). Holds the Wilber D. Barrett Chair at the University of Massachusetts, where he earned his Ph.D., and is Duke Ellington Fellow at Yale University. One of only three jazz musicians appointed to the National Council of the Arts, he received an NEA Jazz Masters Fellowship (1992). Named jazz artistic advisor to the Kennedy Center in 1994.

CECIL TAYLOR b. 1929, Long Island, NY. Attended the New England Conservatory of Music. A pianist, by the mid-1950s

he led his own small groups with Buell Niedlinger, Steve Lacy and Archie Shepp: Began teaching and ran his own record label. Around 1980, his career gathered energy with new recordings released in Japan and Europe. Was elected to the *Down Beat* Hall of Fame in 1975 and repeatedly voted number one pianist in *Down Beat* magazine's international critics poll. His music is both nuanced and abrasive, inspiring younger musicians to innovation. Received a MacArthur Grant and the Berlin Free Jazz Society held "Cecil Taylor Week" in 1986. Recorded over seventy-five albums, including his recent solo *The Willisau Concert* (2002). Also a poet; Robert Duncan, Charles Olson and Amiri Baraka have been cited as influences. Weaves poems into his musical performances and the liner notes of his albums. He recites his own poetry without music on *Chinampas* (CD, 1987, 2000). Lives in Brooklyn, NY.

STEVEN TAYLOR Received a Ph.D. in ethnomusicology from Brown University. Poet, musician and cultural critic, he is author of *False Prophet: Field Notes from the Punk Underground* (2003) and two poetry books. Composed music for and performed on many recordings, film, radio and stage projects. Collaborated and toured with Allen Ginsberg, Anne Waldman, Kenward Elmslie and the Fugs. Directs the Naropa Audio Archive and teaches poetry and critical theory at Naropa in Boulder, Colorado.

CLARK TERRY b. 1920, St. Louis, MO. Studied trombone in high school. Worked in the 1950s with Duke Ellington, played with the Doc Severinsen Band on the *Johnny Carson Show* for twelve years, then started playing flugelhorn, which became his principal instrument. His discography spans fifty years from *Clark Terry* (1954) to *A Jazz Symphony* (2000).

JOHN THOMAS b. 1930, Baltimore, MD. Attended Loyola College, thought of becoming a priest, then joined the Air Force. Was a computer programmer before computers were widely used. Worked on UNIVAC but left because they were building "another one with which to make bigger bombs". In 1959, with fourteen dollars, he hitchhiked to Venice, California, from Baltimore, becoming part of L.A.'s avant-garde "outsider" tradition, the Venice Beats. Poetry published in *Floating*

Bear and *Evergreen Review*. Interested in Buddhism and a simple lifestyle, he was a friend of Charles Bukowski, Wanda Coleman and married poet Philomene Long. Died 2002.

HUNTER S. THOMPSON b. 1937, Kentucky. Served two years in the Air Force. Journalist and counterculture icon, he created Gonzo journalism in the early 1970s, which rejects objectivity, focuses on the writer as part of the story and blurs the line between fact and fiction. Author of at least fifteen books, including *Fear and Loathing in Las Vegas* (1971), which follows Raoul Duke and his attorney, Dr. Gonzo, as they travel to Las Vegas, NV, to cover a motorcycle race in a drug-induced haze; it first appeared in *Rolling Stone*. Johnny Depp played his character in the 1998 movie adaptation. *Fear and Loathing on the Campaign Trail '72* (1973) came next. Rode with motorcycle gangs and wrote *Hell's Angels: A Strange and Terrible Saga* (1999) and *Fear and Loathing in America: The Brutal Odyssey of an Outlaw Journalist* (2000). Committed suicide 2005.

STANLEY TWARDOWICZ b. 1917. Painter and photographer, neighbor and friend of Jack Kerouac's in Northport, Long Island, NY, in the early 1960s. They hung out at the artist's studio/loft and played softball together. Recipient of a Guggenheim Fellowship in 1955.

JOHN TYTELL b. 1939, Belgium. Emigrated with his family (Jews who fled the Nazis), to Manhattan's Upper West Side. Earned a Ph.D. from New York University. Literary critic, scholar and specialist on the Beat Generation, he wrote *Naked Angels: The Lives and Literature of the Beat Generation* (1976), *Paradise Outlaws: Remembering the Beats* (1999), *Passionate Lives: D.H. Lawrence, F. Scott Fitzgerald, Henry Miller, Dylan Thomas, Sylvia Plath…in Love* (1991), *The Living Theatre: Art, Exile, and Outrage* (1995), *Reading New York* (2003) and *Ezra Pound: The Solitary Volcano* (2004).

JANINE POMMY VEGA b. 1942, New Jersey. At fifteen, inspired by Kerouac's *On the Road,* she became involved in the Manhattan Beat scene. Left America in 1962 with her husband, painter Fernando Vega, to travel in Europe and Israel, where he died in 1965. City Lights published her first book, *Poems to Fernando* (1968). After living in San Francisco and South America, she returned to New York in 1975 to teach poetry and writing. Author of more than a dozen books, including *Tracking the Serpent: Journeys to Four Continents* (1997), and coauthor with Hettie Jones of *Words over Walls*, a handbook on starting writing workshops in prisons.

GORE VIDAL b. 1925, West Point, NY. Novelist, playwright, screenwriter, essayist, provocateur and historian, he published his debut novel, an account of his military experiences, at twenty-one. Became a spokesperson and pundit for the New Left and a champion of freedom and justice. Author of over sixty books and plays, his works include *Burr* (1973), *Myra Breckinridge* (1968), *Lincoln* (1984) (a masterwork of historical fiction), *Perpetual War for Perpetual Peace: How We Got to Be So Hated* (2002), *Dreaming War* (2003) and *Imperial America: Reflections on the United States of Amnesia* (2005), a collection of articles written for *The Nation, Esquire* and other magazines. Lived much of his life in Italy, now resides in Los Angeles, CA.

KURT VONNEGUT b. 1922, Indianapolis, IN. Studied chemistry at Cornell. Served in the infantry in World War II and took part in the Battle of the Bulge. As a prisoner of war, he witnessed the 1945 bombing of Dresden, Germany, which influenced his future writing. Received a Purple Heart. Earned an M.A. in Anthropology at the University of Chicago. Was a police reporter in Chicago, and public relations man for General Electric in Schenectady, NY before turning to writing full-time in 1951. Known for overtones of black comedy, satire and science fiction, he was the author of over twenty books. His first novel was *Player Piano,* (1952); others included his preeminent anti-war novel *Slaughterhouse Five* (1969), *Cats Cradle* (1963) and *Breakfast of Champions* (1973). He called *Time Quake* (1997) his last novel; *A Man Without a Country* (2005) is an essay collection. Lives in the Cape Cod area, Massachusetts.

ANDREI VOZNESENSKY b. 1933, Moscow. Studied at Moscow Architectural Institute. A controversial yet celebrated poet of the post-Stalinist era in Russia. A leader of the 1960s poetry and literature renaissance in the Soviet Union, his writings were attacked by Khrushchev in 1963. One of the first poets to appear at and support huge audience public poetry events in Russia in the early 1960s. A protégé of Boris Pasternak. Author of *An Arrow in the Wall: Selected Poetry and Prose* (1988). Since democratization of the Soviet Union in 1989, he reads and performs worldwide. Now working on Videoms, visual poetry using technology.

TISA WALDEN b. 1954, raised in Washington, DC. Poet, publisher of Deep Forest Press and editor of the *Deep Forest Review*, she has featured poets such as Michael McClure, Tom Clark and Kirby Doyle. Received an M.A. in English Literature from San Francisco State University. Was the companion of the late poet Howard Hart. Teaches in the Poetics Program at the New College of California. Lives in San Francisco, CA.

ANNE WALDMAN b. 1945, New Jersey, raised on MacDougal Street, New York, NY. Received her B.A. from Bennington. Poet, teacher and performer. Influenced by New York School, Beat and experimental traditions, she worked at the St. Mark's Poetry Project in New York (assistant 1966–1968, director 1968–1978). *Fast Talking Woman* (1974) published by City Lights. Cofounded, with Allen Ginsberg, the Jack Kerouac School of Disembodied Poetics at Naropa, Boulder, Colorado, in 1974. Toured with Bob Dylan's Rolling Thunder revue in the 1970s. Author of numerous books, including *Outrider: Essays, Poems, Interviews* (2006), *Structure of the World Compared to a Bubble* (2004), *Helping the Dreamer: New and Selected Poems 1966–1988, In the Room of Never Grieve: New and Selected Poems 1985–2003, Marriage: A Sentence* (2000) and *Vow to Poetry* (2001). Editor of *The World Anthology: Poems from the St. Mark's Poetry Project* (1969), *Disembodied Poetics: Annals of the Jack Kerouac School* (1993) and *The Beat Book* (1996). Collaborated with dancers, musicians Steve Lacy and Steven Taylor, and visual artists Joe Brainard, George Schneeman, Red Grooms, Susan Rothenberg, Richard Tuttle and Elizabeth Murray. Honors include the Poets Foundation Award, Shelley Memorial Award and a Foundation for Contemporary Performance Arts Grant (2002). Two-time winner of the World Heavyweight Poetry Bout in Taos, New Mexico.

JOHN WEINERS b. 1934, MA. Graduated from Boston College. Studied at Black Mountain College under Charles Olson and Robert Duncan (1955–1956). Published *Measure* literary magazine in Boston. In 1958, moved to North Beach and became an active participant in the San Francisco Poetry Renaissance. Friend of poets Robert Duncan, Jack Spicer, Joanne Kyger, Ed Dorn and artist Robert LaVigne. Returned to Boston in 1960. Entered graduate school at SUNY Buffalo in 1965. Published *Selected Poems, 1958–1984* (Black Sparrow Press, 1986), the autobiographical *The Hotel Wentley Poems* (Auerhahn Press, 1958) and *Asylum Poems* (1969). Active in Poet's Theatre in Cambridge. Three of his plays were performed at Judson Poet's Theater, New York. Moved to Boston in 1970 and became involved in politics and gay rights. Died 2002.

ruth weiss b. 1928, Berlin. In 1933, with her Jewish family, she fled to Austria and began writing poetry. Escaped to the US in 1939, lived in New York and Chicago and graduated in the top 1 percent of her high school class. Attended college in Switzerland. Back in Chicago, gave her first reading accompanied by jazz in 1949, with subsequent performances at The Cellar in North Beach, San Francisco, beginning in 1956. Vocal and jazz rhythms suffuse her poetry. Wrote over a dozen one act plays, and produced a series of film-poems and a movie, *The Brink (1961)* (said by Stan Brakhage to have "a haiku feel.")

FLOYD RED CROW WESTERMAN b. 1936, South Dakota. Member, Dakota Sioux Nation. Holds a degree from Northern State College. Native American actor, folk artist, singer, poet and environmental and anti-nuclear activist, he has appeared in television shows and films, from *Northern Exposure* and the *X Files* to *The Doors* and *Hidalgo*. Played the character Ten Bears in *Dances with Wolves*. Founder and executive director of the Eyapaha Institute, he continues to work with the American Indian Movement. Lives in California.

KRISTEN WETTERHAHN San Francisco visual artist and poet who was once a belly-dancer. Coedited *Beatitude #23* (1976) with Jack Hirschman, her companion from 1975 to 1983. A North Beach icon and politically involved, she works in wood-cuts, pen and ink, collage and calligraphy. Designed album cover art for Kitty Margolis.

PHILIP WHALEN b. 1923, Portland, OR. Served in World War II, attended Reed College on the G.I. Bill. Gary Snyder and Lew Welch were his college room-mates. Poet and novelist, he moved to San Francisco, where he was a fresh voice in the San Francisco poetry renaissance of the mid-1950s. Read at the legendary Six Gallery poetry event in 1955, where Ginsberg first read "Howl," with Gary Snyder, Philip Lamantia and Michael McClure. Friendship with Jack Kerouac. Moved to the San Francisco Zen Center in 1972, was ordained a Zen Buddhist monk in 1973 and became head monk, Dharma Sangha, in New Mexico (1984). After fifteen years of formal Zen training, became Abbot of Hartford Street Center, San Francisco. Author of numerous books, including *On Bear's Head* (1969), *Canoeing Up Carbarga Creek: Buddhist Poems 1955–1986* (1996) and *Overtime, Selected Poems* (1999), edited by Michael Rothenberg, with an introduction by Leslie Scalapino. His novels are the quasi-autobiographical trilogy: *You Didn't Even Try* (1967), *Imaginary Speeches for a Brazen Head* (1972) and *The Diamond Noodle* (1980). Received The Poets Foundation Award (1962), American Academy of Arts and Letters Grant-in-Aid (1965), Committee on Poetry Grants (1968, 1970, 1971) and an American Academy and Institute of Arts and Letters Award (1985) for "progressive, original and experimental tendencies." Died 2002.

RON WHITEHEAD b. 1950, Kentucky. Poet and publisher, he was an anti-war activist, edited *Thinker Review,* and cofounded White Fields Press, where he made contact with Diane di Prima, Allen Ginsberg and Lawrence Ferlinghetti. Influenced by Thomas Merton. In 1993, he created The Global Literary Renaissance, a nonprofit organization supporting the world literary community. Author of seventeen books, he has produced over a thousand poetry and music events in Europe and the US. Lives in Kentucky.

GEORGE WHITMAN b. 1914, Salem, MA. His father was an author of scientific books. Moved to Paris in 1946 and received his diploma from the Sorbonne. Started the bookshop and library, Le Mistral, renamed Shakespeare & Company in 1964, with the approval of Sylvia Beach, founder of the original expatriate bookstore. Lawrence Ferlinghetti, Gregory Corso, Allen Ginsberg, Lawrence Durrell and hundreds of poets and writers have spent time at this legendary bookstore at 37 rue de la Bûcherie.

SYLVIA WHITMAN b. 1981, England. Daughter of George Whitman (conceived at Hotel Dieppe in Paris and named after Sylvia Beach). Studied history at University College, London. Lives in Paris where she helps run her father's bookstore, Shakespeare & Company, organizes literary events and plans to expand into publishing.

INDEX